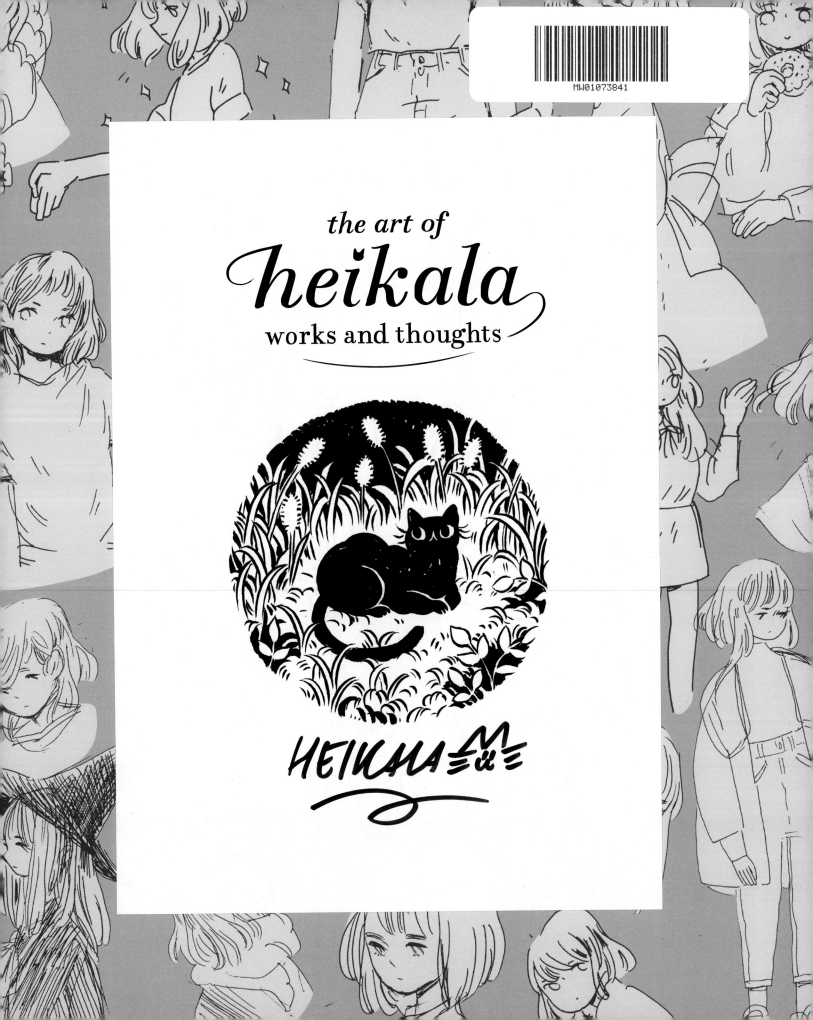

the art of
heikala
works and thoughts

HEIKALA

the art of heikala

works and thoughts

Äidille.

(To Mom)

Correspondence: publishing@3dtotal.com
Website: www.3dtotal.com

Every effort has been made to ensure the credits and contact information listed are present and correct. In the case of any errors that have occurred, the publisher respectfully directs readers to the www.3dtotalpublishing.com website for any updated information and/or corrections.

3dtotal Publishing assumes no responsibility for any damage caused to you or your property by any activities taken up in response to this book.

First published in the United Kingdom, 2019, by 3dtotal Publishing. 3dtotal.com Ltd, 29 Foregate Street, Worcester, WR1 1DS, United Kingdom.

Reprinted in 2021 by 3dtotal Publishing.

Hard cover ISBN: 978-1-909414-81-5
Printing & binding: Gutenberg Press Ltd (Malta)
www.gutenberg.com.mt

Visit www.3dtotalpublishing.com for a complete list of available book titles.

Managing Director: Tom Greenway
Studio Manager: Simon Morse
Assistant Manager: Melanie Robinson
Lead Designer: Imogen Williams
Publishing Manager: Jenny Fox-Proverbs
Editor: Kinnor Wroughton

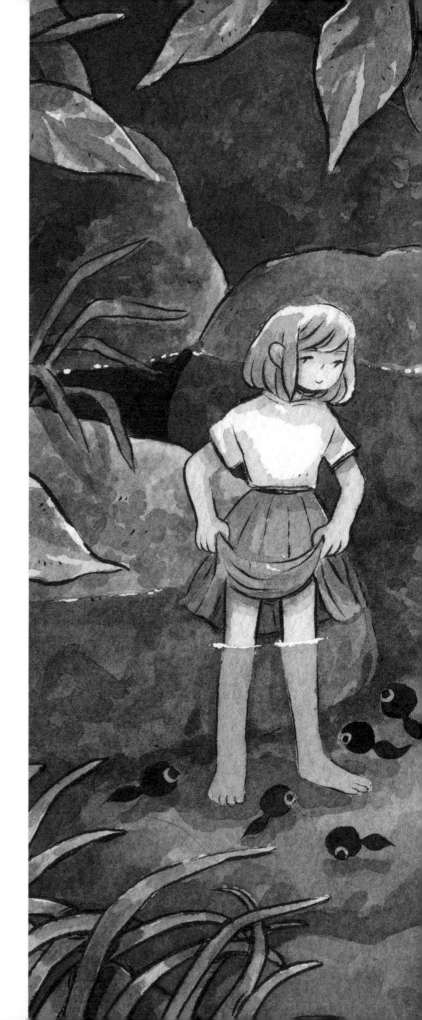

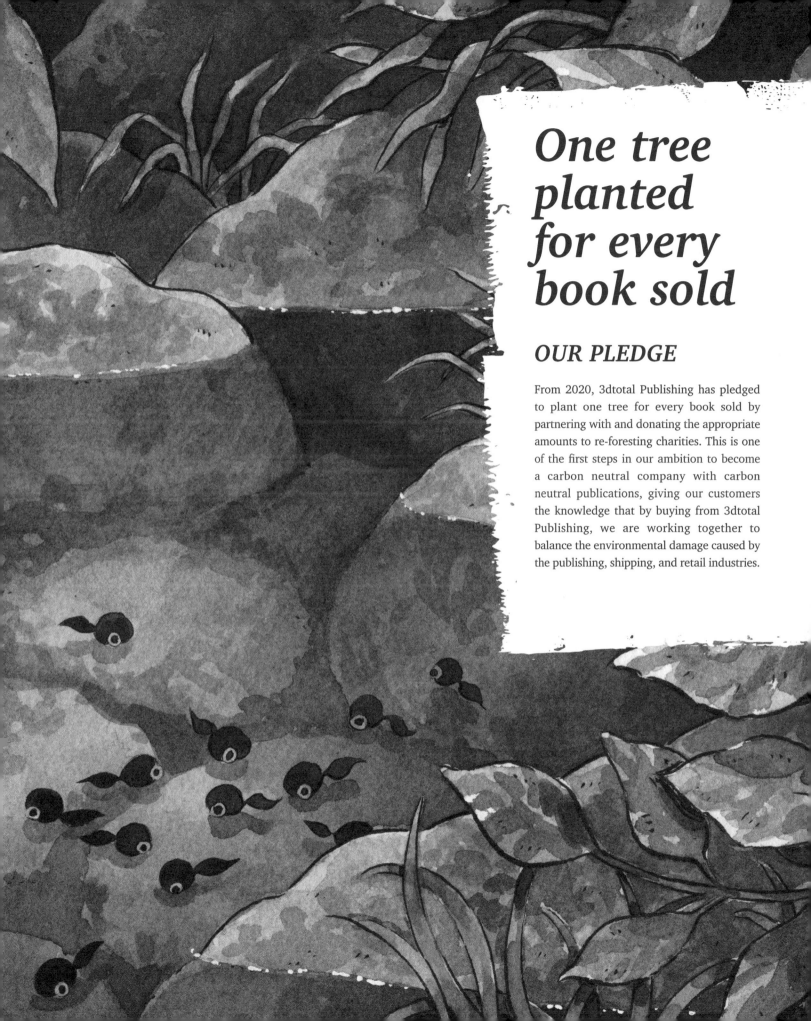

One tree planted for every book sold

OUR PLEDGE

From 2020, 3dtotal Publishing has pledged to plant one tree for every book sold by partnering with and donating the appropriate amounts to re-foresting charities. This is one of the first steps in our ambition to become a carbon neutral company with carbon neutral publications, giving our customers the knowledge that by buying from 3dtotal Publishing, we are working together to balance the environmental damage caused by the publishing, shipping, and retail industries.

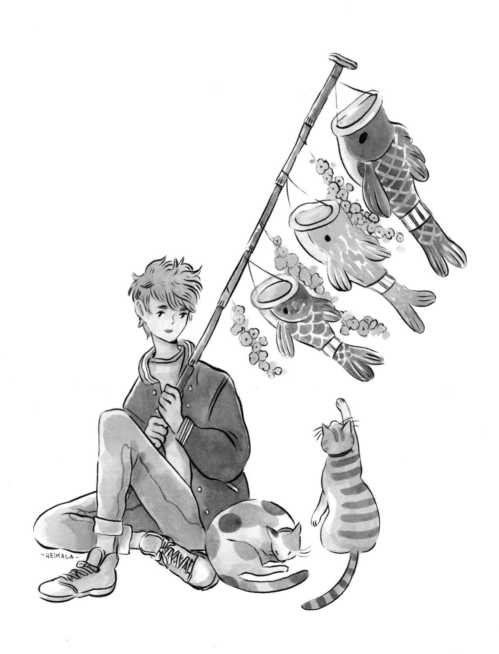

Contents

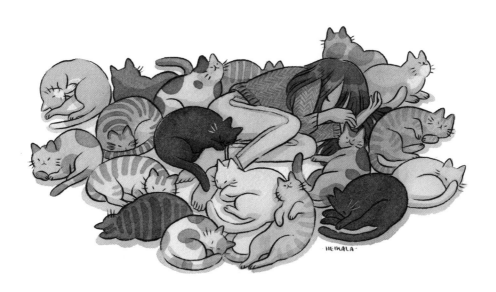

Foreword

by Mateusz Urbanowicz, Illustrator

Some artists will paint what they see, showing you the real world through their eyes; other artists present fantastical worlds. The work of these artists tells you a magical story and makes you feel as if you are there, that you know the places and the people within that make-believe world. They craft artworks that make you feel strangely nostalgic for things you haven't experienced.

If you are reading this, then perhaps you are more interested in "storytelling" illustrations rather than traditional watercolor paintings. If this is the case, I think you have come to the right place!

I have been creating art with watercolors for many years – for illustrations, comics, and even animation backgrounds. However, I have never thought of myself as a "watercolor artist". In my mind, they are the cool types, working outside, painting on an easel, allowing the paint to flow, drip, and mix – producing with a few measured and perfect strokes, beautiful works that traditionally define watercolor painting.

When I saw Heikala's works for the first time, I knew I had found an artist who uses watercolors in a similar way to me. She colors the imagined stories and scenes that fill her head. We both make lines to define the boundaries and to give the stories their shape. We fill them with transparent color, light, and shadow, and imbue them with ordinary life sentiments, and a touch of magic, to create nostalgia and wonder.

From the technical side, I marvel at how masterfully she uses a black ink brush pen to paint linework (I fail miserably, mostly producing black blobs). I also admire her delicate, flowing, and unique style. I love how she uses color, including both bright, saturated tones and really dark, deep shadows, while at the same time keeping the illustrations clean and easily readable. But most of all, I am surprised at how perfectly line and color work together to create her images. I can only imagine how much time, and trial and error, went into developing this awe-inspiring style. And that is only the medium.

What I enjoy the most are the wonderful stories and themes in Heikala's art. We share similar inspiration – Japan and its vibrant visual culture, its animation and comics. It can be dangerous falling head first into such a vast universe of art, and it can be easy to lose yourself and your style. While reading this book I was pleased to find that Heikala has managed to stay true to herself while being inspired by Japanese culture.

Heikala succeeds in creating fantastic works based on real emotions and experiences, which is why I think it is so important to "read" the stories behind the works of artists like her. This type of art fills us with positivity and gives us motivation to explore and make our dreams a reality. Just like me, I'm sure you will feel more hopeful after reading this book.

Finally, I feel very proud that I could participate in this book, and fortunate that I could meet Heikala herself in Tokyo and work collaboratively with her on animation backgrounds. I look forward to seeing more of her captivating works.

Mateusz

P.S. I also love the tutorial section of this book and may try to steal some secrets to use in my own work!

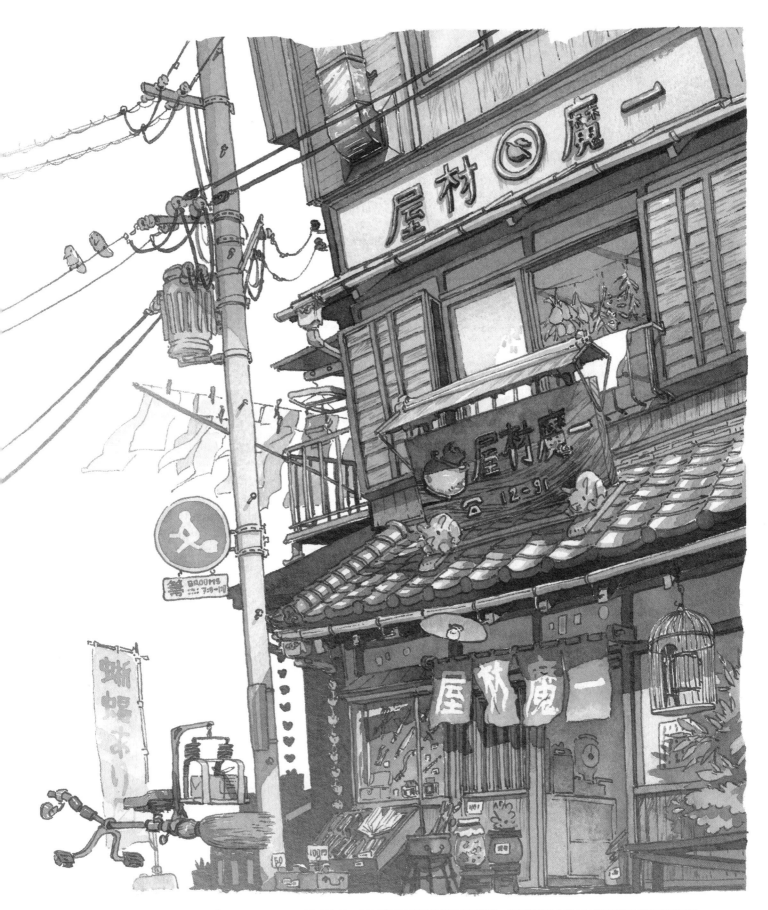

ICHI MAZAI YA (MAGIC INGREDIENTS STORE, LOCATED IN JIMBOCHO, TOKYO) — ARTWORK © 2018 MATEUSZ URBANOWICZ

Introduction

This is not my first book, but it is by far my most ambitious one. I wanted to offer more – to delve deeper into my creative process, and present my stories, ideas, and an extensive collection of my creations in a tangible form.

My art is centered on people and places; stories and feelings. I create art that feels nostalgic and familiar, striving to connect with the viewer on an emotional level. I like to tell stories through my works, and play around with different characters and environments.

My great love of art is entwined with my passion for the traditional mediums of watercolor and ink – creating on paper that has its own unique qualities, with brushes and paint that are surprising and, at times, hard to control. While computer software provides endless opportunities for an artist, I still find myself going back to traditional mediums – partly for nostalgic reasons, but also for the organic process where different elements and materials combine to create a visual narrative. It is also an amazing feeling to hold a finished illustration in my hands, knowing that it is the current culmination of my abilities, and that there is only one of this work of art in existence.

The modern age has made it possible for artists to connect with their audience in a faster, more responsive way, and I find the interaction that can be achieved through social media is a valuable part of my work and process. Through the eyes and thoughts of my followers I can see something more in my own illustrations. I love being surprised by the many ways people see my work, how they feel about the themes and stories I am presenting with my art. I hope to keep evolving, coming up with new ideas and surprising the viewer.

In this book, I show my thought processes – everything that goes into creating my illustrations. I also share tips I have learned along the way, as well as the evolution of my art through the years.

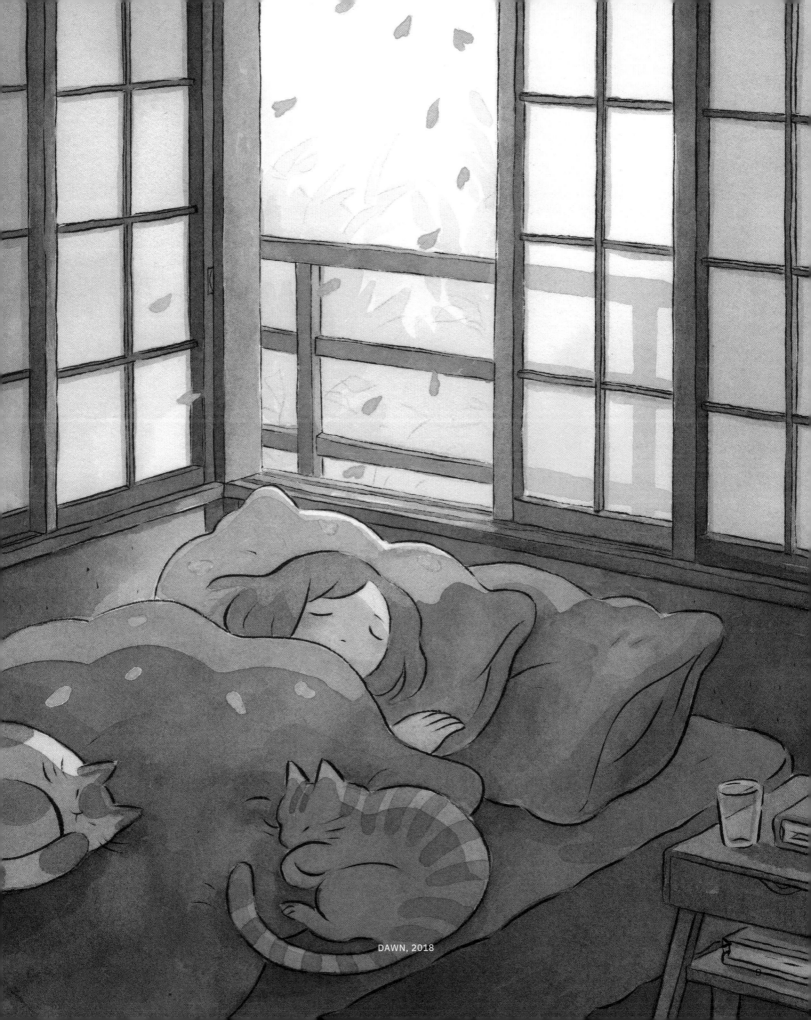

DAWN, 2018

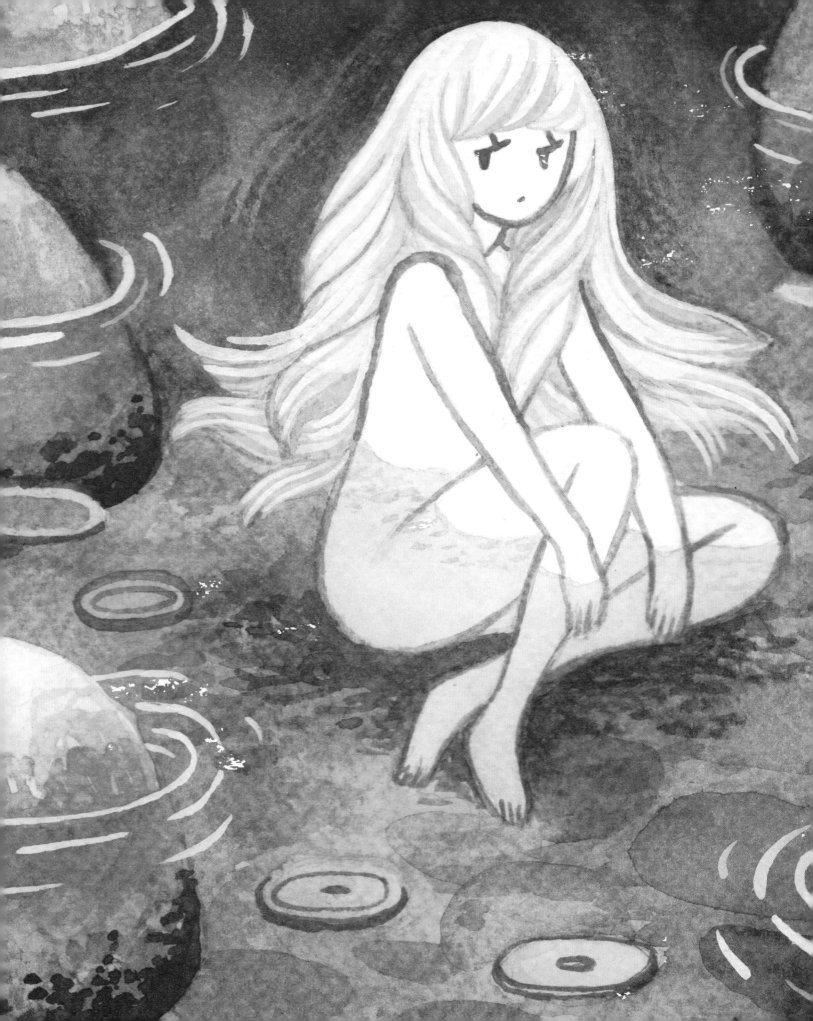

Artistic journey

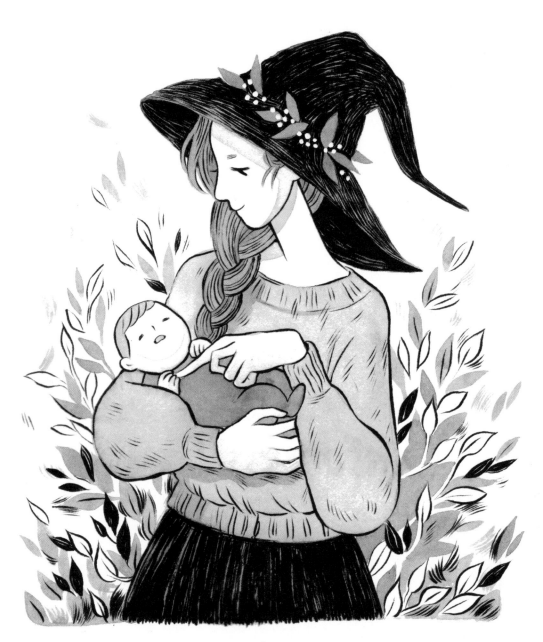

MOTHER AND DAUGHTER, 2016

Beginning

I have always been passionate about drawing and creating with my hands. When I was little, my enthusiasm for making art was so overwhelming that it led to numerous tellings-off for drawing on the walls at home! Nevertheless, my parents always supported me in creating art, which I feel incredibly lucky for – I rarely heard disheartening comments about how difficult it would be to turn my passion into a career.

My education in art started in primary school and continued through to university. Over the years I learned art theory, art history, and different techniques from many inspiring and engaging artists and teachers; having the opportunity to learn in encouraging environments further developed my positive attitude towards art.

Outside school I drew constantly, putting into practice all I had learned while drawing on the influences around me. I knew early on that I wanted to carry the passion for creating with my hands throughout my life, and I feel so grateful that I am able to make a living from it.

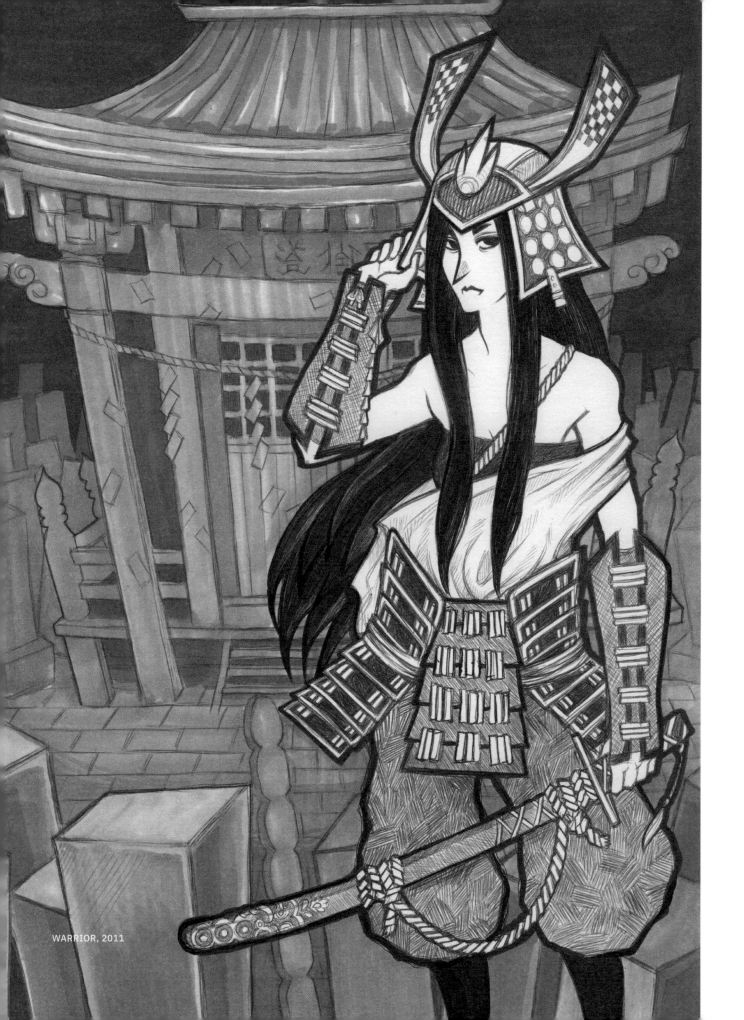

WARRIOR, 2011

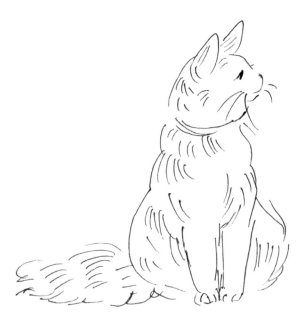

Early influences

The turn of the millennium had a huge impact on my art as *Pokémon* started airing in my home country – followed by several other Japanese animated TV shows and manga. Until that point, my drawings had mostly been of animals and the occasional princess, but something about these cute creatures grabbed my attention and I started to draw them all the time. I had piles and piles of paper with drawings of my favorite Pokémon on them. I started with the most simple designs, but moving on and studying their shapes encouraged me to draw with more complexity.

A few years later, the first two manga series hit the shelves of local kiosks – *Ranma ½* (a Japanese manga series written and illustrated by Rumiko Takahashi) and *Dragonball* (a Japanese media franchise created by Akira Toriyama in 1984). I started saving my allowance so that every month I could buy the new copy of *Ranma ½*; I absolutely adored the style of Takahashi – reading her work triggered a desire in me to draw more human characters.

At the same time, many TV series featuring magical girls were airing that had their own spin-off comics, and these had an effect on the things I drew as well. A few years later, I bought my very first art book – a collection of prints by Yoshitaka Amano; I was inspired by his gorgeous creations and seemingly perfect use of brush and pencil to form his characters.

Education

I began with the mandatory art classes in primary school, which I enjoyed very much, but in the second grade I applied and got into an art-focused class that began the year after. My teacher was incredibly supportive – she was an inspiring person with a background in art education studies and an interest in creating art herself. Our class had opportunities to learn techniques from sculpting to pastels; collaging to oil painting.

After four more years in primary school, I began my studies in another school where I continued in an art-oriented class. Fortunately my new teacher was enthusiastic about teaching art too. There I increased my knowledge in art history and different techniques, such as making films, performance art, and experimenting with printmaking.

During this time, I was developing my interest in Japanese animation and comics and it led me to my first great art-friend (and rival!) who had similar interests in anime and manga. We drew together all the time, comparing our creations with each other, motivating each of us to draw even more.

We decided to create stories together, starting an improvisational comic that went on for more than a hundred pages. At the same time, I noticed I had less and less interest in any other school subject and found myself drawing all the time during classes as well as sending notes with drawings on them to my friends.

Up to this point, I had mainly worked with pens and pencils in my free time, but then I discovered Copic markers, and I finally began to incorporate colors into my personal works. I also posted my works online for the first time – although not under the name of Heikala at this stage.

When middle school was about to end, I started wondering what I'd like to do next. Since there were not as many possibilities to study in an art-oriented upper-secondary school in my hometown, I decided to apply to study in another city.

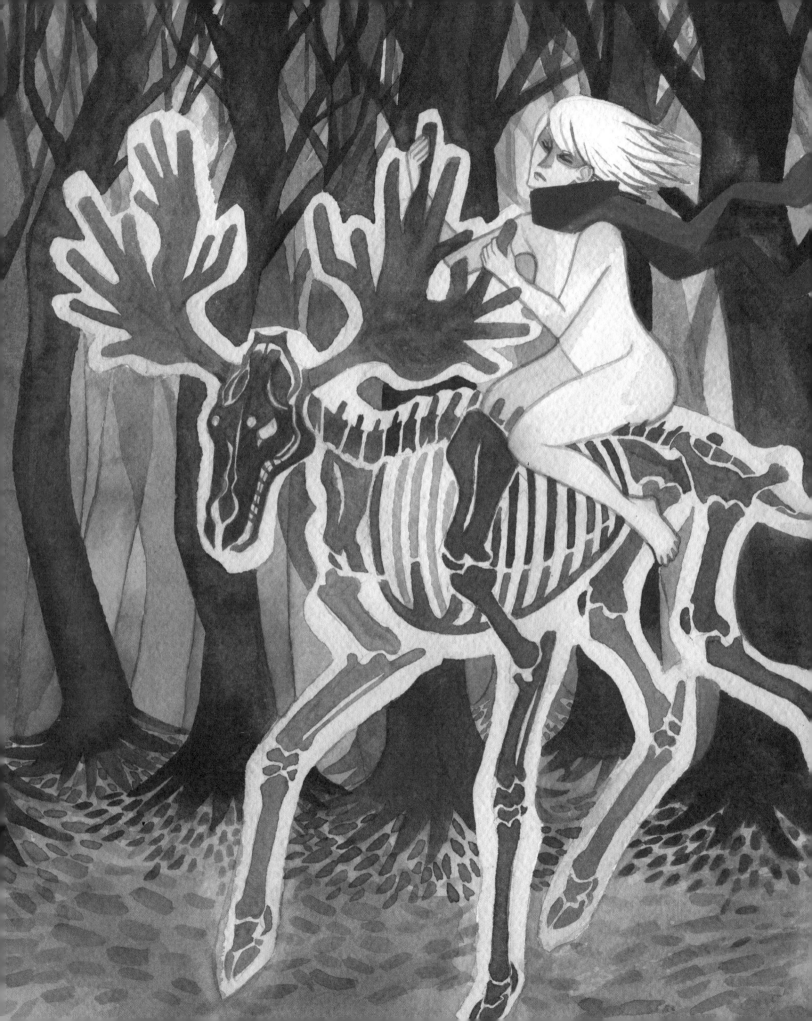

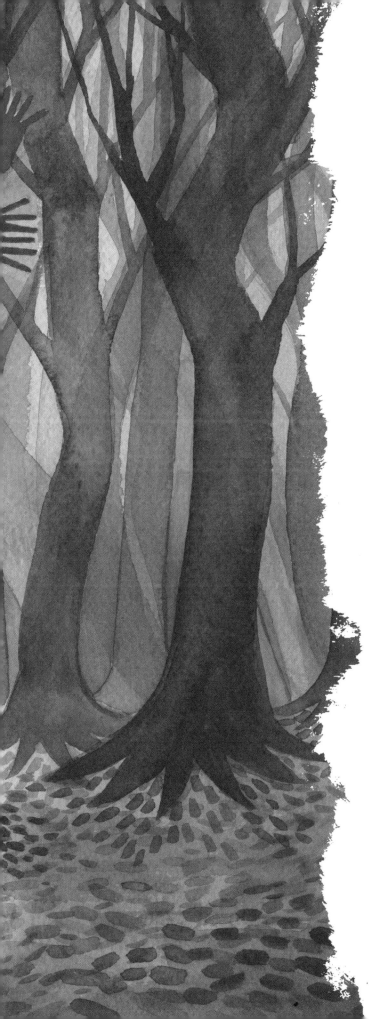

Art school

At the age of sixteen, I applied and got into the art school in Helsinki – *Helsingin Kuvataidelukio* – so in 2008 I moved away from home and began a new chapter in my life, trying hard to be independent and learn new things. The courses covered a lot of what I was taught in middle school, but I still had great experiences. There was such a huge variety of art courses to choose from, so I learned little bits and pieces about everything. I took courses in pottery, screen printing, technical drawing, comics, printmaking, computer programs, and photography. I loved every moment I got to spend in art class. At the same time, however, I was becoming less interested in the more academic, compulsory studies. In the little free time that I did have, I tried my hand at digital art for the first time, and while it was enjoyable, I still found I preferred creating art traditionally.

During the final weeks of my course, with my compulsory studies completed, I finally ended up with a lot of free time on my hands. This was when I started sharing my works online as *Heikala*. I posted mainly fan art of my favorite games, and works I created using different techniques.

I also began to draw more detailed pieces, with backgrounds, implementing what I had learned about color theory, three-dimensionality, and other techniques into my own works. I started using watercolors more frequently for my personal works and preliminary university assignments too.

The last spring of my upper-secondary school was spent wondering what to do next. I was torn between applying to study Art Education or Graphic Design. On the one hand, having been inspired by such encouraging art teachers and role models myself, I also wanted to support others to make art. On the other hand, I knew I had very little interest in the academic side of my studies. In any case, I applied and was invited to take part in entrance exams to both schools. I went to the exams for the graphic design studies first, at the Lahti Institute of Design. To my surprise, I found myself actually enjoying them and I liked the overall atmosphere. During an interview for the course, one of the interviewers implied that my works were great and that I should come and study Graphic Design there. I still took an exam for the Art Education program, but my decision had already been made so I didn't complete the rest of them – Lahti and Graphic Design it was.

MOOSE RIDE, 2011

University

At university I finally felt I had found my place. Being surrounded by inspiring teachers and peers motivated me to learn more and I created art constantly. Getting to grips with the basics of the industry was challenging but fun – the teachers had unique personalities and shared their vast expertise in the field. The first two years of university sparked a flame in me that couldn't be extinguished, and I started to get a grasp of what I wanted to do for a living.

With the equipment and the seemingly unlimited possibilities that the school provided, I was able to fulfill my desires to create all sorts of goods in the form of booklets, prints, wooden trinkets, and hand-printed designs. I was doing occasional graphic design work for clients alongside my studies, but the more I did these, the more I felt unfulfilled having to abide by the expectations of clients; I found I would rather use the spare time to focus on my own works. I realized that I wanted to turn making my own art into a job and, as impossible as that seemed to achieve, I placed all my efforts into achieving that goal.

During the last years of university, I started to use the classes to build my own future with art. The many courses that I had taken during university all helped me form my brand. As my final thesis project, I decided to make a collection of products, so I could make a fluent, permanent switch from studies to working life.

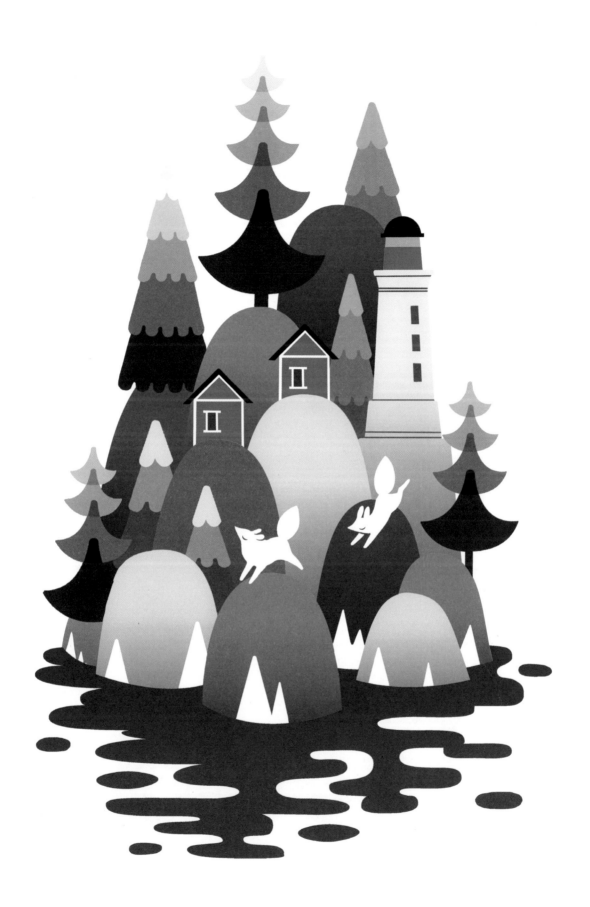

HAILUOTO, 2008

A silk illustration depicting an island on the coast of my hometown

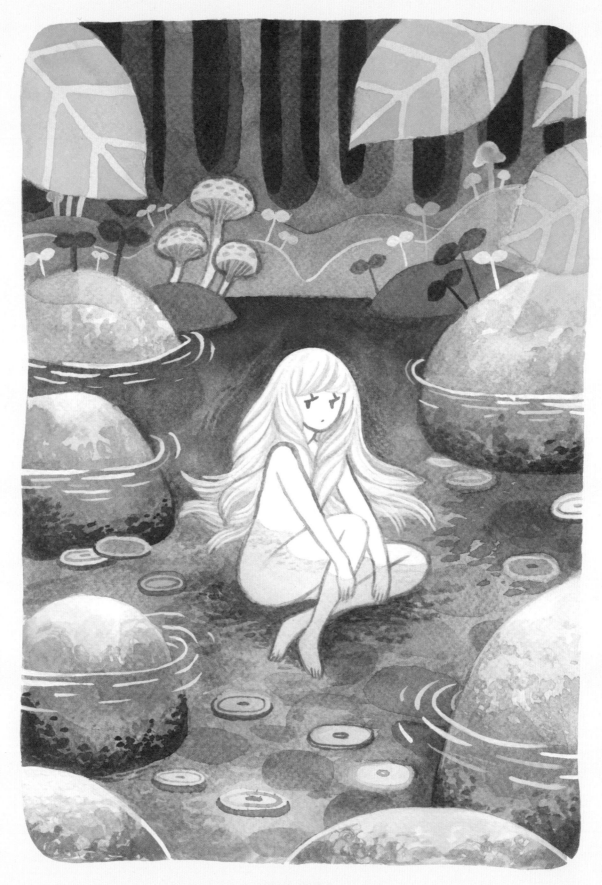

SPIRIT, 2013

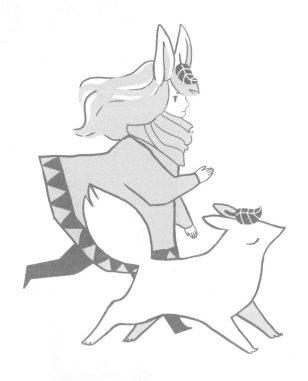

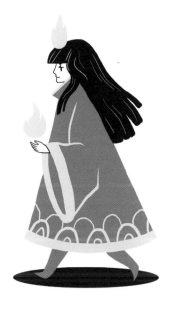

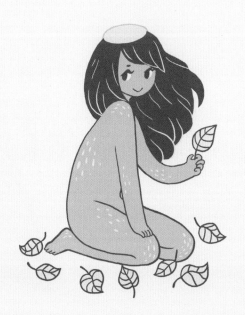

Artist alleys

Visiting artist alleys – spaces at conventions where artists can display and sell their various works – started off as just a hobby for me. I displayed my works at a couple of local alleys during upper-secondary school and was blown away by the amazing feedback I received for them. It was incredible to realize there were people who actually wanted to own the things I made. The hobby stayed with me throughout university, and I created products all the time.

Going to artist alleys also helped me to persevere with my style. At university, I felt pressured to use a prescribed style for illustrating, but the people who bought products from me at conventions were interested in the style that was most natural to me, so I continued with this.

The combination of university and artist alleys helped me to shape my visual voice, ultimately leading me to decide to produce original artworks exclusively.

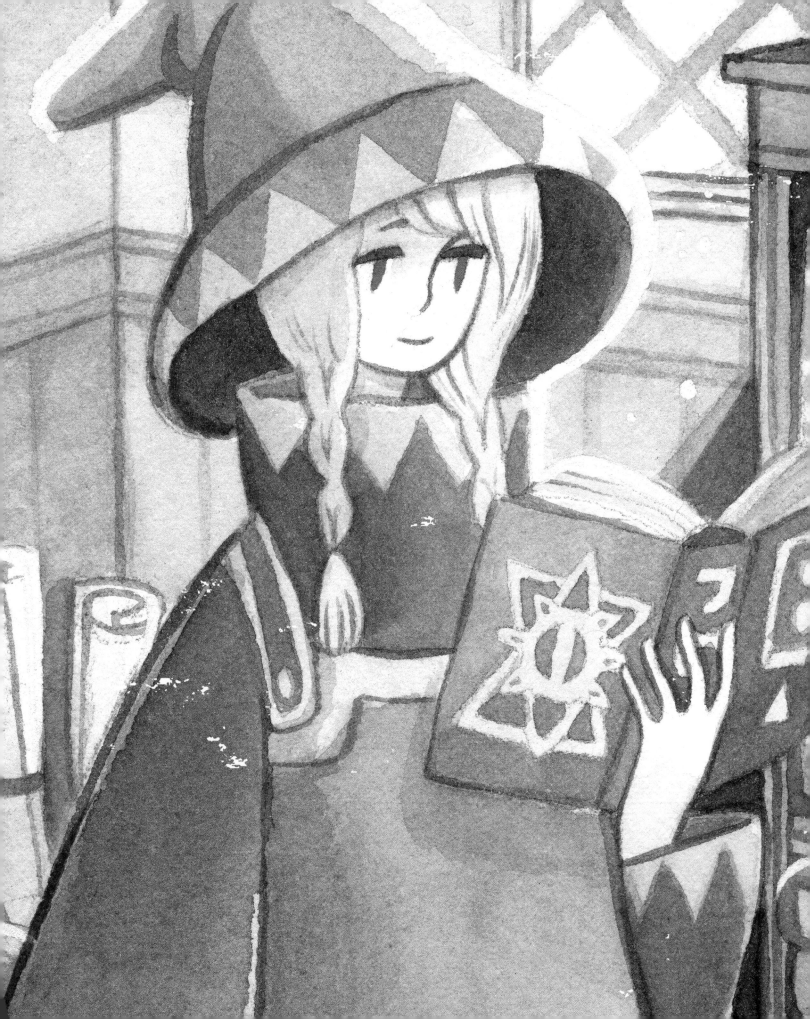

Behind the scenes

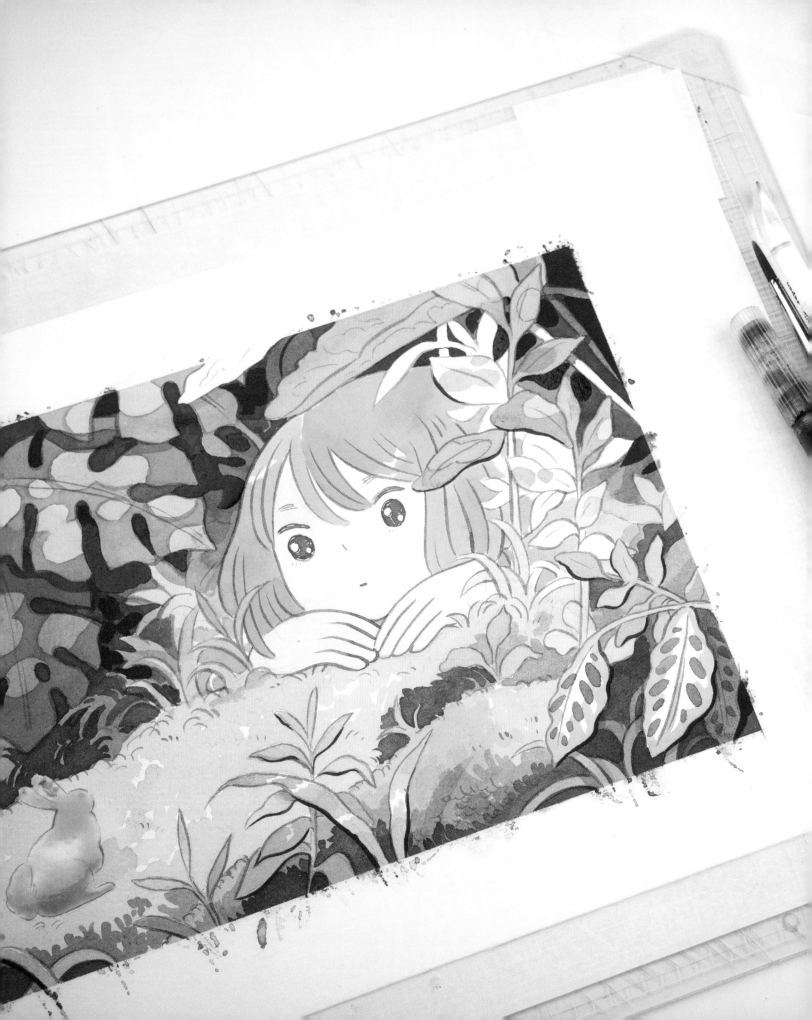

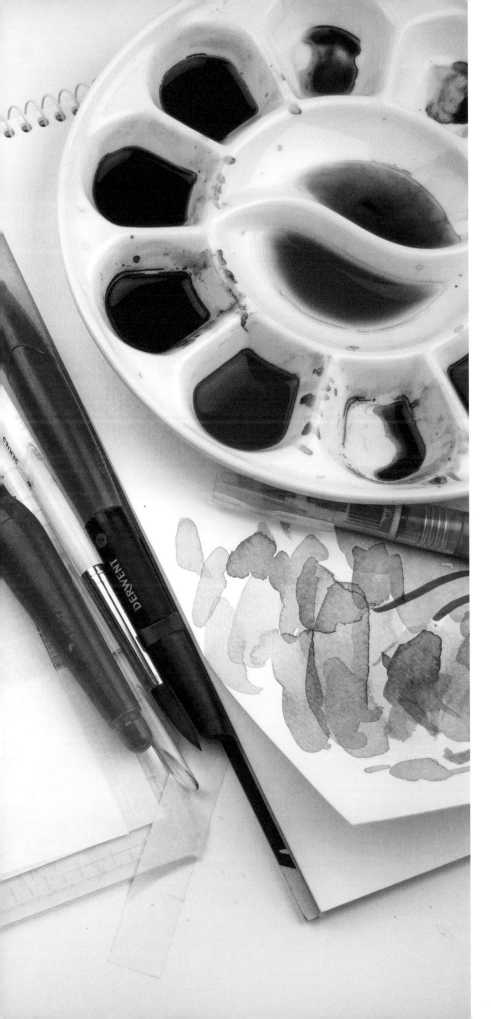

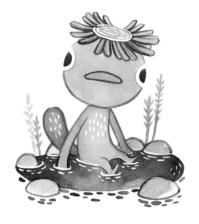

Workspace

I have only had my current workspace for a little while, but I do have some basic preferences when settling on a work spot. My workspace consists mainly of a white table, placed underneath a big window. I think it is important to work in a space where the walls and furniture are mostly white or light gray – I find colorful objects in my field of vision a bit distracting.

When you are creating illustrations, a well-lit space is very important; I mostly rely on natural sunlight to give me the best possible working conditions. This is also the case when using traditional materials. It is completely different from working on a computer screen that provides a constant unchanging light – this can mean that you end up working on a piece at night in poor, unnatural light and then find out the next morning that the colors are completely different to what you intended. When filming my illustration process, or occasionally working after sundown, I have two studio lamps that imitate sunlight. They are effective at providing a continuous and reliable light source, but they are also easy to move elsewhere when not needed.

I have all my art supplies, papers, and a light table within arm's reach in a drawer next to me. On the wall is an inspirational mood board and its arrangement often varies. On the other side of the room I have a collection of art books. I often come here to fetch books for the mood board.

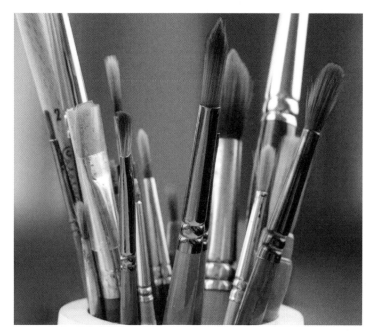

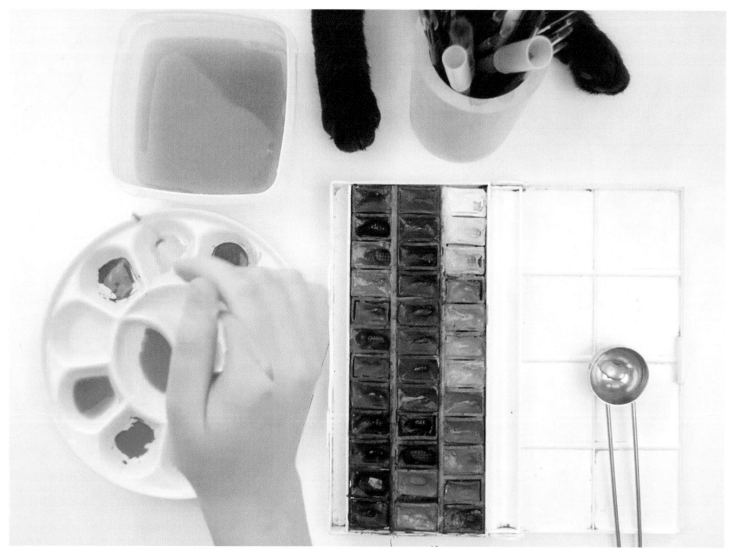

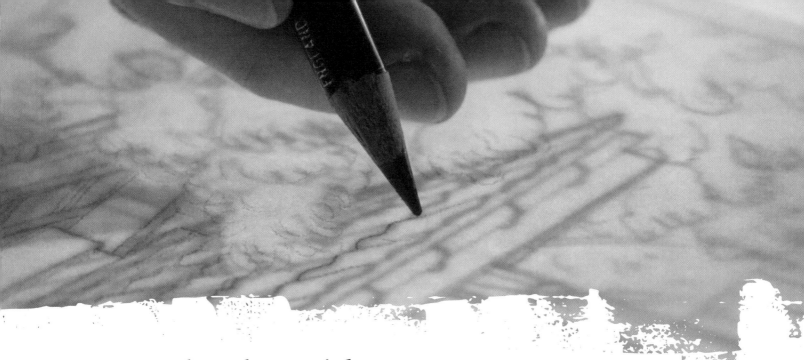

Tools and materials

Even though I have produced illustration work digitally in the past, I prefer creating with traditional mediums. Unlike with digital software where I feel overwhelmed with the endless amount of options, I am filled with tremendous comfort when painting or drawing on paper – the materials are bound by the laws of physics and there is only so much you can do with them. For example, the paper can absorb just a certain amount of water; the pencil needs to be sharpened to get a thin and crisp line; and to get the perfect color you most likely need to mix it yourself. These restrictive qualities act as guidelines, but somehow I can still be surprised by the results.

For me, the possibility of interacting with the paints, brushes, and other tools makes the process of creating art that much more enjoyable. I love how in the process of painting with traditional mediums, the different elements and materials come together to create a visual narrative. The process and result provide a haptic experience, and that is why I always find myself going back to painting and drawing by hand.

Visiting art-supply stores fills me with a tremendous amount of inspiration; seeing all sorts of materials and papers lined up on shelves gets me really motivated. There are not many art-supply stores in my city and none of them are very big, so whenever I go abroad the number one thing on my list is to visit local art-supply stores. My favorites are the enormous multi-storey establishments in Tokyo, where you can find everything you are looking for and discover new and exciting tools and materials. I also enjoy the independent art stores housed in old buildings, where the aisles are narrow and the shelves are brimming with stuff. Every time I visit an art-supply store, I get inspired to try new mediums and experiment with new techniques.

My go-to materials for creating finished artworks are watercolors and inks. When sketching, I use a variety of different pens and pencils. I tend to do freehand doodles with ballpoint pens or other pens, and I use light-toned colored pencils for sketches that go underneath a finished illustration. My favorite pen for line art is a waterproof brush pen. I love the variety of lines it can produce once you master it. For coloring, I use inks or watercolors. I have a variety of synthetic brushes to use with inks or watercolors and I tend to experiment with all sorts of watercolor papers.

There is also an assortment of other items in my work desk that I use frequently, such as poster colors, masking fluid, and porcelain palettes.

Watercolors

In comprehensive school, I remember using a simple palette of six watercolors with warm and cold tones of red, blue, and yellow for a lot of my art assignments. I struggled with them initially, preferring pens and pencils for my work instead. I found that these watercolors would make the paper buckle and the colors were hard to blend. Apart from the odd time that I enjoyed working on large areas with wet-on-wet technique, and doing color washes with watercolor, it wasn't until the ninth grade – when I was gifted a set of fine-quality watercolors from my art teacher – that I started to use them consistently in my works.

I had spoken with my teacher about applying to an "art-focused" high school and she wanted to encourage me by giving me a beautiful set of paints for the entrance exams. The gift I received was a wonderful set of St. Petersburg White Nights in twenty-four colors. I felt so encouraged and inspired by the gesture that I began to experiment more with watercolor. Until then, my personal works were mostly created with pens and markers and I rarely colored my art. But once I had this lovely set of quality colors in my hands, I felt motivated to learn more about them.

What I look for in a watercolor set is for the paint to be easy to blend; I want it to be as effortless as possible for me to mix different colors together and blend the paint with water. I like to use paint that produces a smooth finish and that doesn't appear grainy on top of the paper. Some colors tend to produce smoother and more even surfaces than others – when creating big areas of one color it is nice to have the paint appear even. Choosing colors that are intense means I can create a vast scale of tones from one pan. I also like to invest in long-lasting watercolors; good quality sets are usually quite expensive, but they make up for it because they don't run out as fast. I have had my current set for five years and, during this time, I have only had to replace two single pans.

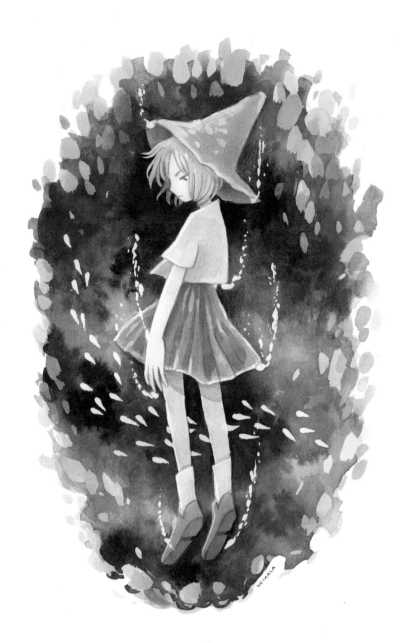

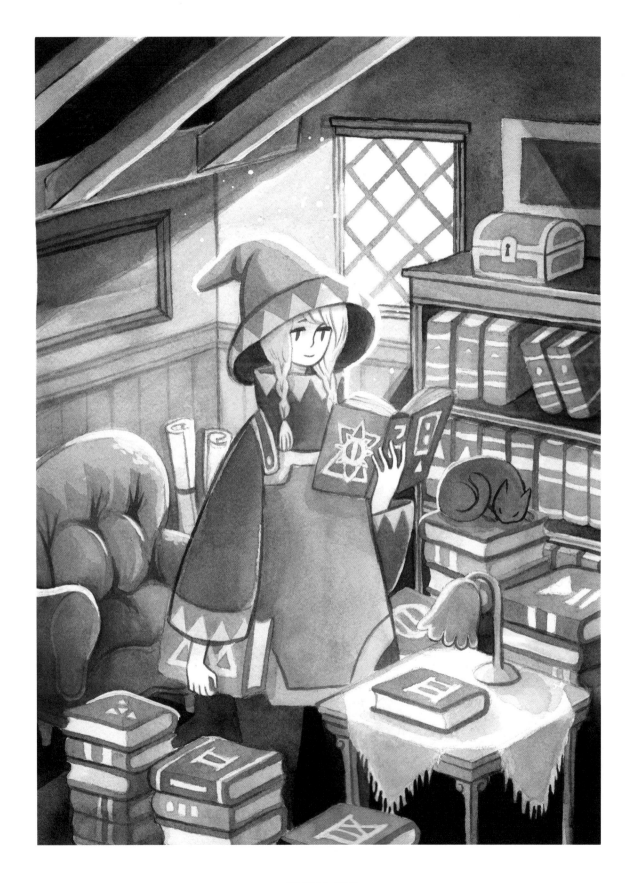

SCHOLAR, 2015

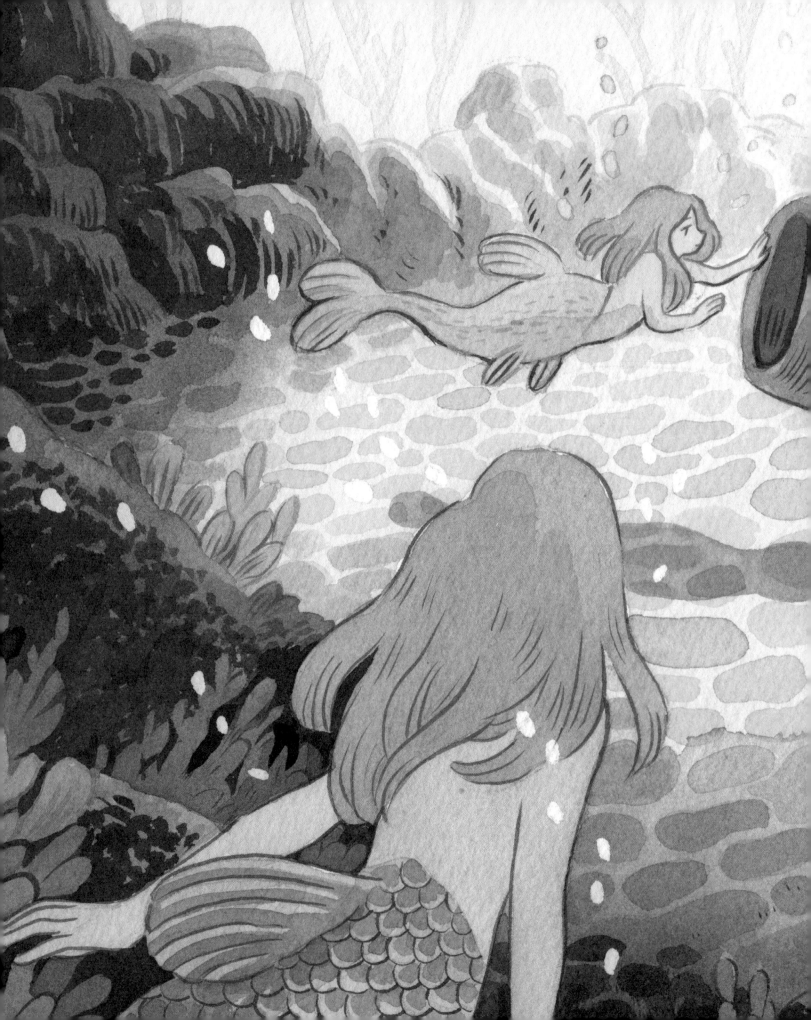

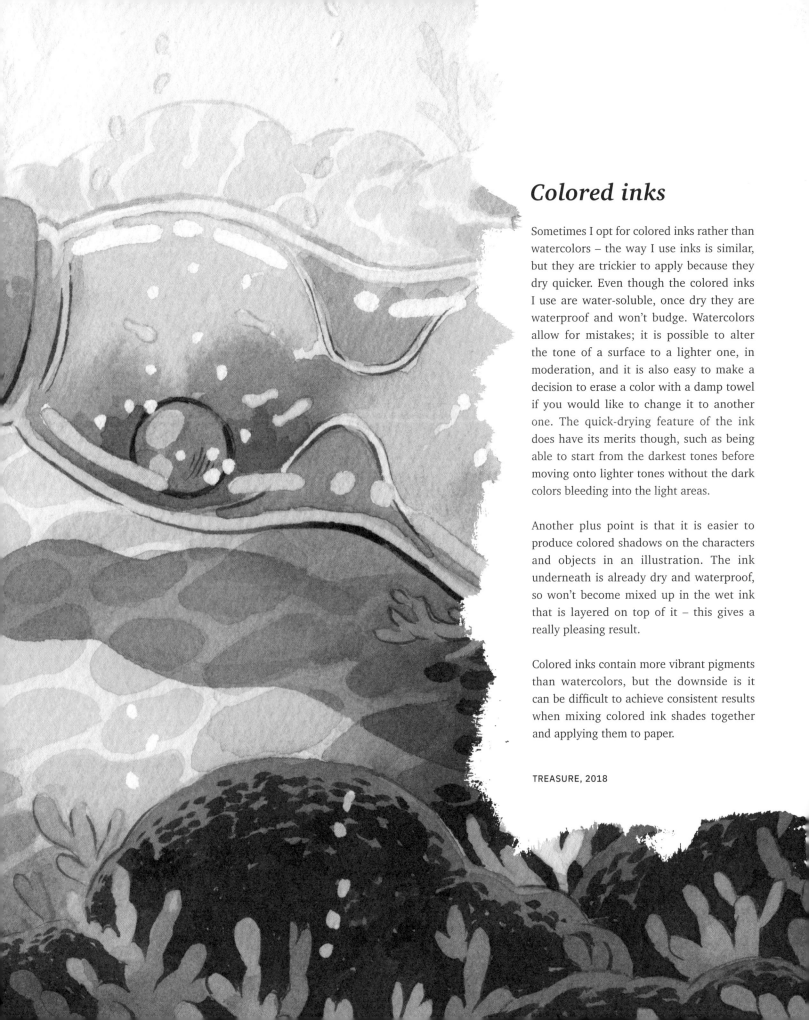

Colored inks

Sometimes I opt for colored inks rather than watercolors – the way I use inks is similar, but they are trickier to apply because they dry quicker. Even though the colored inks I use are water-soluble, once dry they are waterproof and won't budge. Watercolors allow for mistakes; it is possible to alter the tone of a surface to a lighter one, in moderation, and it is also easy to make a decision to erase a color with a damp towel if you would like to change it to another one. The quick-drying feature of the ink does have its merits though, such as being able to start from the darkest tones before moving onto lighter tones without the dark colors bleeding into the light areas.

Another plus point is that it is easier to produce colored shadows on the characters and objects in an illustration. The ink underneath is already dry and waterproof, so won't become mixed up in the wet ink that is layered on top of it – this gives a really pleasing result.

Colored inks contain more vibrant pigments than watercolors, but the downside is it can be difficult to achieve consistent results when mixing colored ink shades together and applying them to paper.

TREASURE, 2018

Unerasable tools

I use unerasable tools for all of my linework and sketching now. It was when I started to do all my sketching with pens, markers, nibs, and inks – all sorts of unerasable tools – that I was able to get rid of my anxieties towards inking, and it ultimately streamlined my process. Being unable to correct my mistakes helped me to work around them, moving on to new sketches and ideas faster than before; I was able to produce sketches in a fraction of the time as I was no longer erasing every little thing that I wasn't pleased with.

After a lot of practice in freehand sketching with ink and pens, it is now a part of the process that I don't have to think about too much while doing it; I feel confident enough to just let the lines flow on the paper.

6 6 Being unable to correct my mistakes helped me to work around them, moving on to new sketches and ideas faster than before 9 9

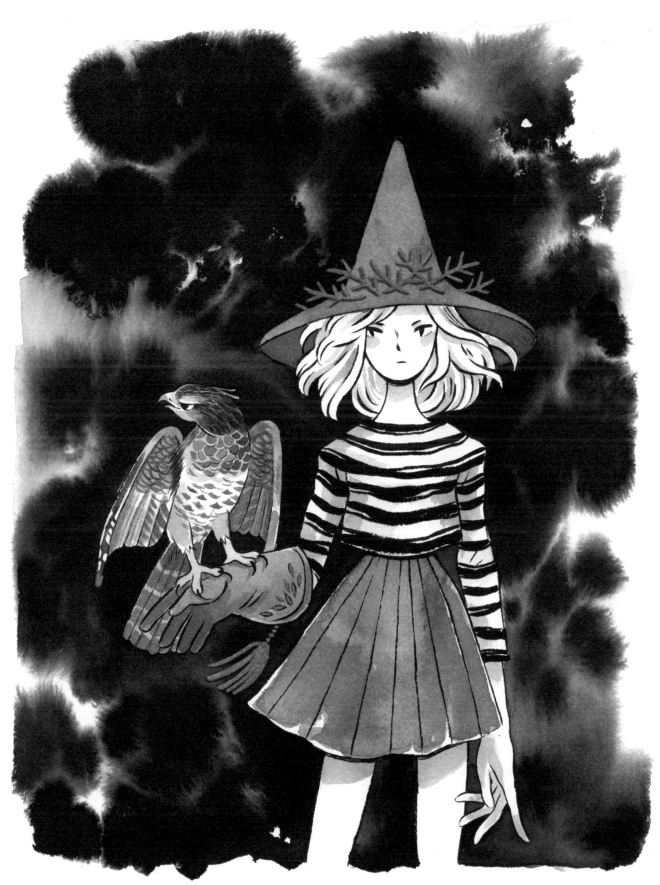

HAWK FAMILIAR, 2016

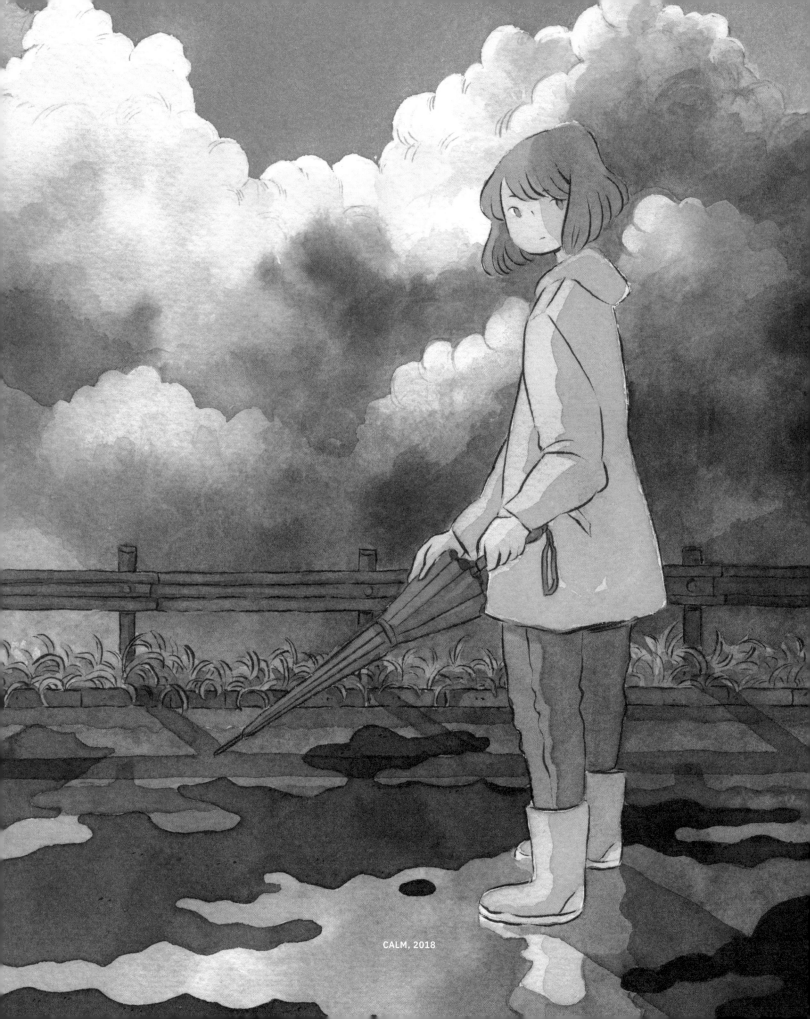

CALM, 2018

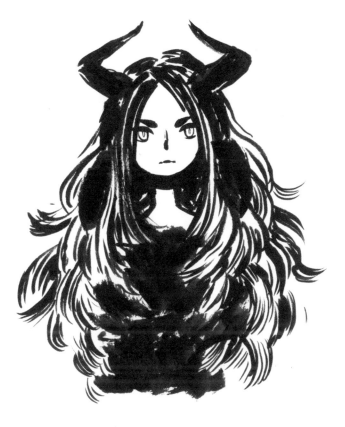

Participating in Inktober (inktober.com) for the first time also helped develop my confidence in inking. I had previously, almost exclusively, used colored pencils for linework in my watercolor works or finished the pieces with lines created with watercolors and a thin brush. I liked how colored linework appeared smoother and not as harsh as black lines. Now I think that using inks is the best for lines; and if I am trying to achieve a subtle and soft look for an illustration I still make the lines with inks, I just opt for colored inks instead of black.

My favorite inking tool is the Pentel Pocket Brush Pen. I do experiment with others occasionally but always go back to this brush – the ability to make varying lines with one tool is something that I especially like about it. Although, as I feel the brush pen is something I have mastered and am able to achieve the best results with, I do find it hard to leave my comfort zone.

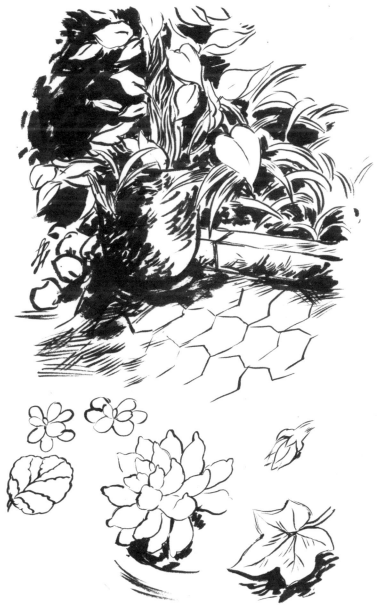

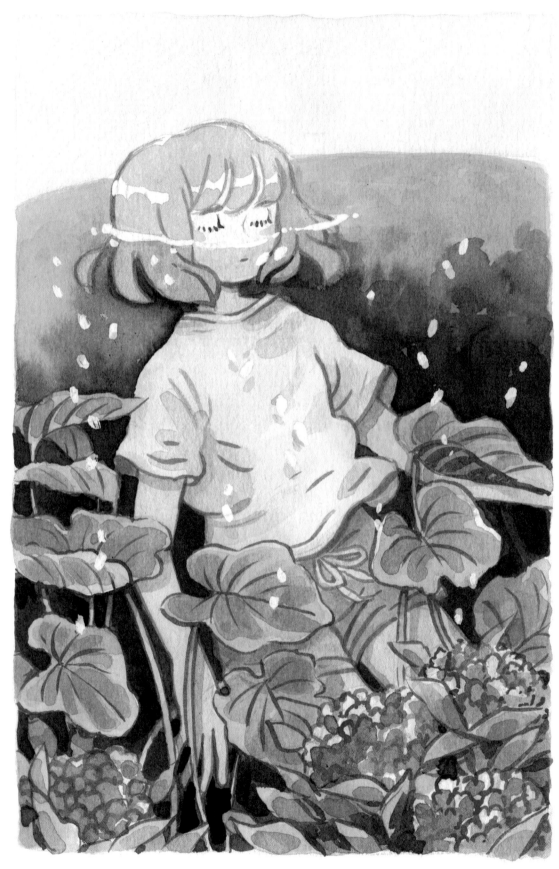

SOAK, 2018

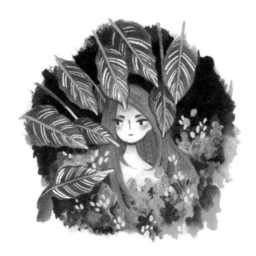

Papers

Watercolor and ink

The beauty of creating art with watercolors and inks is that the results are different depending on the paper you choose. When I received my original set of quality watercolors, I was still using basic copy paper. It wasn't a good choice, so through art classes I began to experiment with quality watercolor paper for both watercolors and inks. I was shocked to discover the difference high-quality materials made to creating art this way – watercolors and inks are both mediums where good-quality papers particularly make a difference.

There is a lot of choice, but I always look for certain attributes in the paper. The weight of the paper is the first thing I check – I usually go for at least 300 gsm. Heavy paper is more absorbent and enables you to work through the same area multiple times, adding several layers of paint. This in turn allows for more intense results in color, as wet, heavy paper doesn't buckle or wrinkle as much as a lower gsm of paper. Watercolor papers are usually made from either wood pulp, cotton, or a mixture of different cellulose fibers. Papers made from cotton are usually more expensive, but they are stronger and more flexible than other types.

When it comes to the texture and feeling of the paper, I choose a hot-pressed or cold-pressed watercolor paper. Cold-pressed paper has more of a rough texture and grainy surface; it absorbs water better and allows for multiple passes with watercolor or ink. The texture of the paper makes it harder to produce fine linework with a brush pen, however. Hot-pressed paper is better for detailed linework as it has a smoother texture and poorer absorption rate – the downside is, you won't be able to create many layers of washes. In summary, I choose cold-pressed paper for illustrations, with multiple color layers; and hot-pressed when in need of creating finer details with line art.

Sketchbook

When sketching, I tend to use sketchbooks with slightly textured paper in them. I mostly use gel-ink pens – such as Deleter Neopiko Line and Muji – or ballpoint pens for sketching, so I opt for paper with good absorption. I don't choose smooth paper because I tend to quickly sketch my ideas in the heat of the moment and the pen would end up smudging and making a mess. I have two favorite sketchbooks to sketch in: a B5 Deleter spiral-bound sketchbook and a slightly-larger-than-A5 sized Muji sketchbook. They each have a nice textured paper in them, which is great for freehand drawing with pens. They are bound from the short edge, so I can choose to sketch horizontally or vertically. Additionally, they are very affordable and you can order them online.

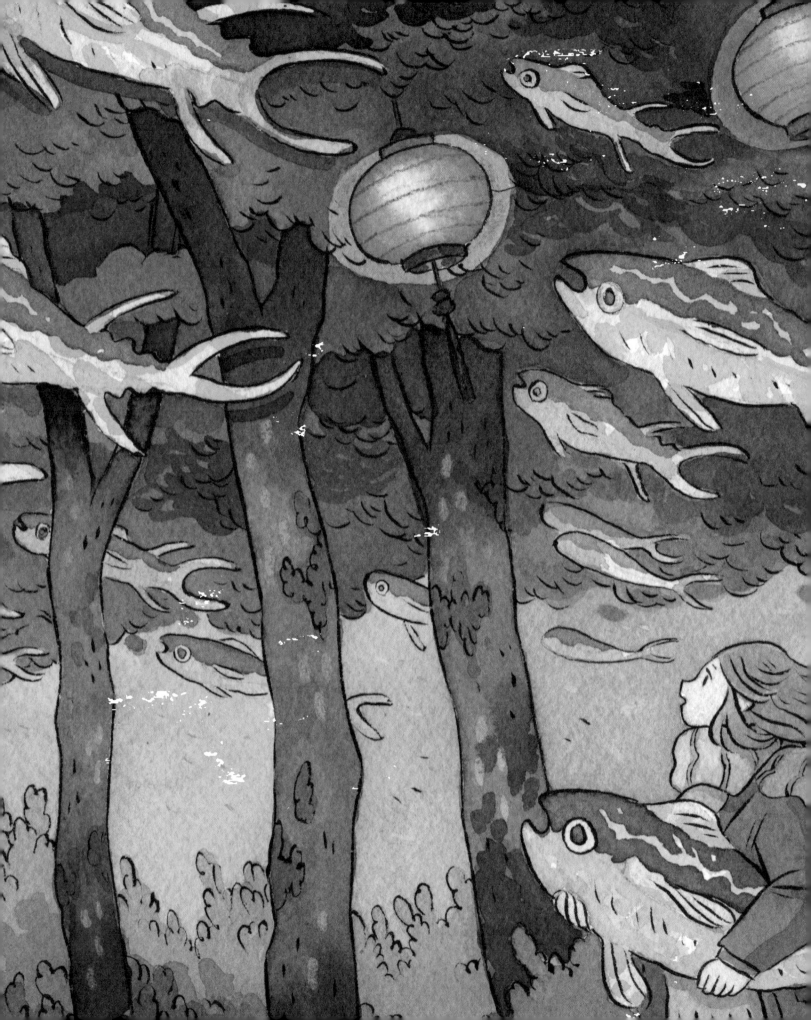

Inspiration and ideas

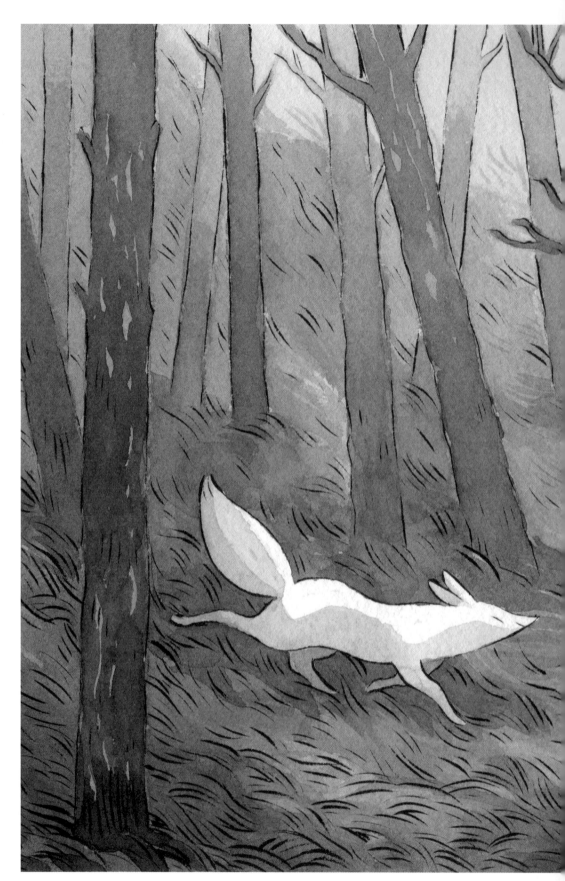

Finding inspiration

It has been a privilege growing up in Finland, surrounded by beautiful nature. Being able to simply wander into a forest almost wherever I went was the greatest thing in my childhood, and held endless possibilities for fun and play. Even now, one of my favorite pastimes in summer is to venture into the forest to pick berries and mushrooms, and be inspired by the sounds, smells, and the beauty around me. While I rarely use my local area as a reference for my work, it has encouraged me to incorporate nature, greenery, and plants into my illustrations.

SLOPE, 2018

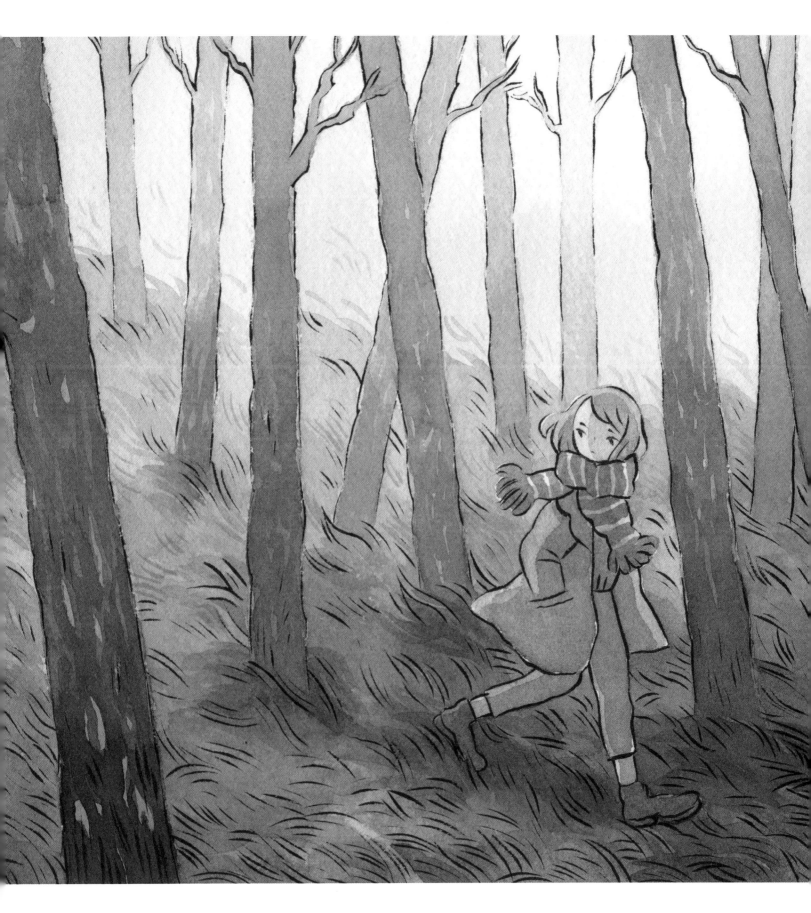

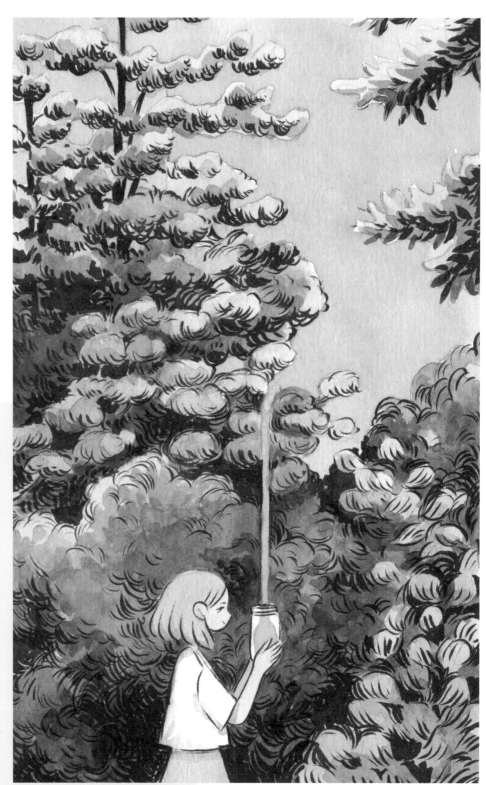

Equally, Japanese popular culture has had a great impact on me and inspired my work. I have been fortunate enough to visit Japan several times in the last few years. Discovering new places and experiencing a completely different environment through traveling has undoubtedly influenced my work. I love that I can bring my suitcase adventures back to my studio desk and incorporate them into my works. Some of my recent illustrations and their settings are directly inspired by the places I have visited.

COLOR PICKER, 2018

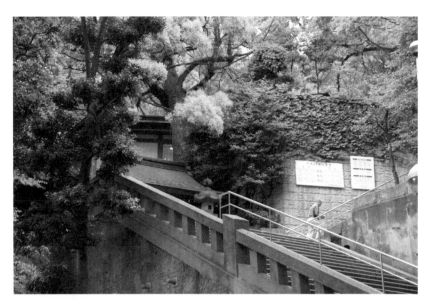

> *Discovering new places and experiencing a completely different environment through traveling has undoubtedly influenced my work*

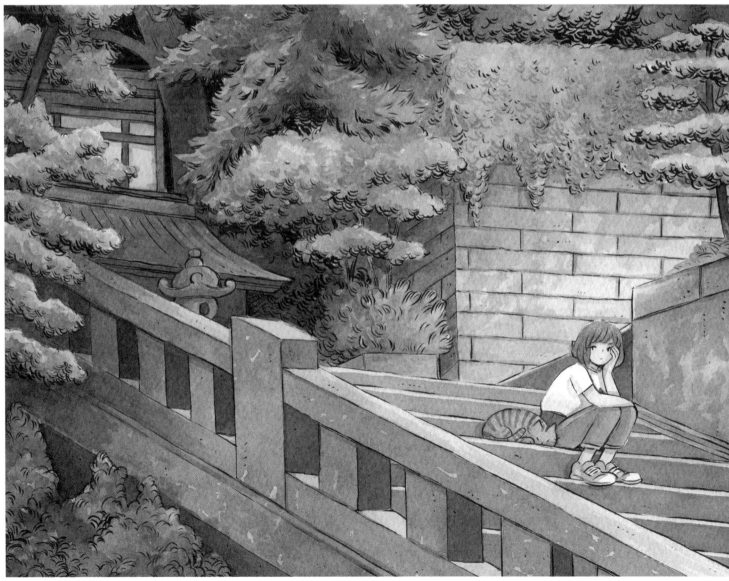

AWAIT, 2018

Other sources of inspiration

I have had the honor of meeting a great many inspirational people throughout my life. People that breathe enthusiasm into their own work make me excited for my own projects, so a common source of inspiration for me is the work of other artists.

My favorite purchases that I make on my travels are art books and small published zines. When I am abroad, I always make it a priority to visit local book stores and conventions with artist alleys to buy new and inspiring printed goods.

On top of the vast collection of art books I have at home, I also gather inspirational pictures and reference image boards online. Then, when I feel motivated to sketch, I take inspiration from the pictures I have saved or the images I have liked on social media, for example.

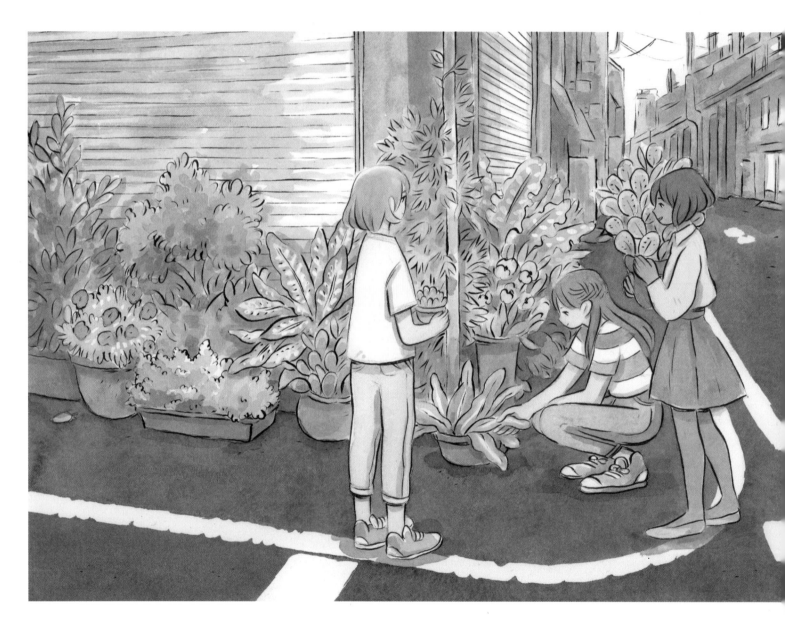

ASAKUSABASHI, 2017
This piece was inspired by the area around the hotel I stayed in on my first visit to Tokyo. I love how the residents there decorate the sidewalks of their houses to the brim with flowers and plants.

In my first year of university I had lectures every Monday with a professor who – in addition to teaching us principles such as color theory, abstraction, and industry ethics, and sharing the ideas from such great minds as Johannes Itten and Josef Albers – encouraged a hands-on approach to creating art and gave us three interesting projects over the year. I still follow his suggestions today:

1 Use forms in nature as a starting point

The first assignment was to walk through nature and wait until a plant made contact with us. Then we would take that plant home and start drawing it. I remember having over twenty sketches of the lichen I had picked. After this, we would simplify the forms of the plant and refine them into an abstract pattern that no longer resembled the plant.

2 Use three dimensions

The next assignment was similar, but this time we were asked to find a couple of three-dimensional objects in our home – one precious item and one common household tool – which we would then study and draw.

We were also asked to sketch our hands in different poses, and from different angles, again looking for interesting shapes. We then used the sketches to design an abstract three-dimensional sculpture which we carved out of gypsum (plaster).

3 Study a good painting

The final assignment was to find a Finnish traditional painter, ideally from the golden age and preferably choosing an original piece of their art that you could see in person. We were asked to study the painting: its composition, colors, movement, and contrast – all the visual elements and choices the artist had made for the piece to come alive. In addition to studying the original painting, we were asked to make a life-size study of the artwork with the same materials the artist had used.

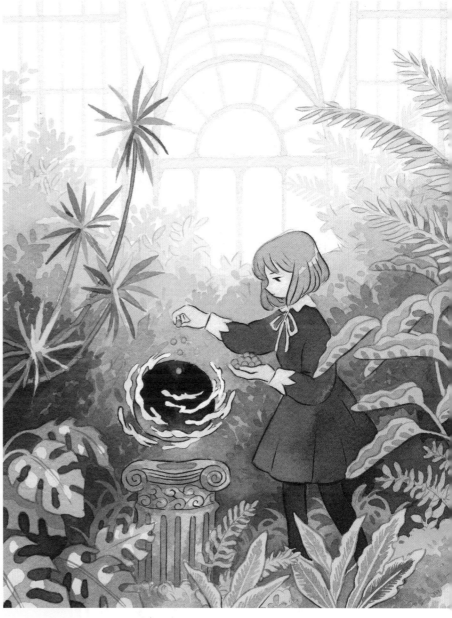

PLANETARY GARDEN, 2018

TIP: If you are having a hard time finding inspiration, perhaps try going for a walk and interacting with nature, sketching the things you find around you and maybe looking at them differently.

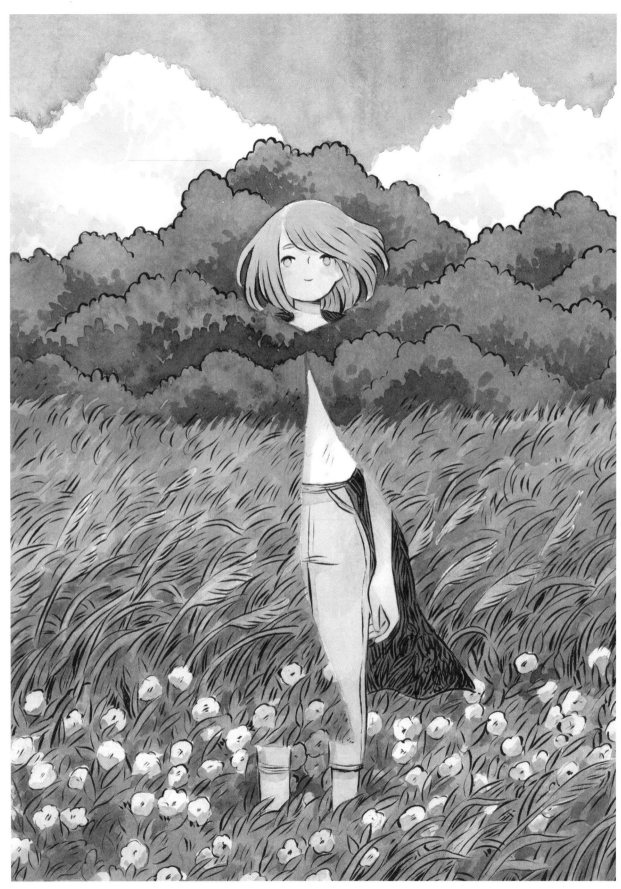

GRANDMA'S CLOAK, 2017

Ideas behind illustrations

Stories behind the illustrations play a big part in my art. What is taking place in the artwork is only a moment of the character's story, and it is important to give hints of the narrative that is taking place outside the image. Even though I don't see myself as much of a storyteller, the illustrations I create almost always suggest that something else is going on outside the setting.

Sometimes I wonder who the person watching a specific scene might be and, in my mind, create a story for that non-existent character. I choose not to explicitly tell the ideas or the story behind my illustrations and leave them vague or open to interpretation as I really like to hear what my followers see in the illustrations I make and what narratives they come up with.

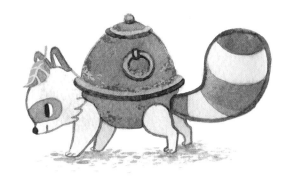

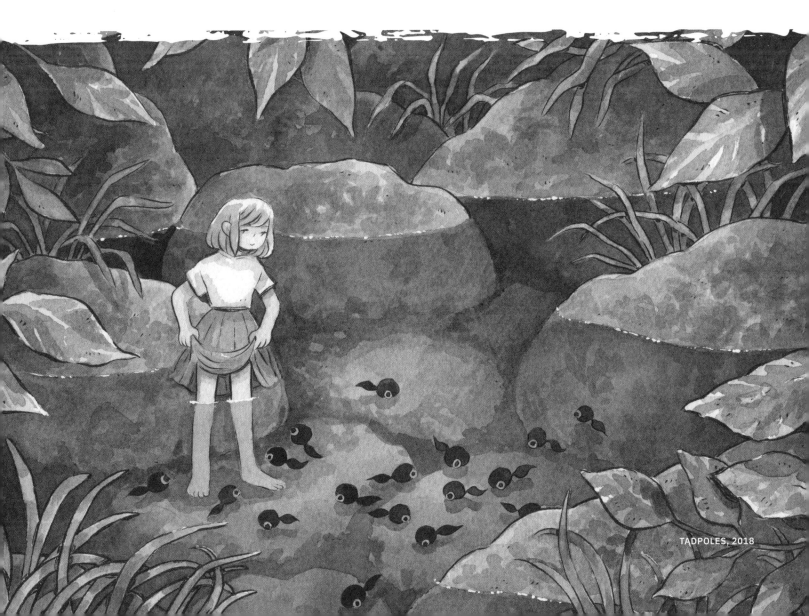

TADPOLES, 2018

Characters and settings

My art is full of fantasy elements; subtle suggestions of magic and surreal places. I like to think that the settings in my works are from a different reality altogether. Whenever possible, I also like to include plants in my works. Exotic plants already have a surreal vibe to them, and plants in indoor settings can make the place feel closer to nature.

I like to draw tiny characters in scenes of nature. I enjoy the way a small puddle can turn into an ocean, or a meadow can turn into a jungle, if I just place a match-sized character in the setting. I also love depicting the places I have been to and the places I would like to go, whether they be real or fictional. I enjoy drawing my characters into utopic settings – places where the person viewing the illustration might like to go too.

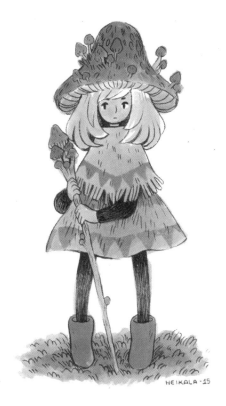

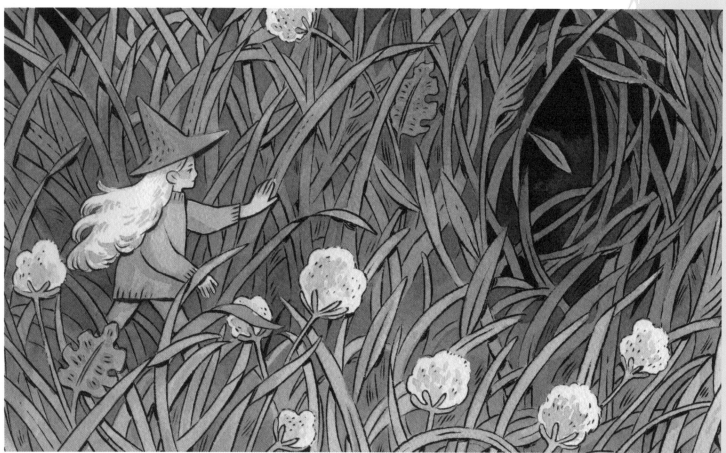

HARE'S TAIL, 2017

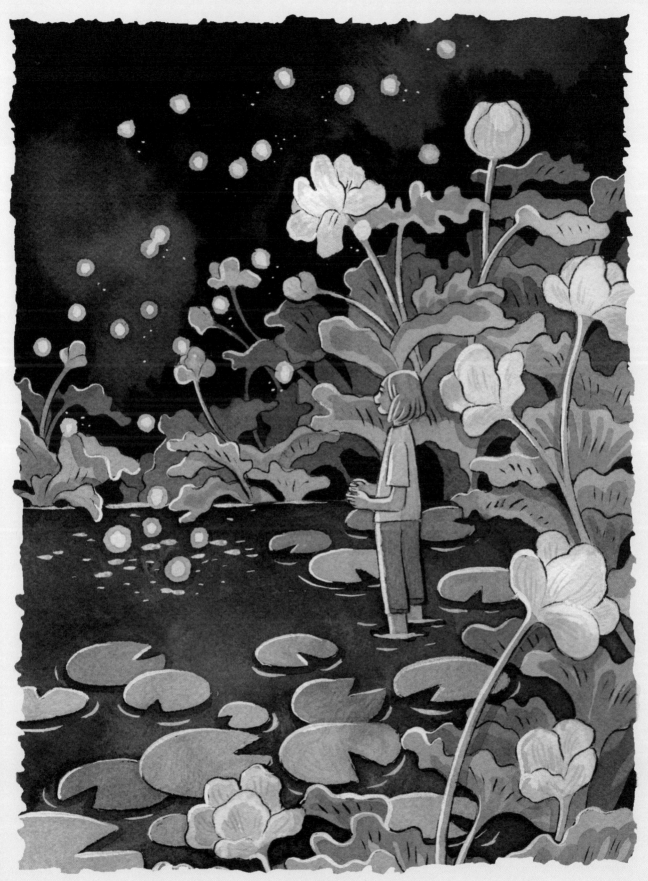

POND, 2017

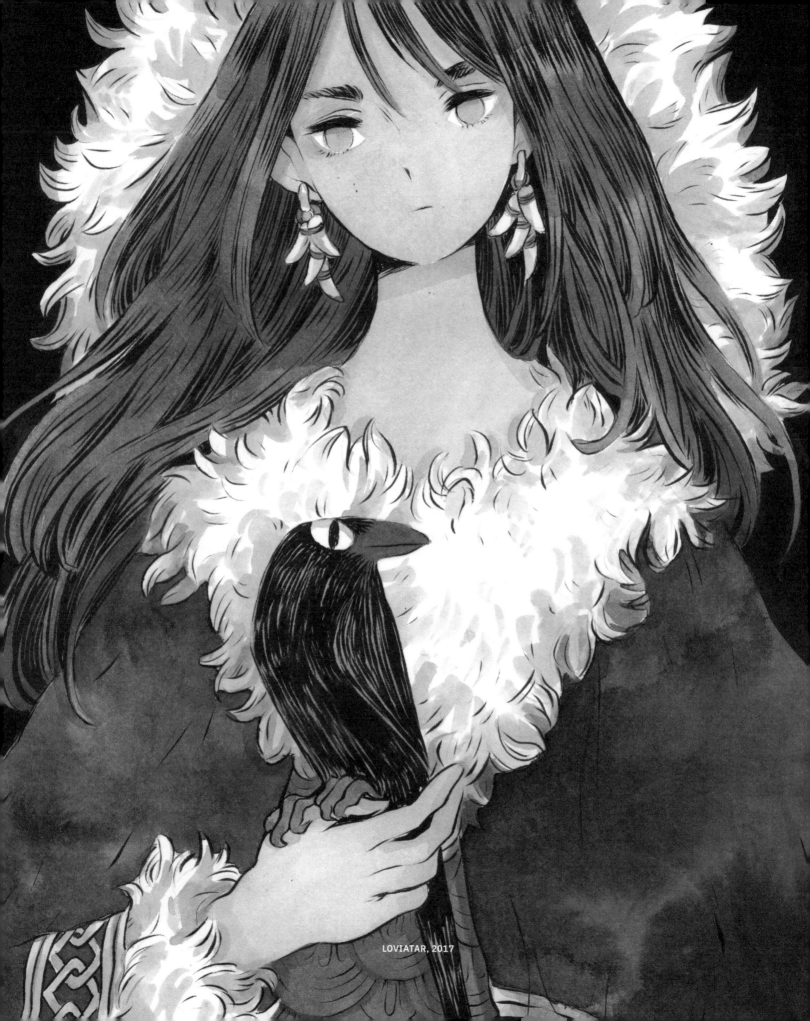
LOVIATAR, 2017

The characters not only interact with their environment as a part of a story – thereby forming a connection with the viewer; they also tell a story with their appearance, pose, and clothes.

I decide if the setting will be the focus or not, as this determines how basic or complex I will make the character. If the scenery is the focus of the illustration then I want the character to take a minor part in the image, so I create a basic character.

I choose characteristics for the person I am drawing and try to depict their traits visually. I might also choose colors that support the features and the mood of the characters in the illustration. For example, in the *Loviatar* piece (Loviatar is the "Goddess of death" in Finnish mythology), I used dark and murky colors to support the intense feeling that the character emits; I used pastel colors to suggest a character that is kind and caring, in *Baby Dragon*.

I prefer to draw women and almost exclusively feature female characters in my finished illustrations. I enjoy portraying their stories in my illustrations and feel most comfortable when drawing this gender, but I also feel a responsibility in how I should represent them. It is very important to me to not objectify the characters I illustrate, and that is why I rarely draw them in revealing outfits or in sexually suggestive poses. My characters wear comfortable clothing that fits their characteristics and personality.

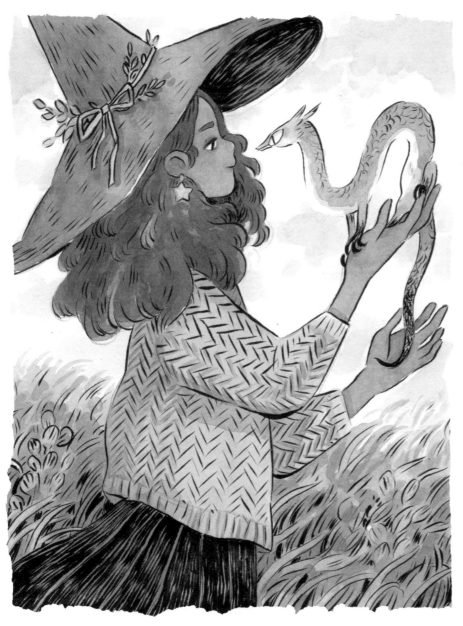

BABY DRAGON, 2017

53

Witches

For a while now, my favorite character subject has been witches. In addition to the magical and surreal possibilities they provide, their innate character traits mean I can draw powerful women that have an inner strength and possess unique abilities. I also find it really encouraging how popular witches are as a theme today, and how far we have come from the prejudice. It gives me hope that things will change and that there will be even more strong and impactful women in fiction.

When drawing magical characters, I like to portray them going about their everyday tasks and having ordinary occupations. I often find myself playing with such thoughts as, "What kind of fruits would a merchant witch sell at a farmers' market?" Or, "Would witches have auto-piloted brooms for overseas travels, and would they have to go through customs when flying abroad?"

Sometimes merging two different ideas together in one character makes an interesting combination worth illustrating, and I have especially applied this to my witch illustrations. It is also a challenge to depict multiple characteristics coherently. What would a mermaid witch, a vampire witch, or an astronaut witch look like, for example?

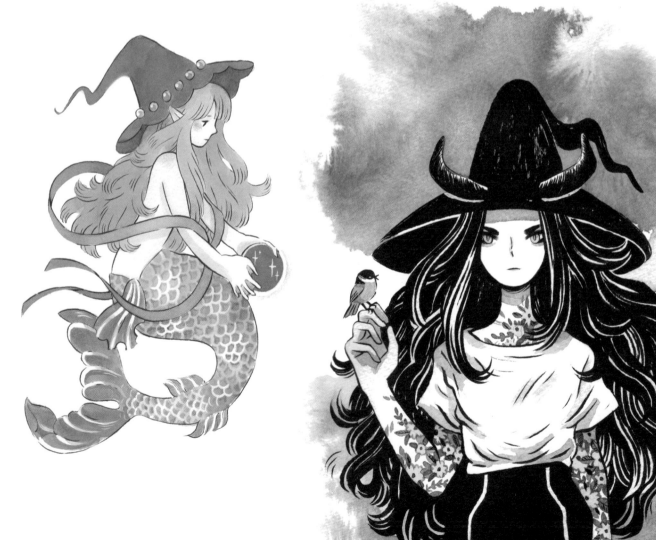

54

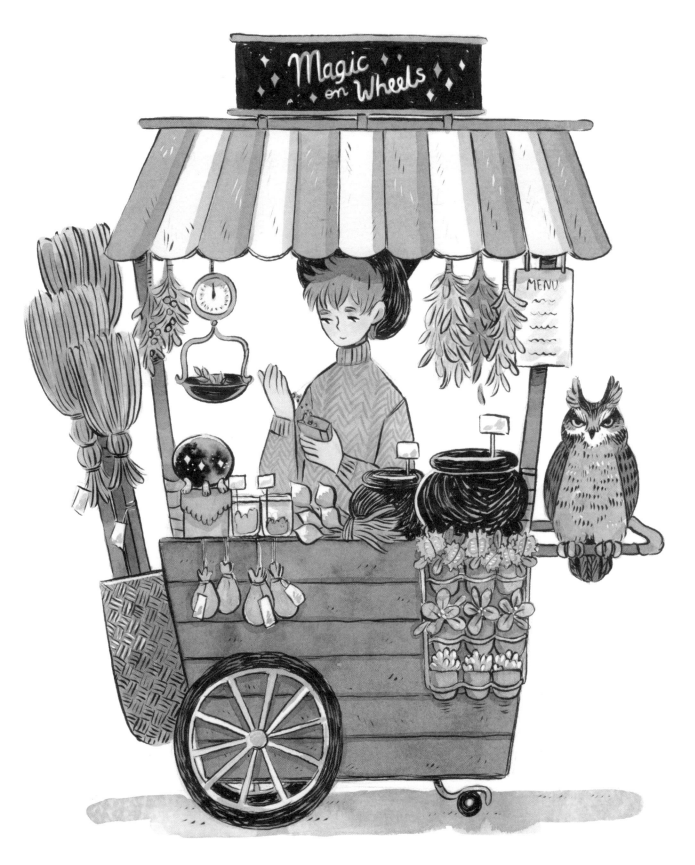

MERCHANT WITCH, 2017

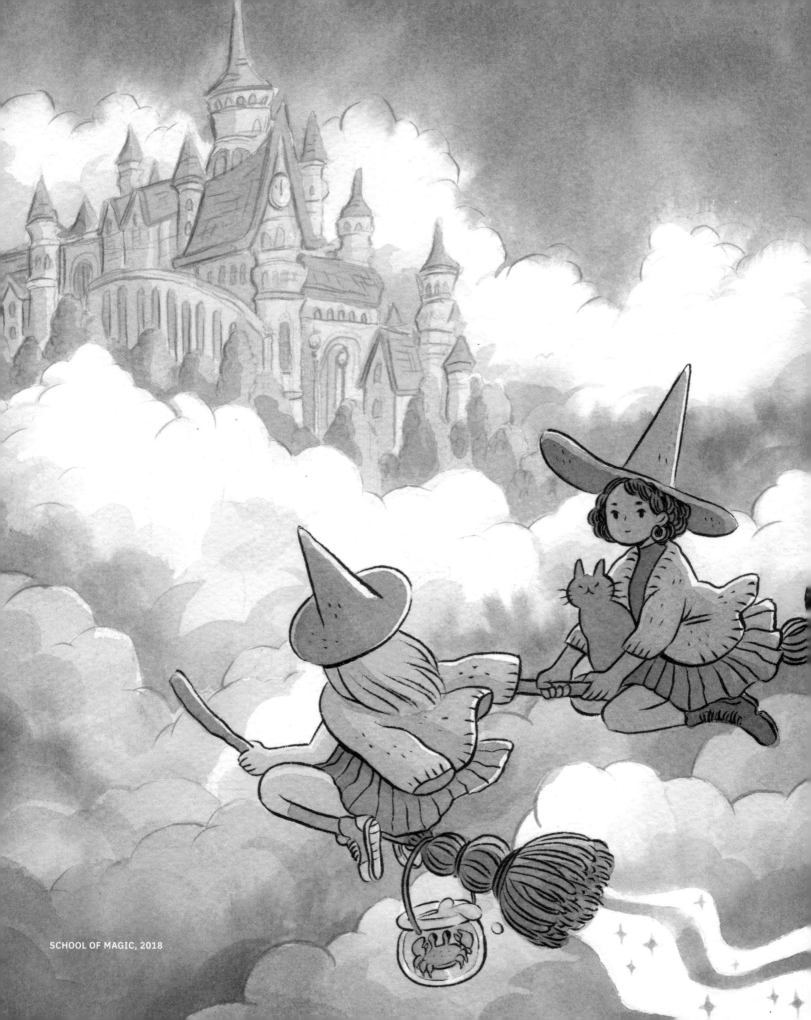

SCHOOL OF MAGIC, 2018

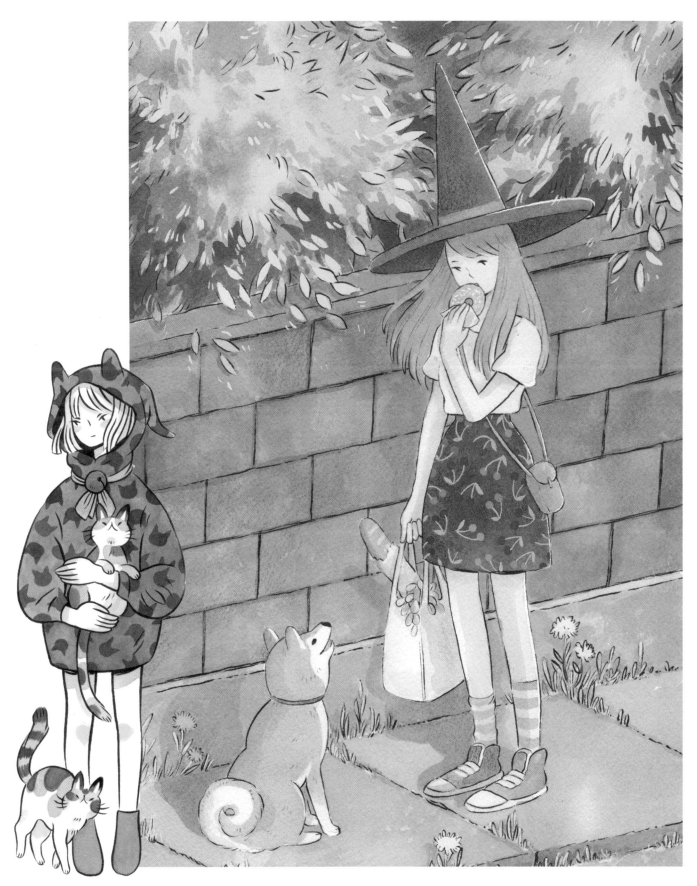

GIMME THAT TREAT, 2017

Storytelling

Just like a single illustration can tell a story – through the choices of elements such as backgrounds, a character's dress, and their proportion in relation to their environment – you can build even more of a narrative by repeating an object, character, or setting in separate and consecutively shared pieces.

I worked with this theme of "continuity between illustrations" for some of my Inktober 2018 works. For example: *Meteor Shower*, *Crash Site*, and *Astrochemist* were released over three separate days, and combined together to tell more of a story than each one presents on its own.

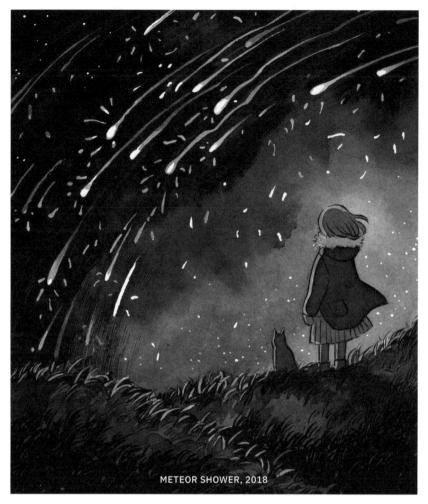

METEOR SHOWER, 2018

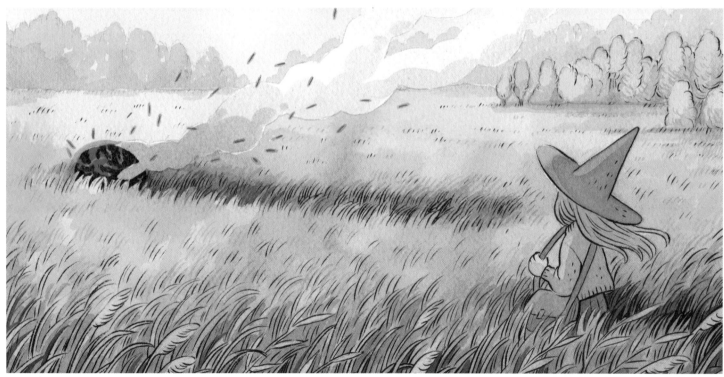

CRASH SITE, 2018

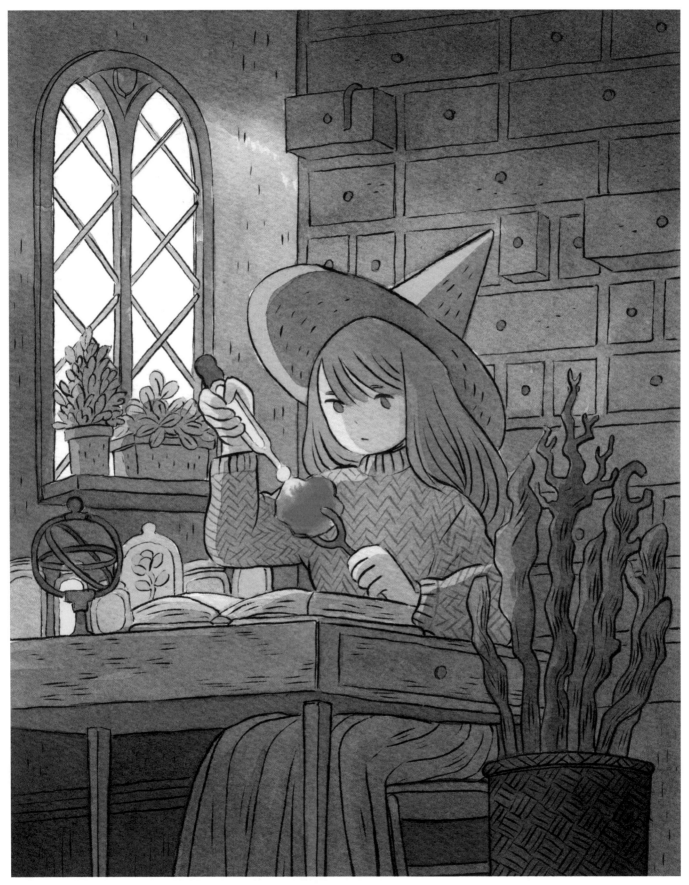

ASTROCHEMIST, 2018

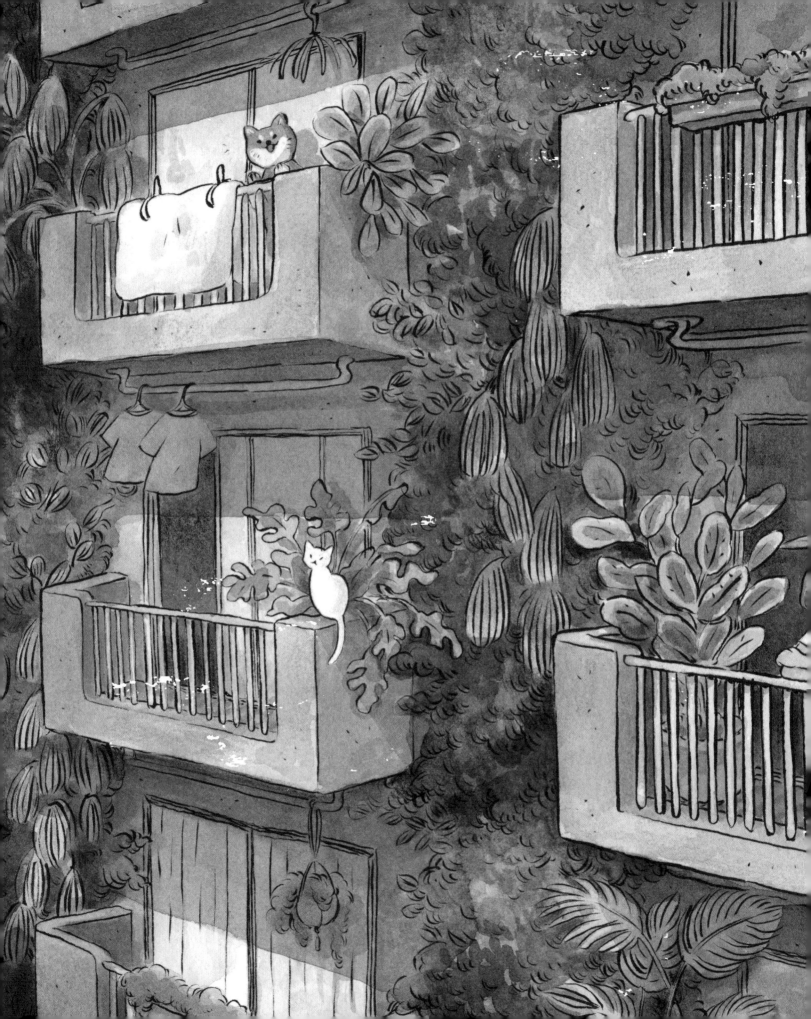

Techniques and approaches

Sketching

With sketching, I either have motivation and inspiration or no ideas at all; it is the one part of my creative process that sees such a fluctuation. I try to keep a habit of sketching every day as I believe your imagination is like a muscle that you need to exercise frequently so you can keep on producing fresh ideas. I also find that being able to create sketches is closely linked to the amount of visual stimuli you expose yourself to.

Whenever I sketch, I have a pile of inspirational art books on my desk for ideas; I might also sketch people from TV shows or look for references in my personal image boards. I rarely do field studies or go outside to sketch. I blame this mainly on the weather in Finland, which is not great for most of the year so usually not suitable for doing work outside. However, it is also because I am easily distracted by what is happening around me.

I always use pens or other unerasable tools for sketching because being unable to erase and correct my sketches means my workflow is streamlined. I never work on a single big piece for more than a day and I am always striving to move on to the next illustration. One thing I am grateful for learning early on is that "done is better than perfect".

My sketches fall into two categories: mindless doodling with the purpose of just getting characters and objects on paper; and sketching with determination or with a visible goal in mind, which is usually to create a new illustration. I rarely get ideas from mindless doodling – I mainly use it to wind down or if I am in a creative rut. I find that my sketching needs to be goal-driven for me to get new ideas, and restricting myself to a particular theme really helps when I feel overwhelmed with all the possibilities.

At this point I try not to criticize my ideas too harshly as even if the idea ends up not working, I will have learned something in the process. Also, creating illustrations – certainly for me – is about more than just the idea. I am happy creating illustrations that don't have a greater importance to them; sometimes the process and the execution of the final piece play a more important role.

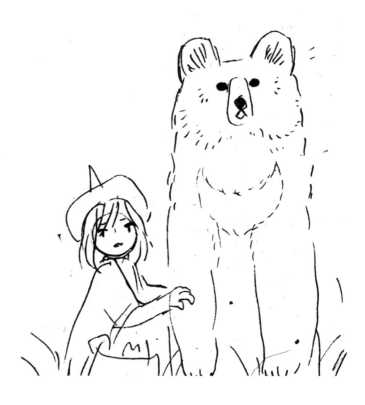

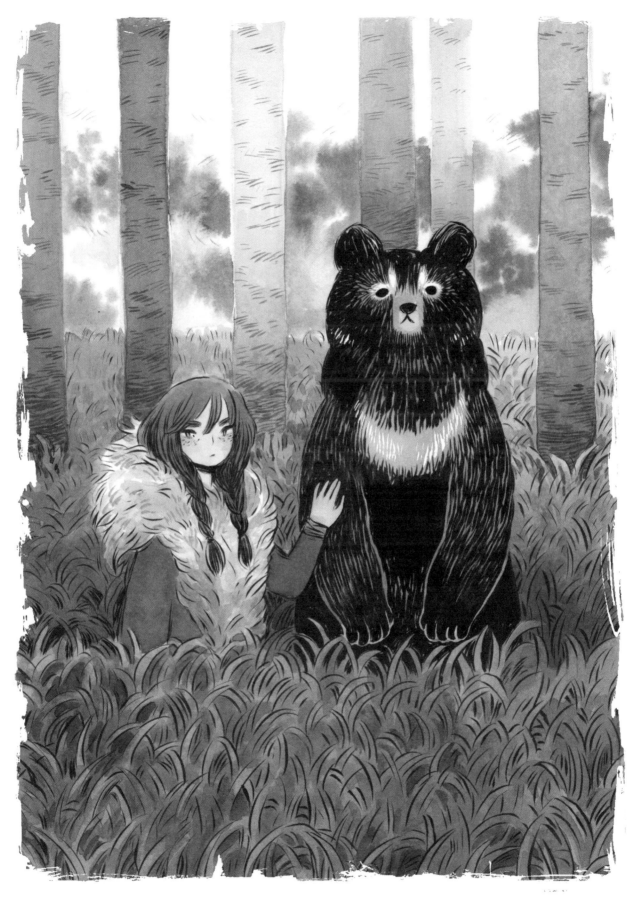

DID YOU HEAR THAT?, 2017

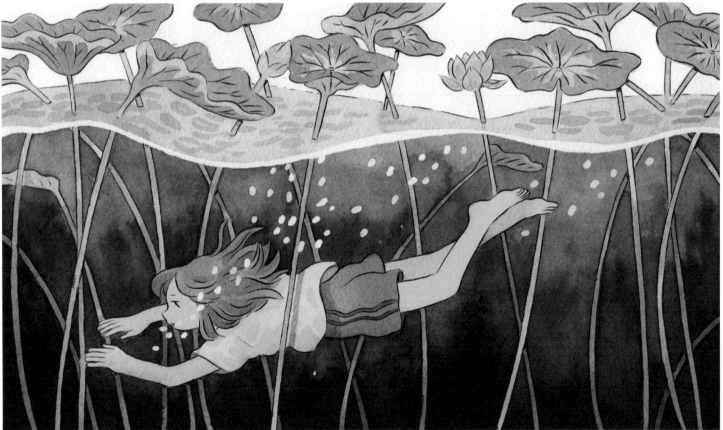

DIVE, 2018

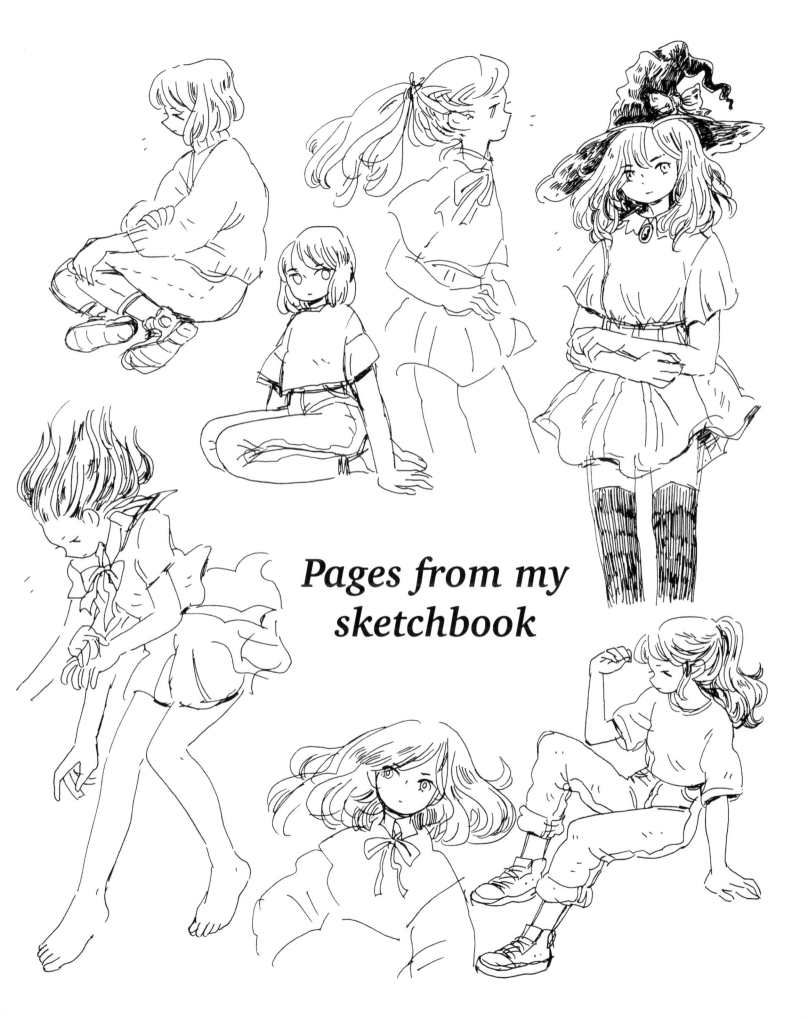

Pages from my
sketchbook

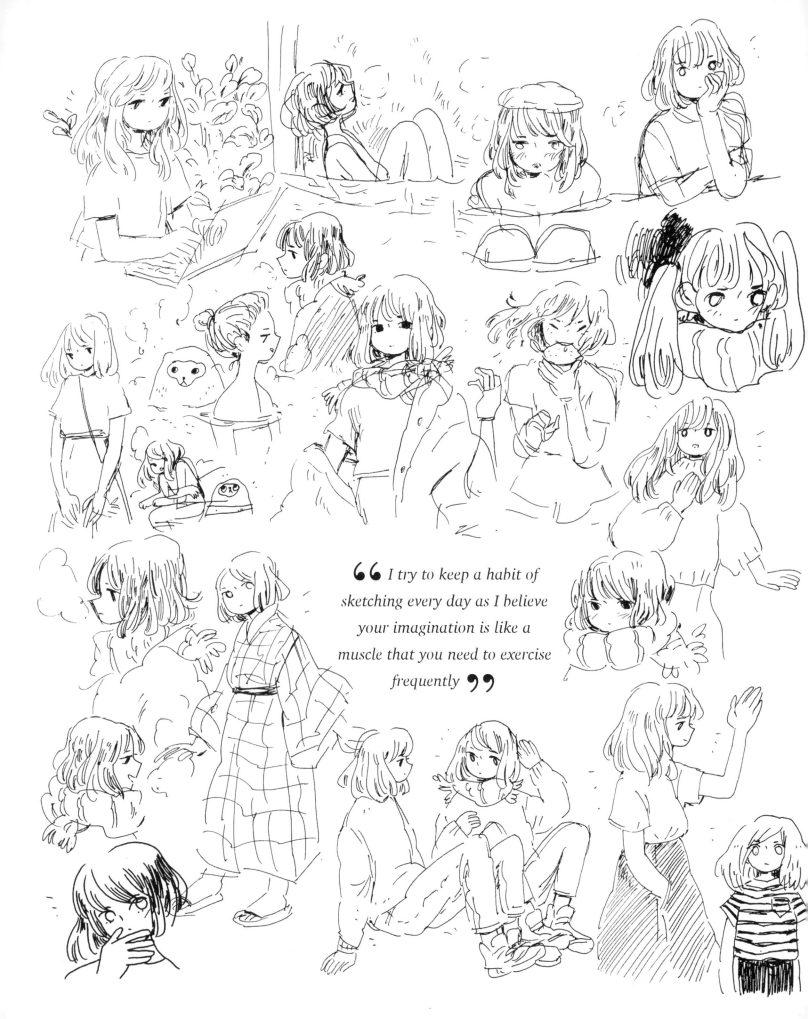

> **"** *I try to keep a habit of sketching every day as I believe your imagination is like a muscle that you need to exercise frequently* **"**

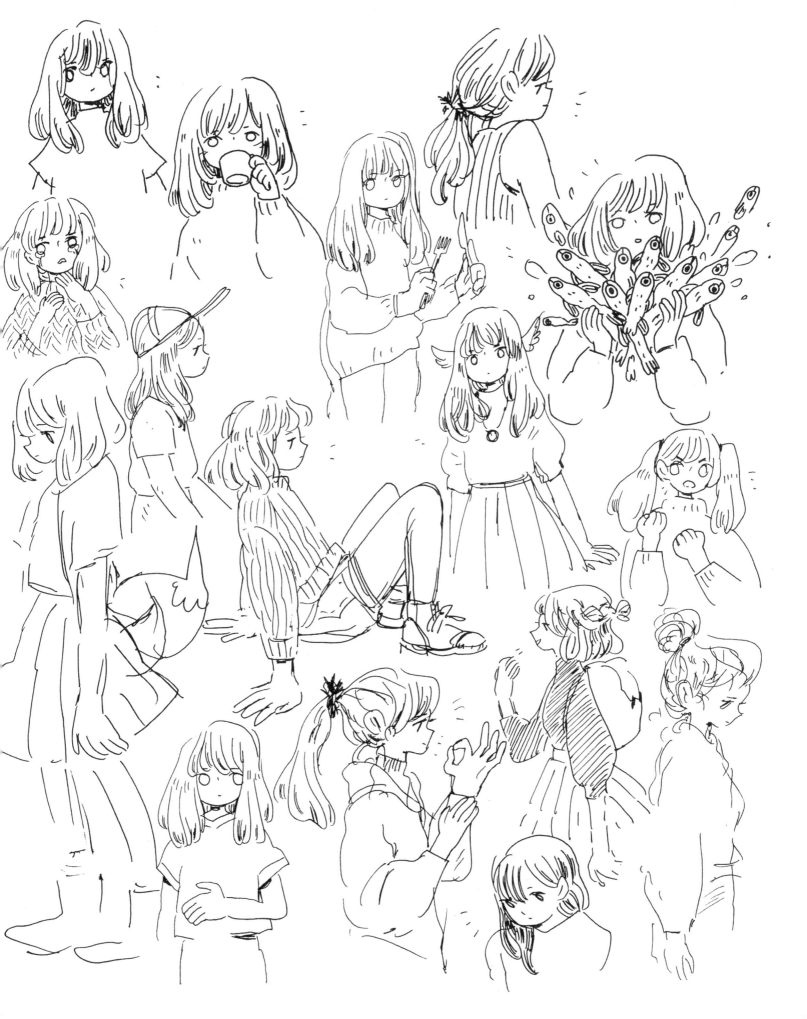

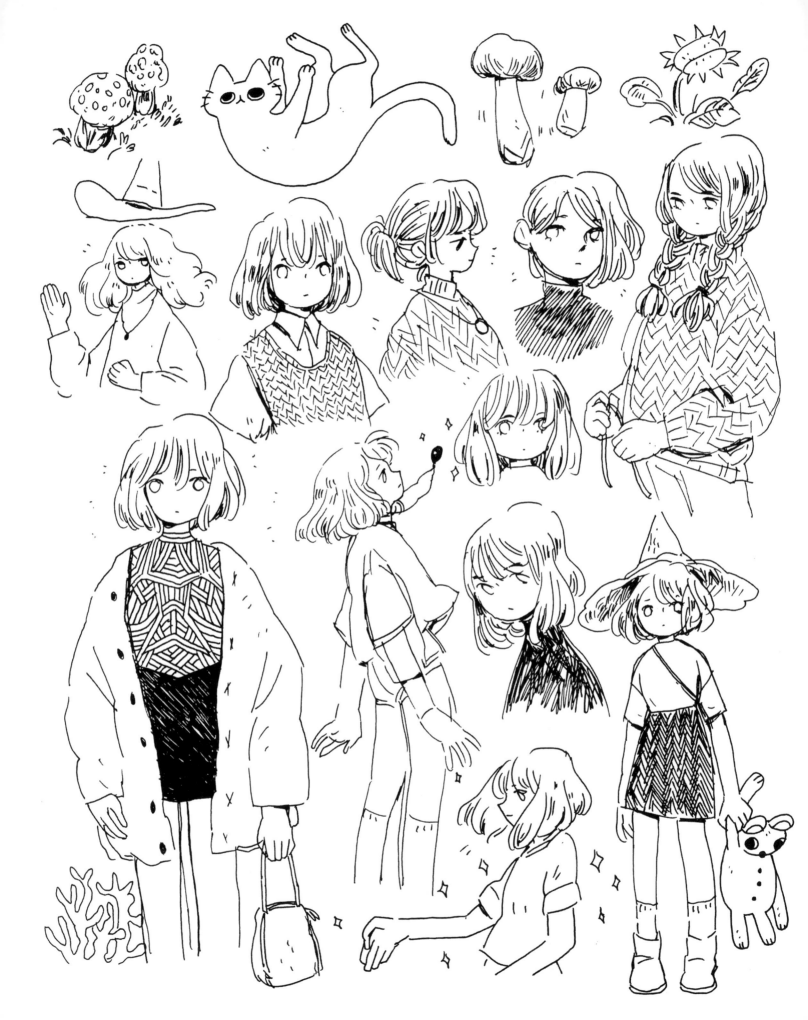

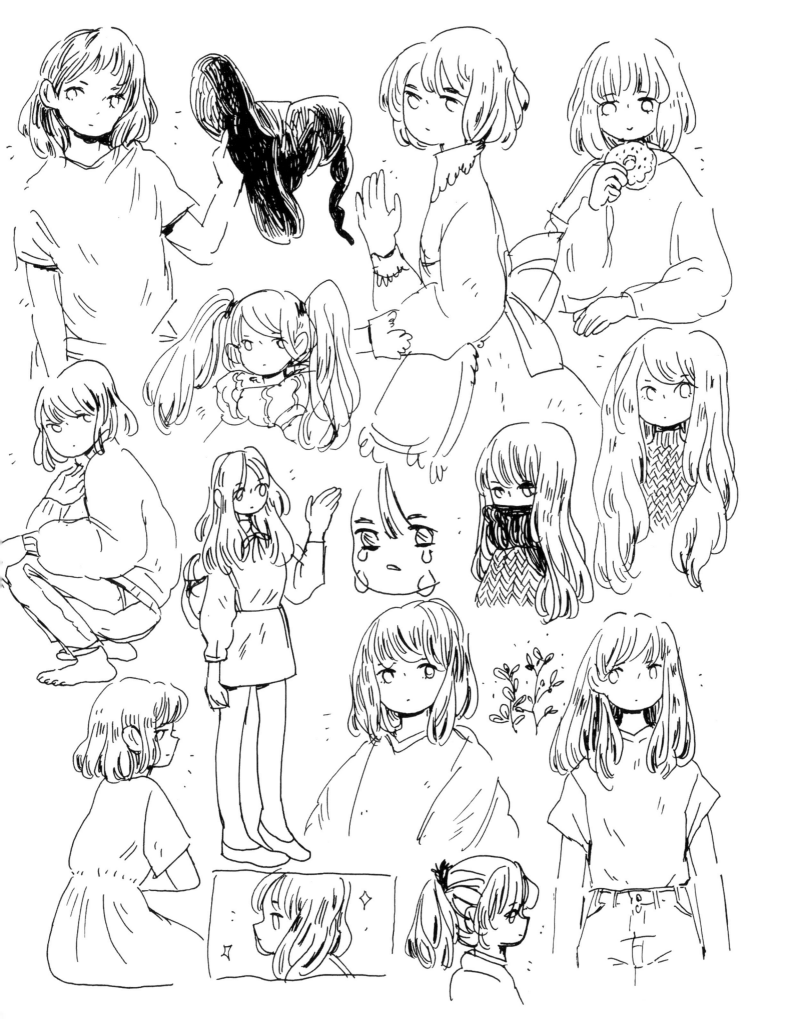

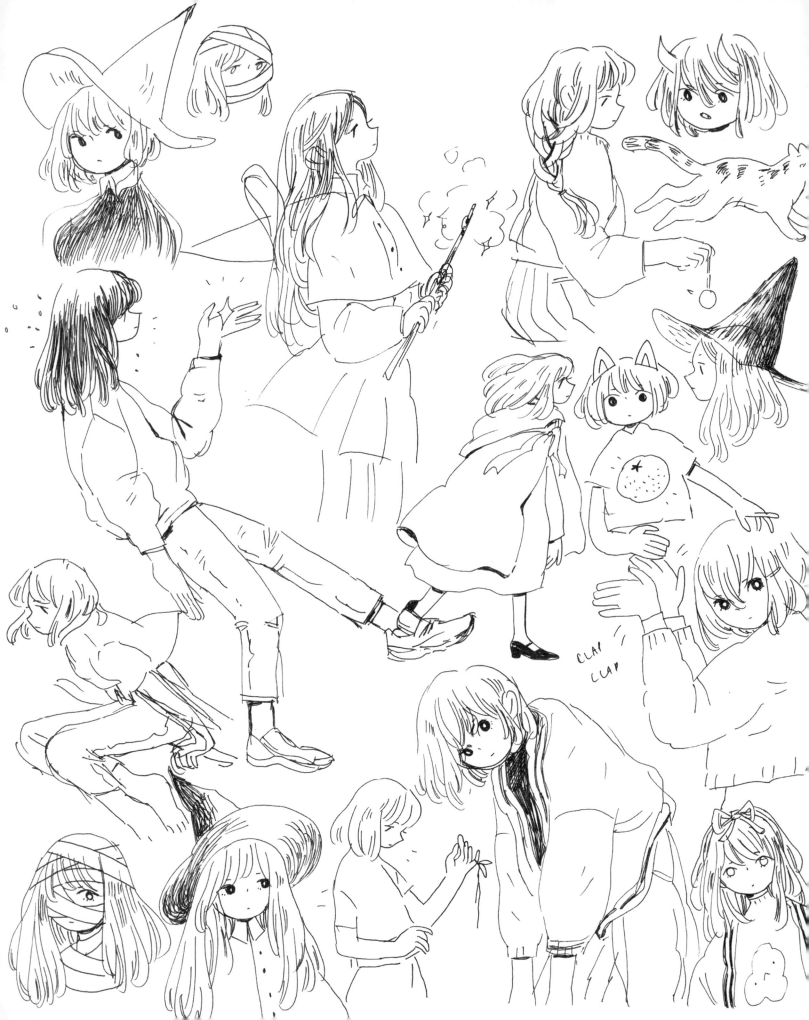

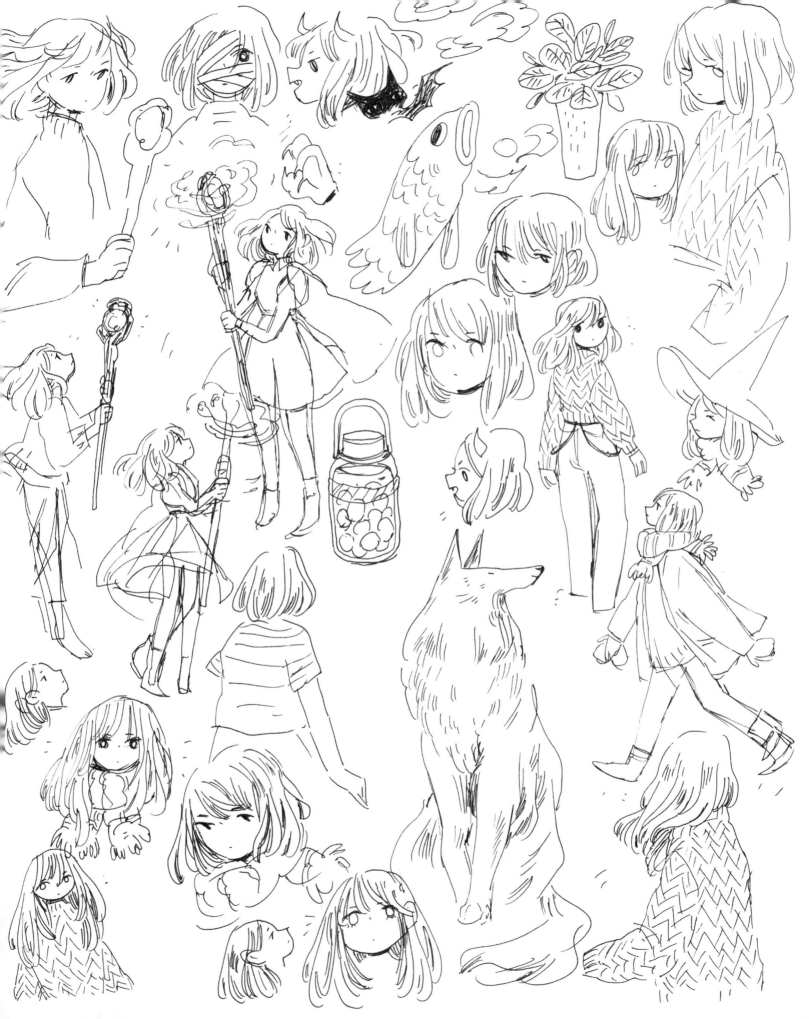

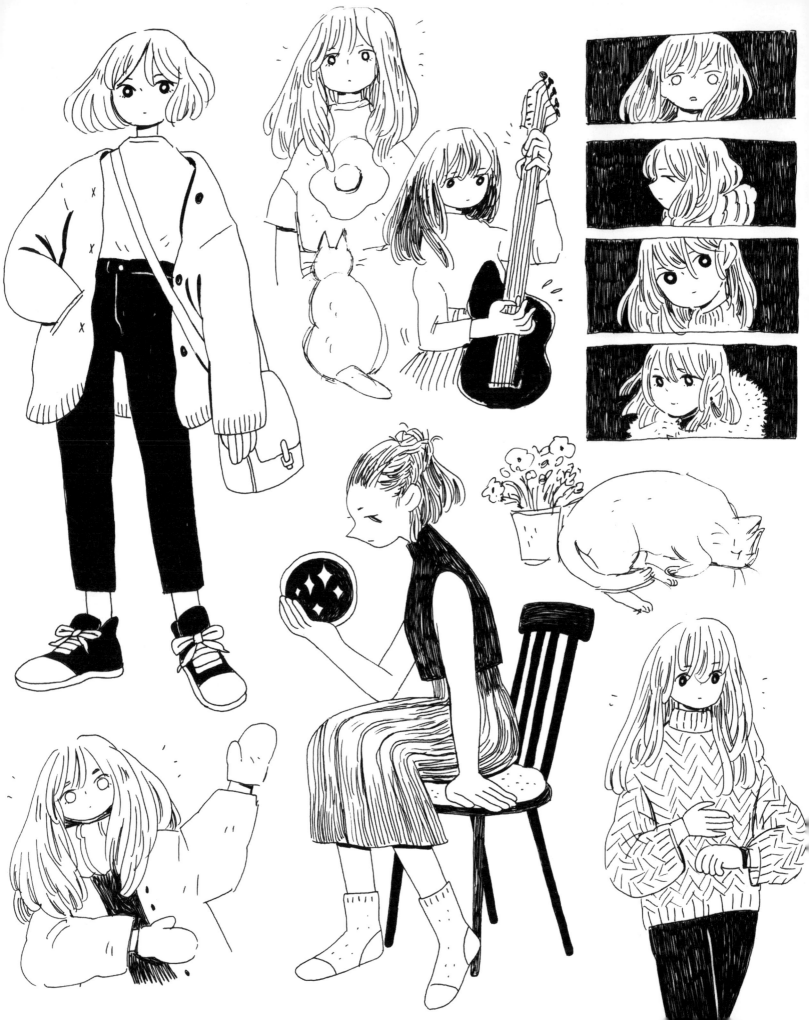

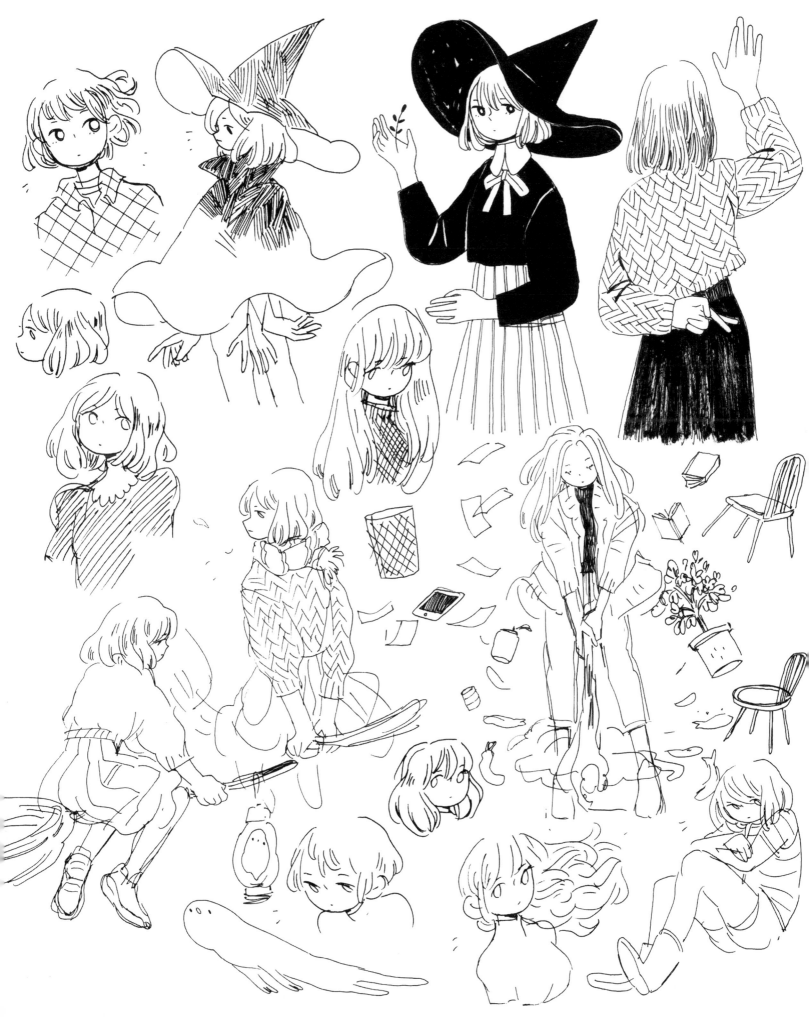

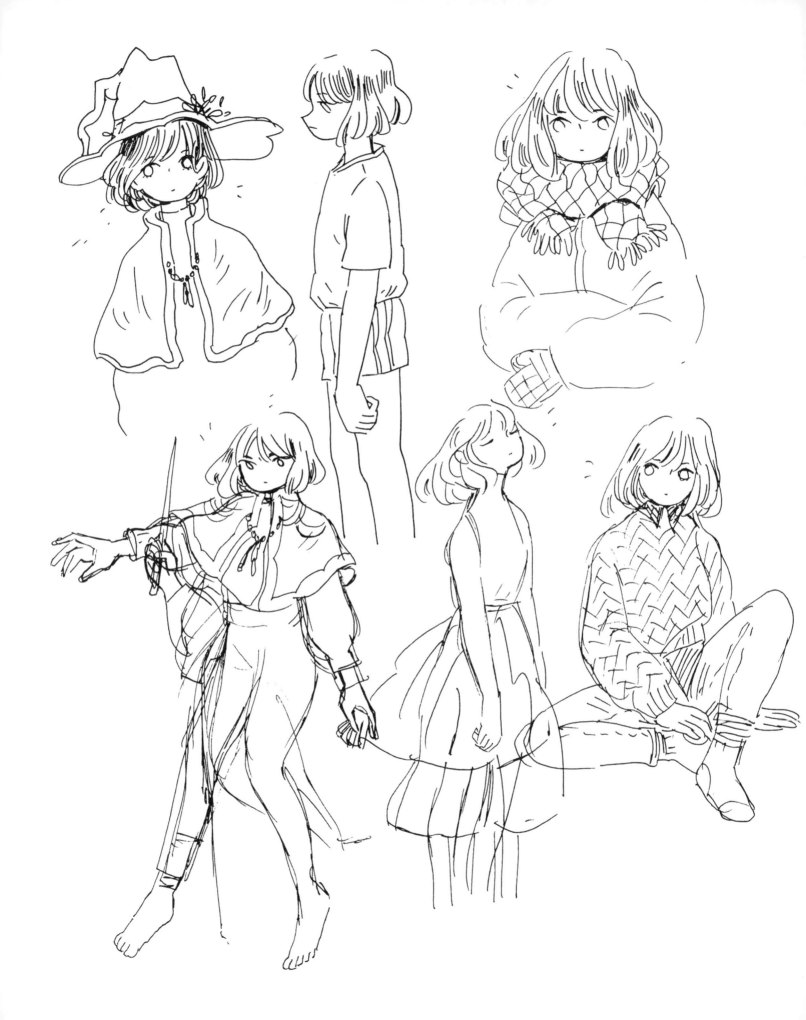

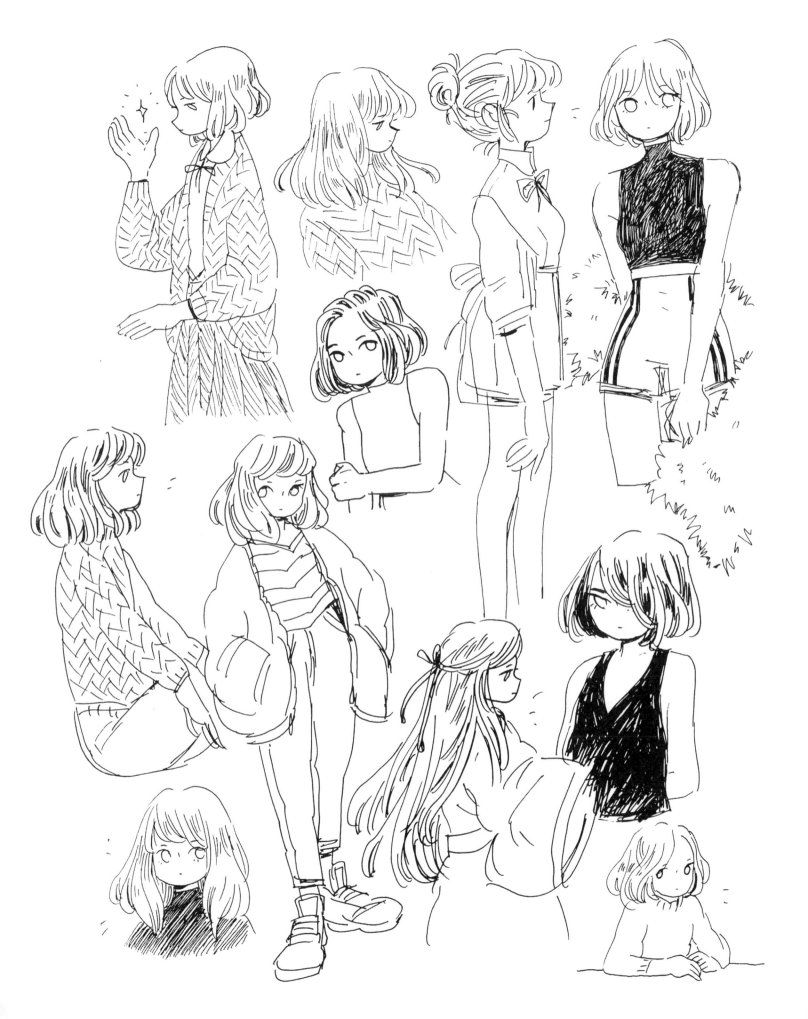

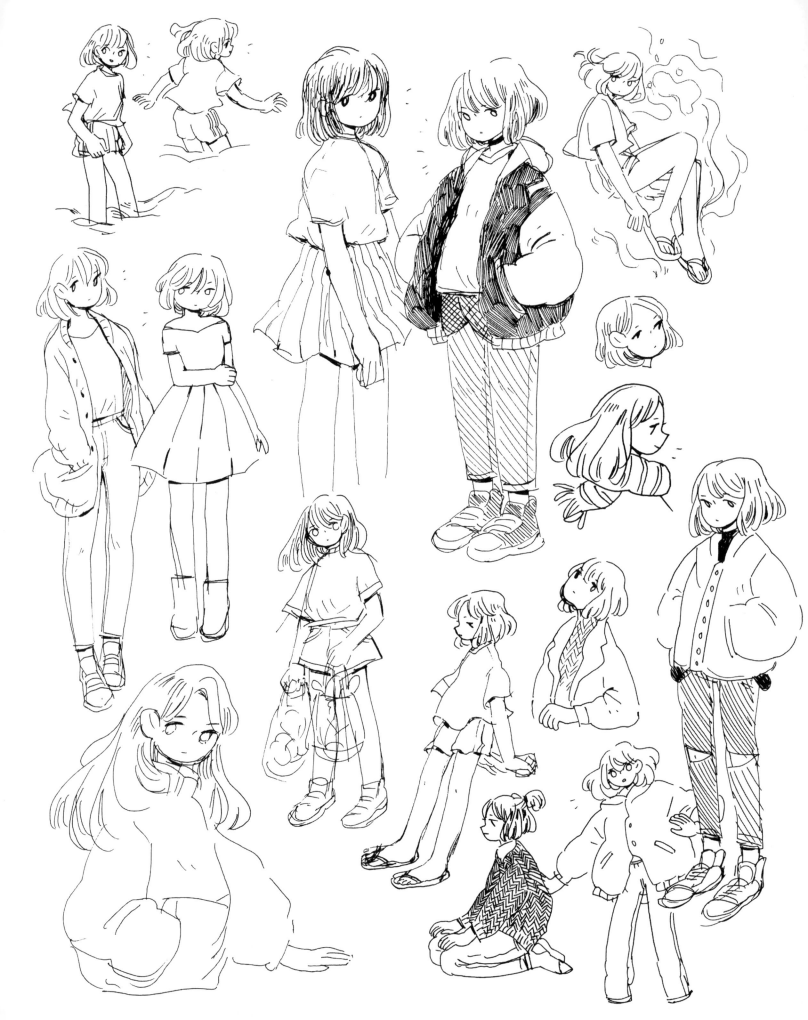

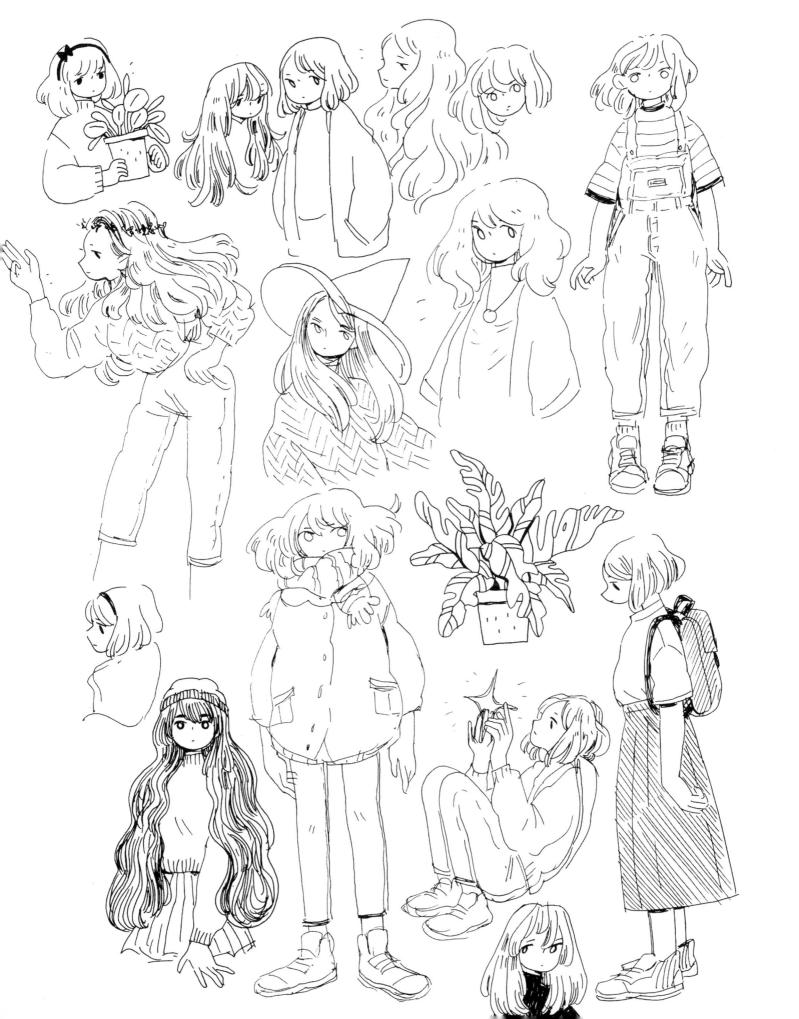

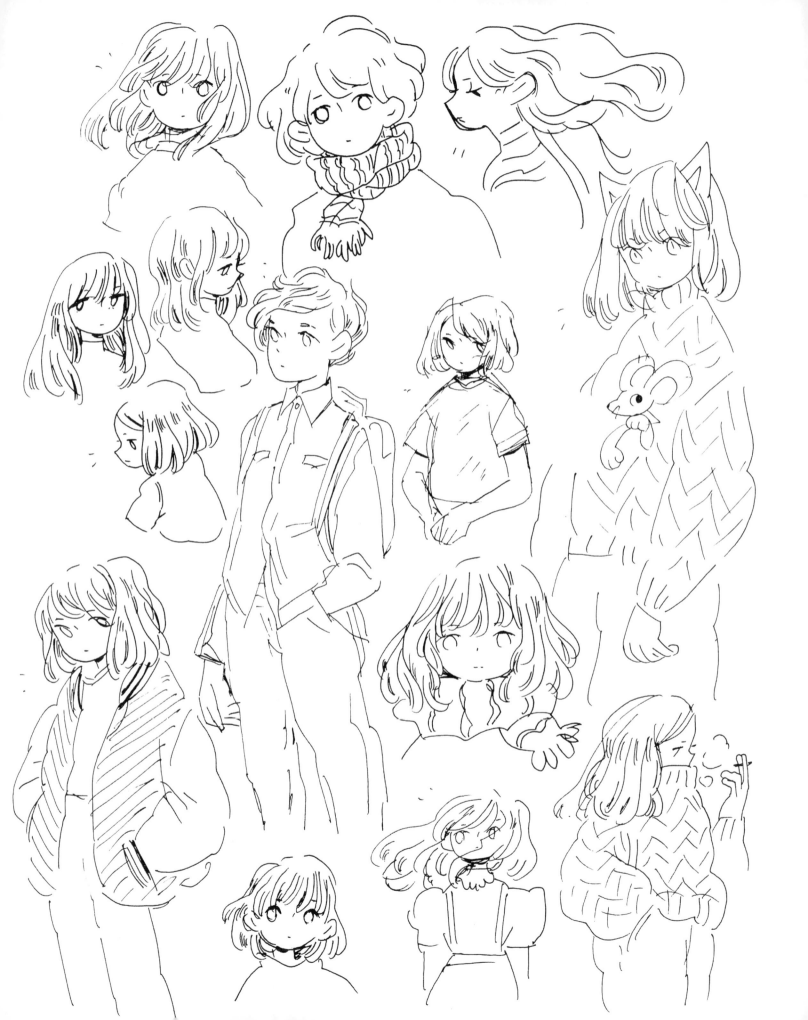

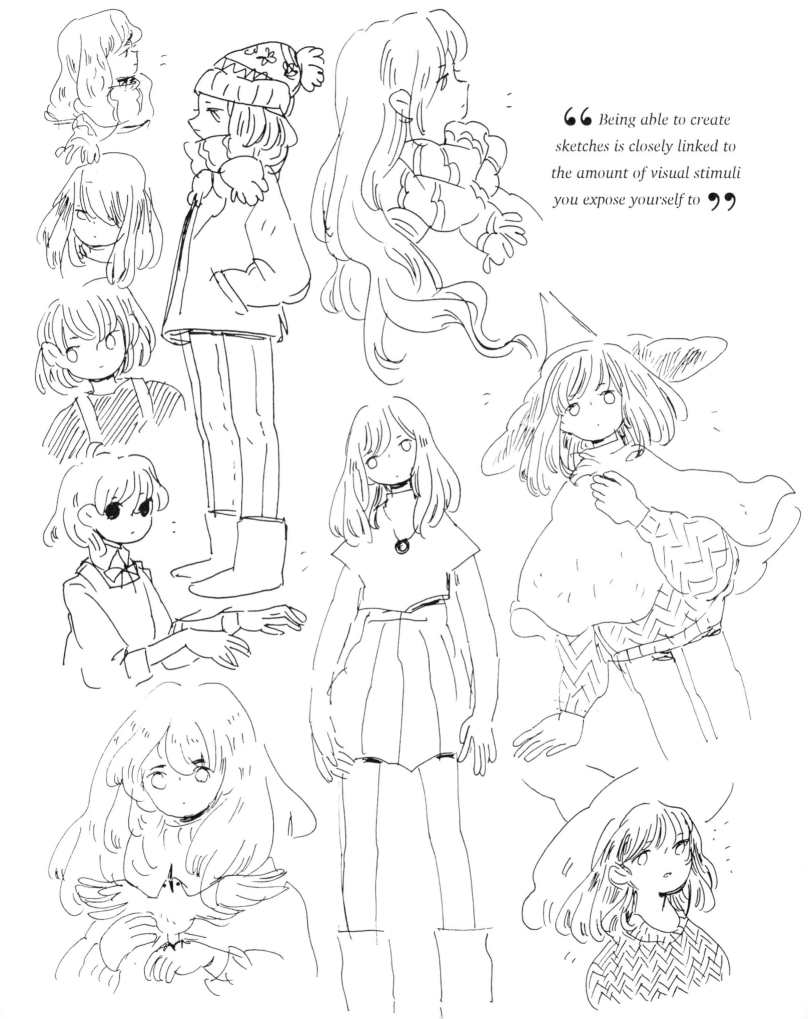

Being able to create sketches is closely linked to the amount of visual stimuli you expose yourself to

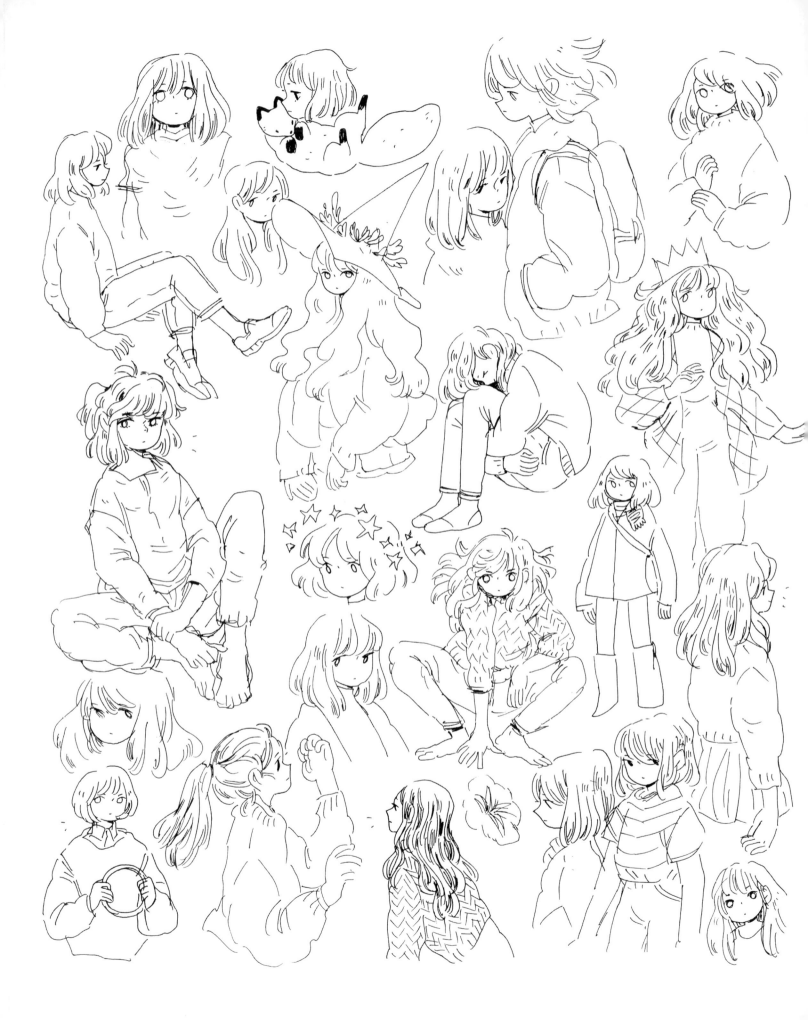

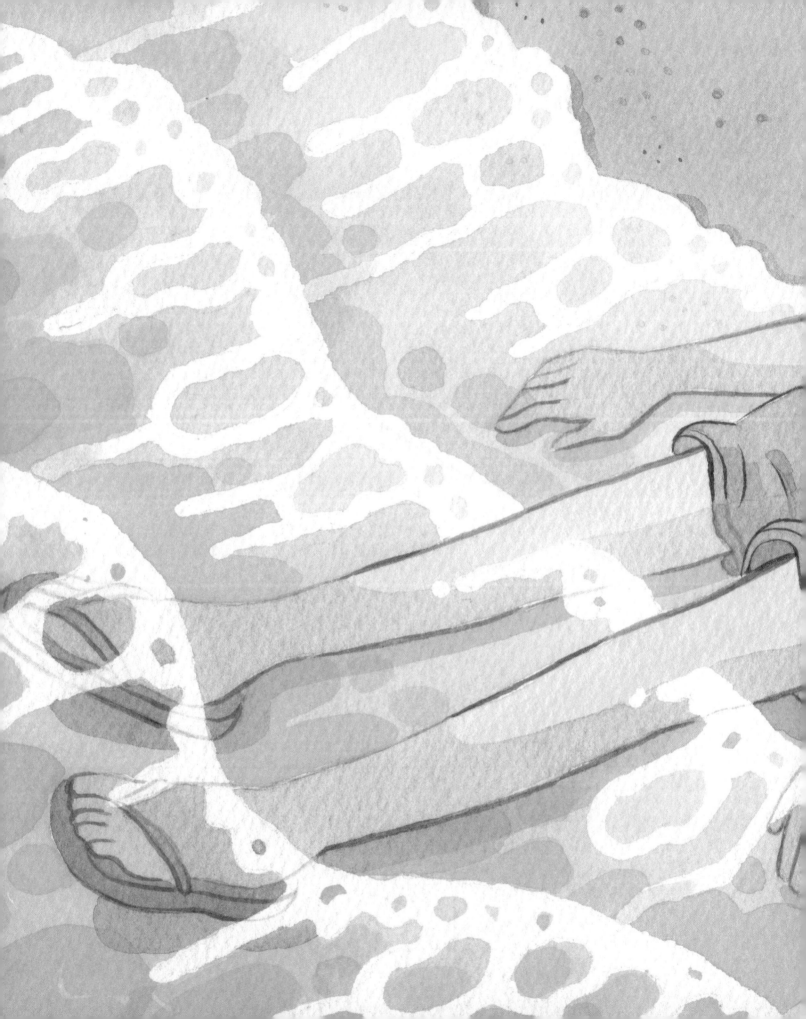

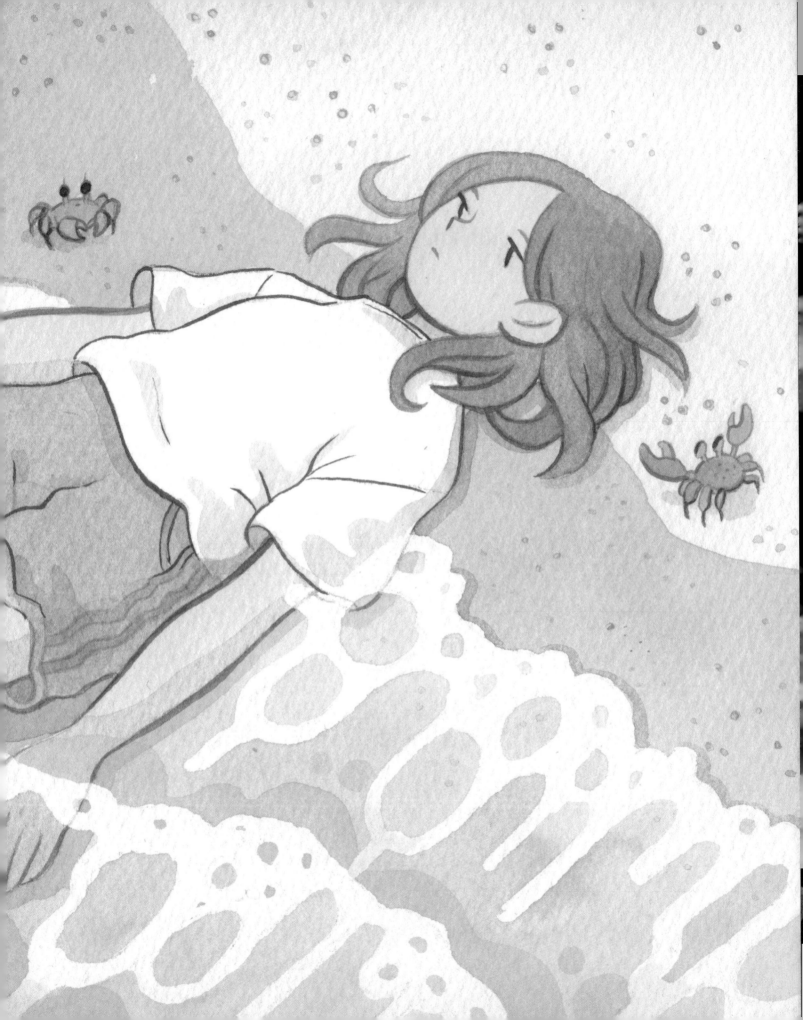

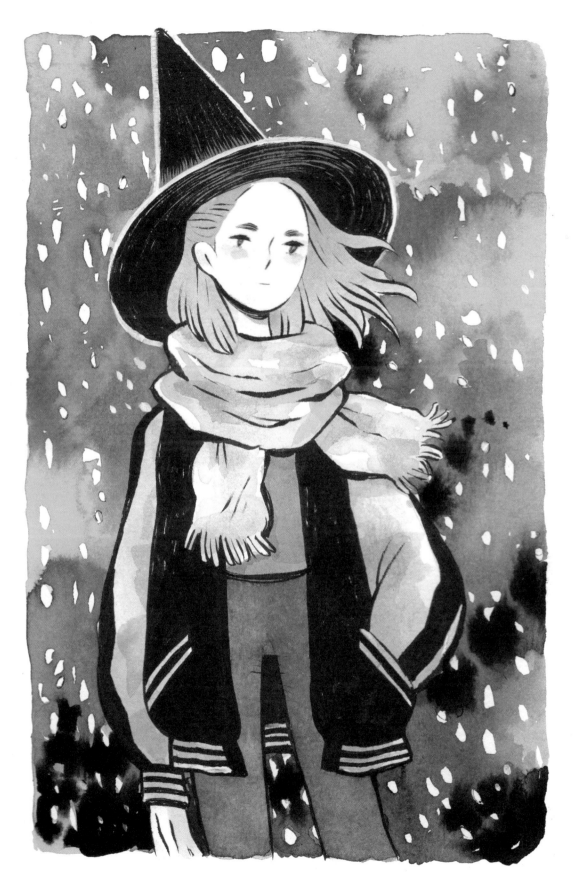

SNOWFALL, 2017

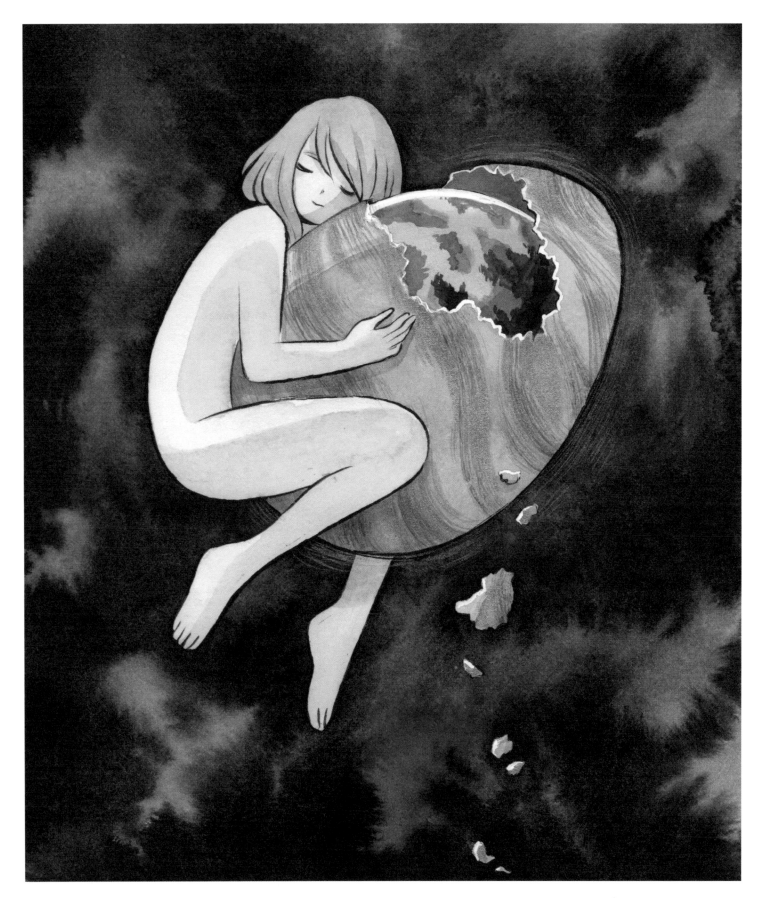

ILMATAR, 2017

Format

When I come up with an idea, the first thing I draw is usually a match-sized rectangle to represent the edges of the paper. I prefer to try my ideas on a tiny area first because if the composition works in a small size, it will also work in a bigger format. Sometimes I make various sketches of the same thing, but usually I just proceed with the first drawing by scanning it, enlarging it, then printing it onto its preferred size on a large piece of paper.

When I have the preliminary sketch printed and in front of me, I take out my light table and start drawing on top of it. My preliminary sketches are bare-boned; I start building on top of the skeleton of an idea, thinking of the mood of the illustration and how I can interpret it with what I place on the paper.

The sketch might only start with a character, but I begin to build the environment around them thinking about the perspective and the underlying story while adding more elements.

Sometimes I go back to the scanning process several times to adjust the placement of the character on the background or to flip something around. Because of my background in book design, whenever I make landscape illustrations I make sure I don't place important things in the center. It makes me uneasy to think that the focal point of the artwork could end up hidden in the fold of a book.

I usually make my illustrations on A4 paper, but depending on the complexity of the illustration I might make it a bit bigger. I never work on anything as large as A3 because it would be too difficult to scan with the scanner I use.

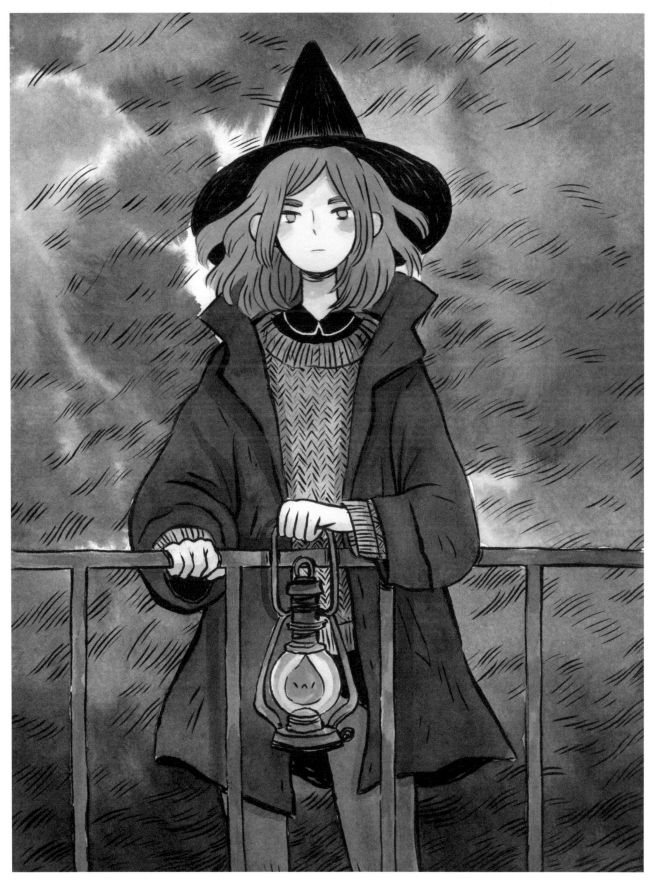

STORM, 2016

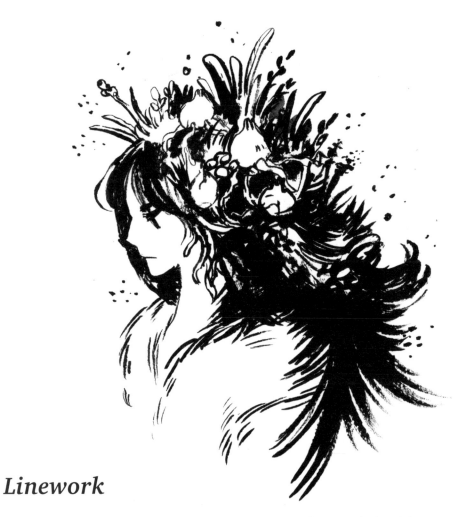

Linework

Depending on the result I am looking for, I do my linework with either colored ink or a brush pen. A black brush pen is my go-to tool for linework and I use it in the majority of my finished works; however, from time to time, I also make illustrations with colored ink outlines for an added effect of brightness or for a smoother, painterly finish.

Using the sketch on top of the watercolor paper as a guide, I start inking the piece – concentrating first on the background so I can ease myself into the inking. The reason I do this is because it doesn't matter as much if you make slight mistakes with the parts that are not supposed to be the focal point of the image. If the illustration doesn't have a background but only a character, or characters, I might start with the clothes or the hair before doing the facial features as I personally feel making a mistake with the latter would be devastating.

I use a brush pen for its ability to produce a variety of line thicknesses. Throughout my process I like to vary between thick and thin lines. I use thin lines for bright areas and for objects that are further away in the picture. Meanwhile, bold, thick lines are used in the areas that are left in shadow or that are closer to the viewer.

My linework is very lively and the lines that I lay on top of the paper are often disjointed as I like to lift my hand from the paper a lot, making quick strokes with the brush. I use patchy linework and might also do several aligned strokes close to each other to achieve a sketchy look in my finished artworks. There are some difficulties in creating linework with ink because you can't correct your mistakes easily. As I am right-handed, I have learned to start from the upper-left corner of the page and move from there to the lower-right to avoid creating smudges on the paper from the wet ink.

RAINY AKIBA, 2018

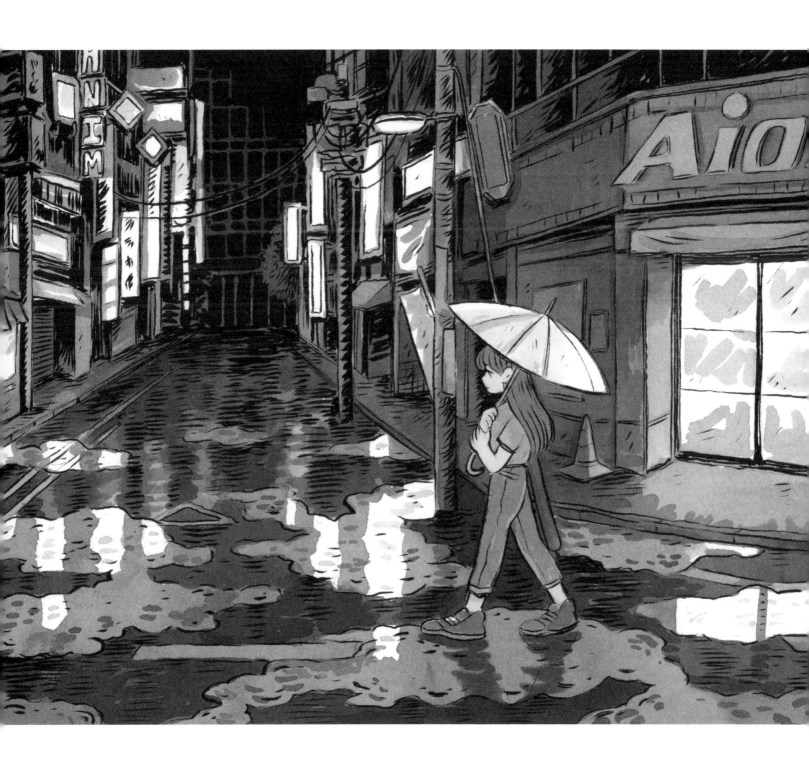

Colors

I usually think about the colors I want to use in an art piece before I start to sketch it. At the very least, I try to have an idea of the tones so I can produce a detailed sketch on the watercolor paper, laying out the elements in the illustration with the corresponding colored pencils. Alternatively, I might just create quick color roughs digitally or with watercolors.

My inspiration for colors comes from photos, other illustrations, or just everyday objects. Choosing the right combinations for artworks can be difficult as I know that making a mistake might ruin the whole illustration. Over time, however, I have learned some combinations that never let me down. I have also been surprised by the unconventional choices that have turned out as happy accidents.

The coloring tools I end up using for an illustration depend on the order that I need to lay out the colors, and the result I am after. With watercolors I need to begin with the lightest tones and move forward to the darker colors, since they are prone to bleeding onto lighter areas. With inks it doesn't matter if you start with darks because when they dry they will stay put, so if I have big areas of dark tones where I would like to have color washes, I will most likely opt for colored inks for the color, or perhaps use a combination of ink and watercolor.

Watercolors are more toned down and less intense, so if I am after mellow, washed-out tones I will use watercolor; for a bold and bright finish I use inks. When using watercolor it is also good to start from warm tones such as reds, yellows, and oranges, and then move on to the cold tones of greens, blues, and purples. Cold tones of color are more likely to bleed into the warm tones if you lay them next to warm ones.

As I add colors to my artworks, I use bold, intense, warm colors on the foreground and for important objects because it makes them stand out and seem closer. And vice versa, using toned-down, lighter and colder colors makes objects look like they are further away. It is easy to create a feeling of depth in an artwork by using this technique. Another trick that I often use when coloring my pieces is to use colored shadows, mostly tones of blue or purple; doing so makes the illustration look more realistic. The color of the shadows can also define the lighting that is present in the artwork. Using intense blue shadows can make the setting feel like it is taking place at midday when sunlight is most intense, and using light purple shadows makes the setting feel more like it is taking place at sunset or sunrise.

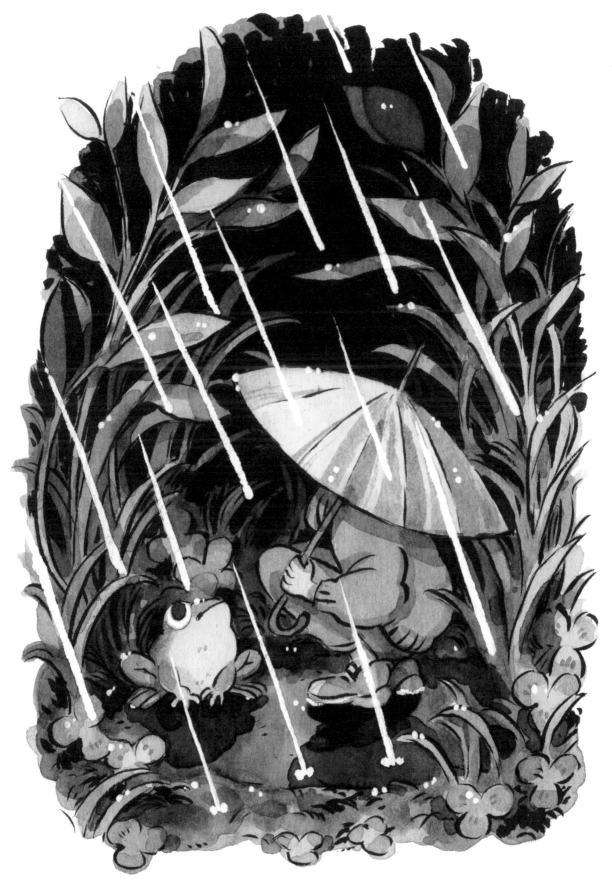

DRIZZLE, 2018

Special tools and finishing touches

Different tools and materials have their own strengths and weaknesses, and when I have a clear image of the finished piece in my mind I like to mix and match different techniques and tools for the preferred effect.

Masking fluid

One of the special tools that I use most often is masking fluid. I turn to it after creating the lines on the watercolor paper, applying it to places that I want to leave unpainted. If the intended blank area is a complex shape or I need to make an even color or a wash around it, I mask it rather than try to maneuver around it. This is especially the case with ink, which dries quicker than watercolor. Masking fluid is also good for creating multiple tiny details like rain or snowfall.

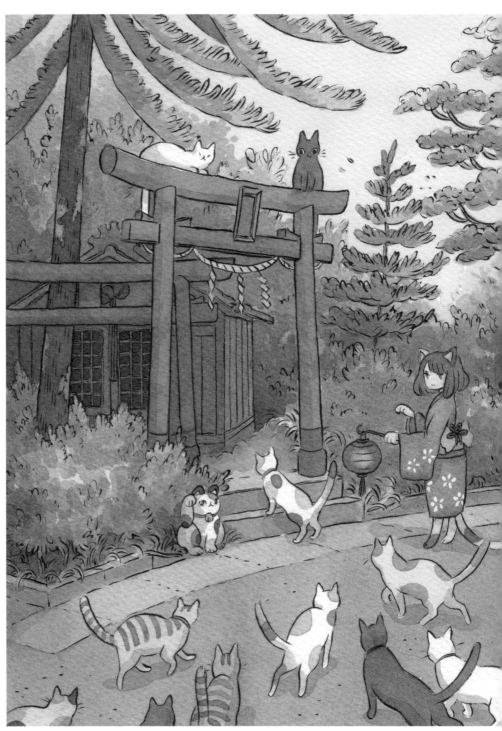

GATHERING, 2018

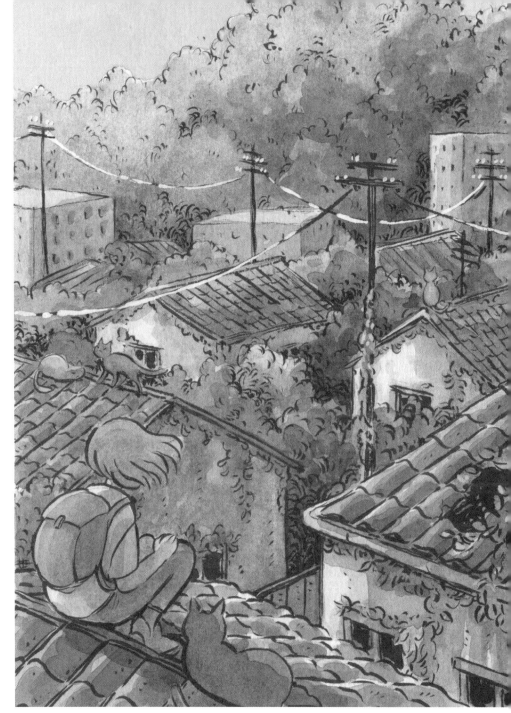

RUINS, 2018

Poster color

I use opaque poster color for fixing tiny mistakes as I finish up a piece. Poster color offers an easy fix for areas where the color has bled a little to areas it shouldn't have, or for creating extra highlights. It can be used in the same way as masking fluid, except with masking fluid you can paint the area with your preferred colors once the masking fluid is removed. To maintain the transparent feel that watercolor and colored ink have, it is better to use poster color sparingly. In the artwork above – *Ruins* – I used white poster color to highlight the electric wires.

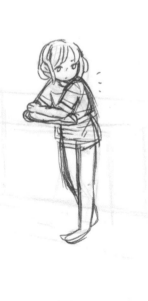

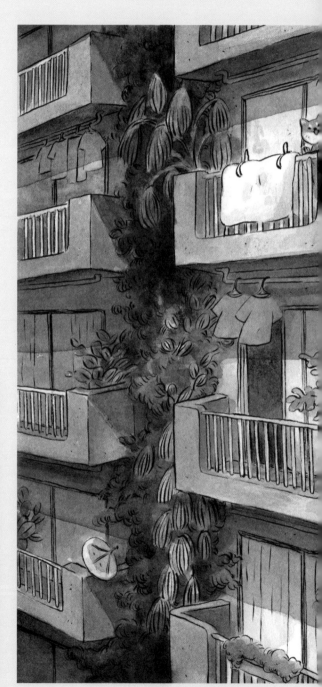

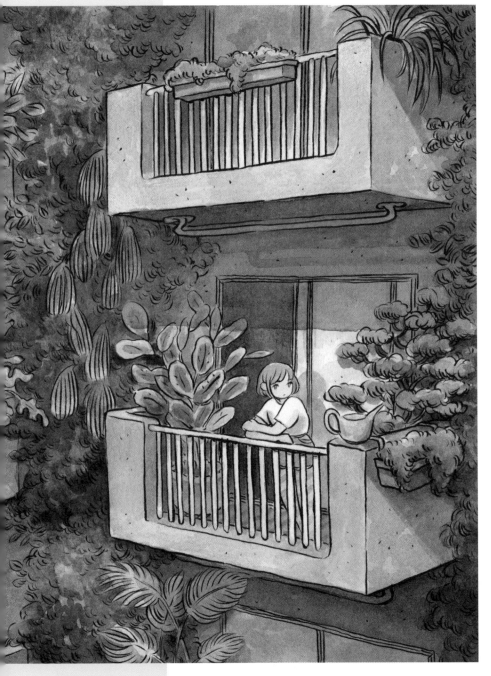

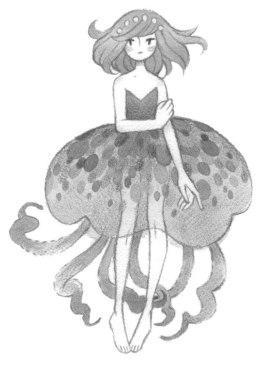

Colored pencils

One thing that I rarely use, even though it brings a special finishing touch to certain works, is a colored pencil – drawing lines on top of the painted original. Filling a large area of the rough-surfaced watercolor paper lightly with a colored pencil creates an effective, additional texture on top of the paint. Sometimes, I use colored pencil to slightly alter the tone of the color underneath. For example, I might decide to make a tone of green more turquoise by using a blue colored pencil on top of it.

In this piece – *Urban Jungle* – I used purple, red, green, and orange colored pencils on top of the watercolors, rendering the piece before adding a final wash of a purple watercolor to create the shadows.

URBAN JUNGLE, 2018

Style

In my mind, the style I work with is a combination of elements from Japanese popular culture and Finnish children's book illustrations. I like to think that my way of drawing things is a mishmash of styles that I have seen and elements that I have incorporated into it over the years. Ultimately, my drawing style is a vessel that I use to create the images I have in my head. I still feel like my style is constantly evolving into something new, and I hope I can always elevate it and make it grow even further.

In the most basic sense, a style of drawing is the way you see things around you and depict them in your work. I think a drawing style is something that you grow into eventually but too many artists, including me, are trying to accomplish too much, too fast. I remember struggling for the longest time thinking that I needed a unique style, but this style-driven thinking was only holding me back; I was being too hard on myself for not liking the way I drew things. I also found myself foolishly comparing my work to that of industry professionals, who had already found a unique voice in their creations. I especially struggled with my style at university during my graphic design studies, where anime was definitely not regarded as highly as the "Western" illustration styles. Having insecurities about this meant I ended up doing all of my schoolwork in a completely different style to my favored one.

After participating in a few month-long daily illustration challenges, such as Inktober, I realized my style developed the most when I paid little attention to it. I started concentrating more on the underlying ideas behind the illustrations. Finding endless inspiration in drawing witches was a turning point for me. I started to make all of my illustration around one theme and wanted to explore that further in my works. I wanted to create multiple illustrations without the subject becoming stagnant and was always trying to find a new point of view for the theme. And since I was concentrating on a simple theme but wanted the characters to be different from each other, I found myself thinking more of the characters and their traits rather than the style of drawing. The fact that I also made myself draw daily and pushed myself to have a finished piece ready every day was a significant factor in my style developing to where it is today.

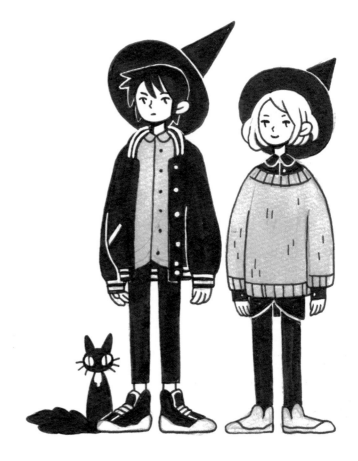

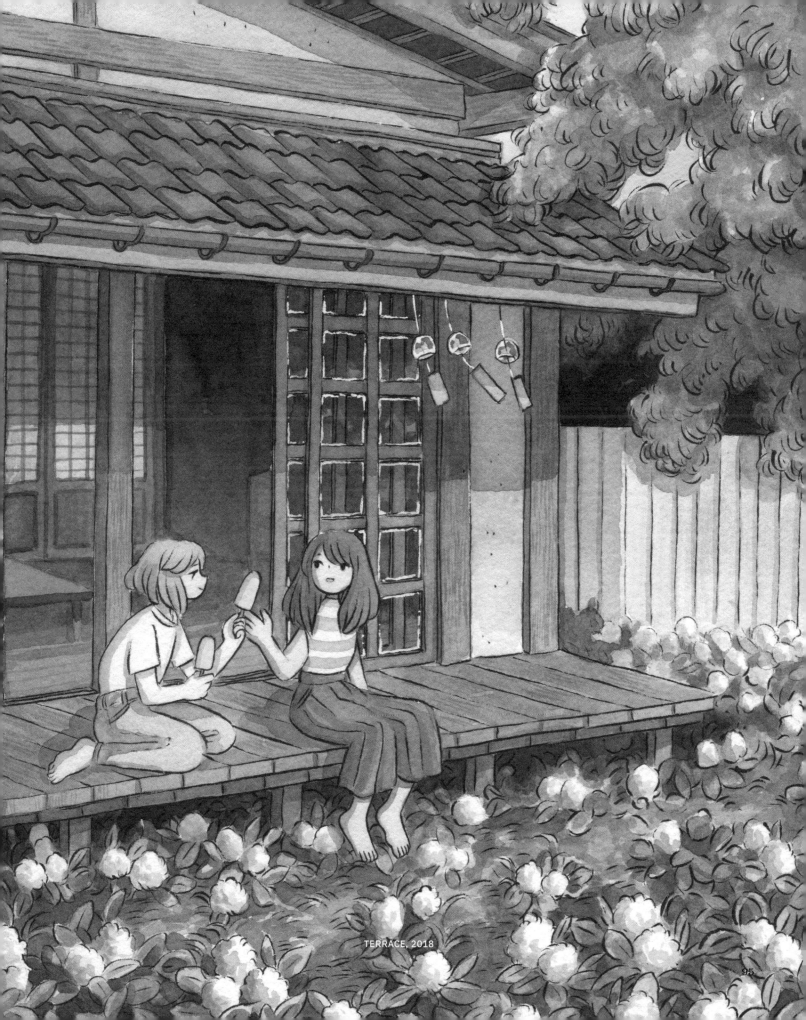

TERRACE, 2018

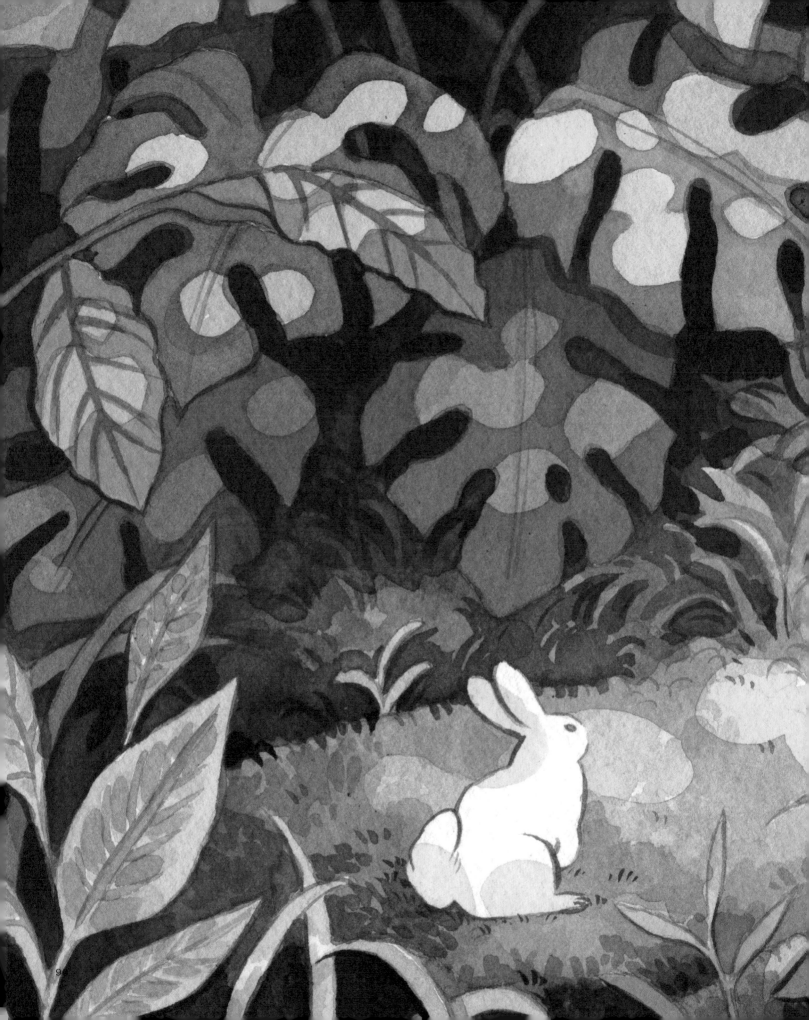

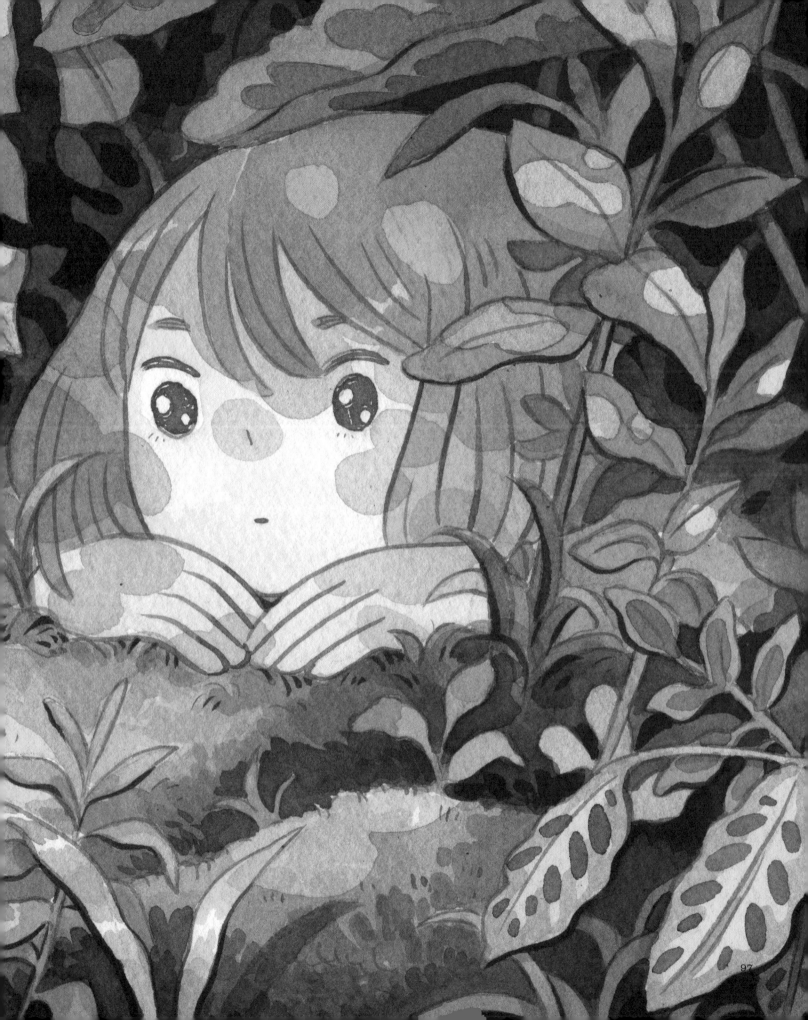

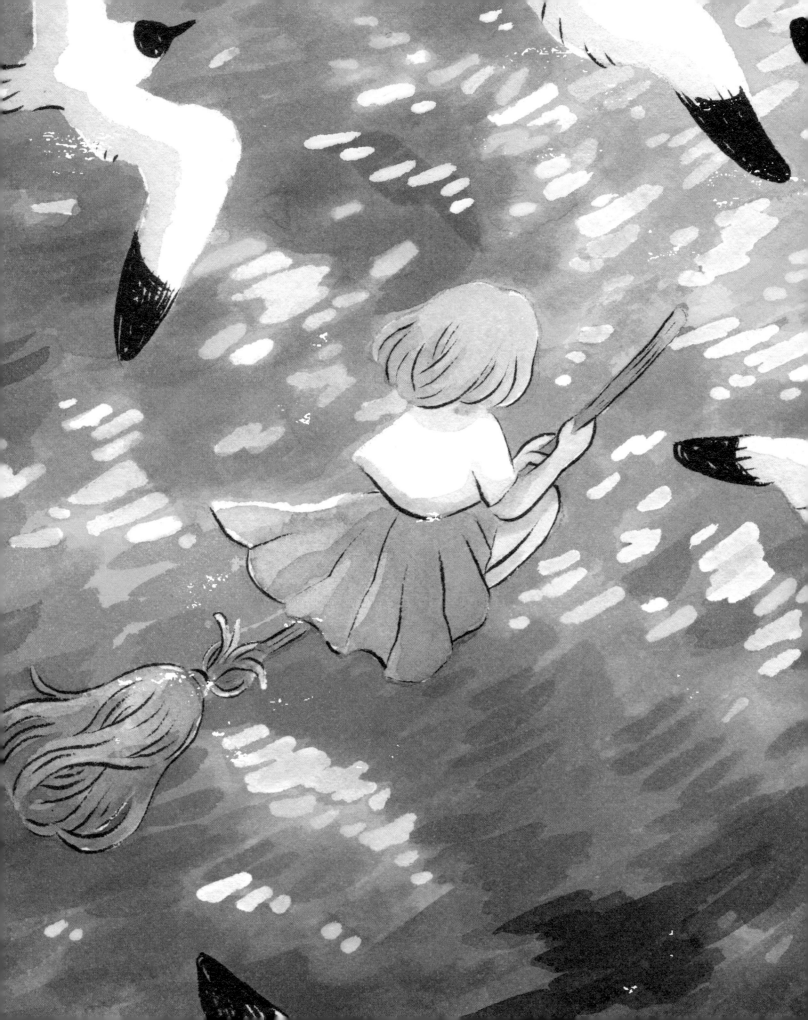

Building a profession

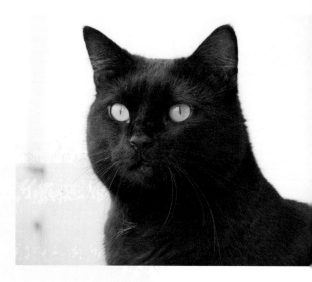

Sharing artworks online

Taking the leap and sharing my artworks on social media has been the biggest asset to developing my career as an illustrator. Without building an audience through regular postings on platforms such as Instagram and Twitter, I would not be able to support myself by making art. I am grateful for all my followers and enjoy replying to comments when I can. The artworks I share and how and when I share them is key, and a lot of thought goes into each post.

Once I have finished second-guessing if the illustration is lacking contrast or if I could improve it by adding "one last thing", I scan the artwork and get it ready for sharing. When working with traditional media, it is important to have a good scanner at hand. I usually scan my illustrations as 600 dpi files to make sure I can create larger prints of them in the future. Once in digital form, I make color adjustments so the digital version looks as close to the original as possible.

Depending on the media I use to create with, the final piece might look better photographed if, for example, the illustration contains shimmering or shiny effects that would only be visible in a photo. When sharing illustrations from my sketchbooks, I photograph them with my phone, sometimes including the materials that were used for the finished artwork in the frame. My favorite tool to show alongside the illustration is the mixing palette – not only does this show the colors in the pan complementing the work, but it also shares the splotches of color that the artwork originated from.

I started sharing videos of my process after my first Inktober art book. Before this I had only posted video content of screen printing, quick sketchbook tours, and a tiny "making of" my bookbinding processes. At first, I felt really anxious to draw while the camera was recording my every move, but soon I figured that it wouldn't matter if I took the footage or not as I wouldn't have to publish it. I started by filming myself doodling tiny witches while signing the copies of my art book. Those that came out well I posted on my social media platforms. I created these short videos now and then until Inktober 2017, when I decided to film every single piece that I did over the month. I had help with the editing of the footage, and picked the best parts of the process, turning them into one-minute videos. People really enjoyed seeing the illustration that they saw the day before come to life in front of their eyes. Now I feel sharing the process behind the illustration is as important as sharing the illustration itself.

It has become a yearly tradition for me to draw a magical cat for one of my Inktober illustrations. This is my inspiration – my cat baby, Miura.

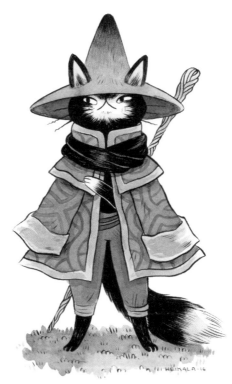

MAGE CAT, 2016

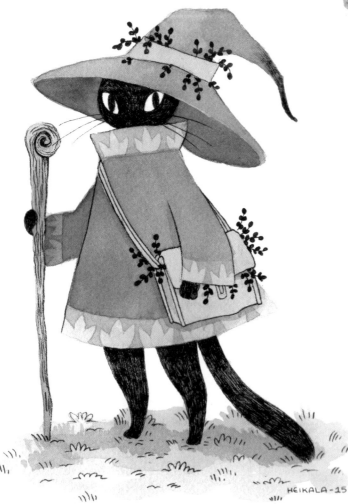

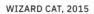

WIZARD CAT, 2015

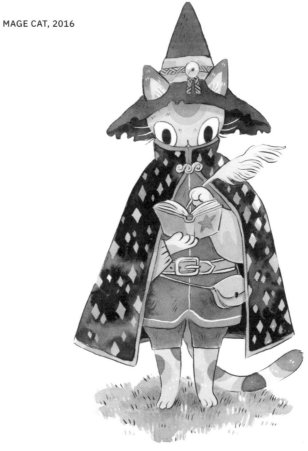

SORCERER CAT, 2017

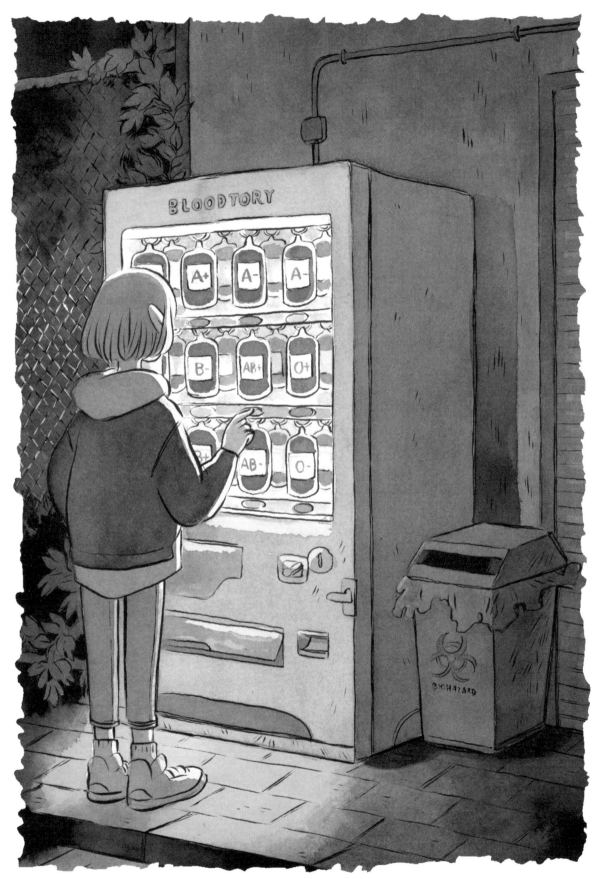

MIDNIGHT SNACK, 2017

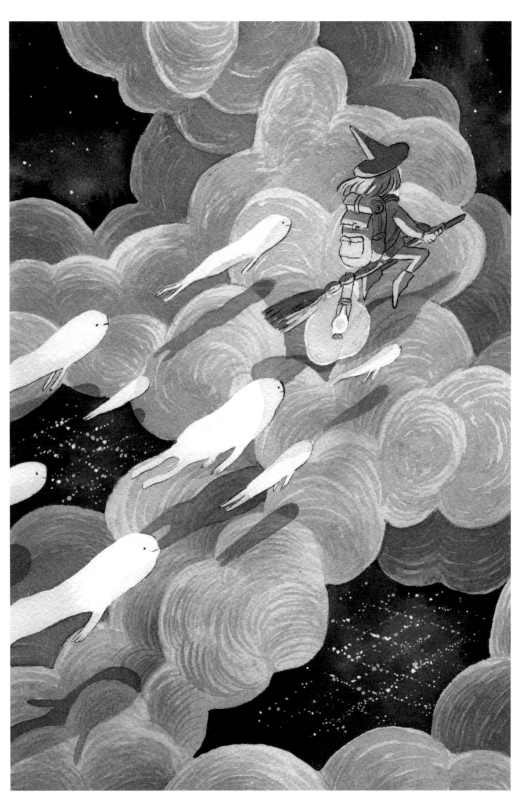

GHOST MIGRATION, 2017

The name

When sharing my work, the final and most important aspect for me is the name. Whether in a gallery, as a printed good, or showcased online on social media platforms, I find that the name might be the element that turns a picture into a work of art. It can add to the narrative of the illustration or make you think of it from another angle.

At times I come up with the name while I am working on the illustration, but sometimes it takes me half an hour after the piece is scanned and ready to be posted before it comes to me.

Printed media

I began my studies at university at a time when all the teachers knew that more focus should be placed on teaching web design and design in digital media. Nevertheless, the curriculum was still heavily based on printed media. One of the recurring conversations during class was a debate on whether printed media was dying and if digital media would eventually replace it altogether. Since most of our teachers had been part of the industry a generation before ours, it was no wonder they had a great love for print, and their enthusiasm was one of the reasons I too fell in love with printed media. I have since gone on to produce and sell all manner of printed goods, from self-published books and wrapping paper to postcards and original prints.

When creating paintings and drawings with traditional mediums, the material that you create onto plays an important role. Depending on the texture, thickness, material, and other attributes, the resulting line and surface change. The chosen materials also play a big role in the haptic feedback that you get from the work of art – this is mostly prominent in works of art that you are able to touch, like with some sculptures. You can especially play around with the feel of the material when creating printed media, and I love the moment I get to choose the paper for a printed project. There is so much variety in paper when it comes to colors, textures, and qualities. It is important to me that the finished product also feels good. For my watercolor works, I tend to use a slightly textured paper material to emphasize the painting technique in the print. When used correctly, and with devotion, special printing processes can bring an extra touch to the finished product without feeling gimmicky. My favorite printed goods are the ones that make me feel that I own a special item.

At university we were able to buy all kinds of paper for our personal and school projects from a well-stocked storage cupboard, and were allowed to use the university's professional printing machinery. We also got to visit print houses. These hands-on experiences and having access to so many materials further developed my love for printed media, and combined with my enthusiasm for bookbinding; I ended up experimenting with all sorts of papers and techniques in my personal projects. The most ambitious one must have been my self-published sketchbook, *Lines*, which had four different paper types inside for sketches where I had used different techniques. I went on to sell almost all 300 copies I produced, online and at events.

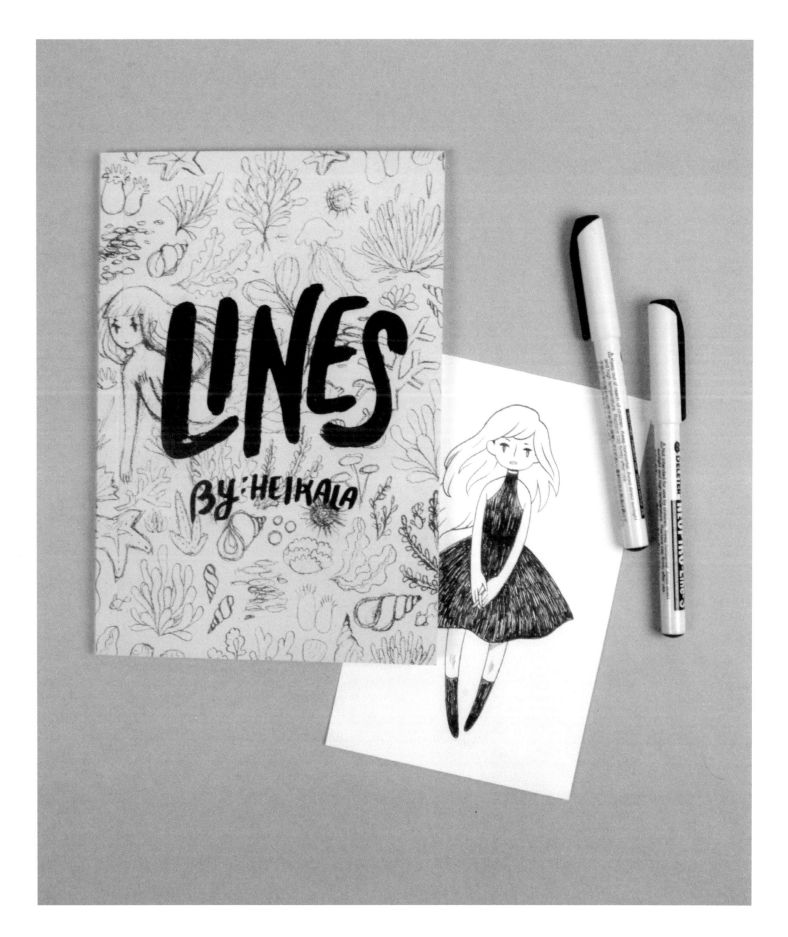

Books

At the start of my artist alley hobby I was really into comics and small-press zines. I had made prints, postcards, and other products for sale before, but in the summer after upper-secondary school I had the time to create my very first comic. I made an adventure comic with a focus on videogame references. At the time, I was really into gaming so I loved incorporating elements from my favorite games into the comic. Once it was finished I managed to print a few, just in time for a local comics event where I actually won a small-press prize!

I love the freedom that making a zine or a book gives – that is why many of my books have been made by hand. As with other printed media, I like to pick just the right papers for a book, and maybe have a different material on the cover. I take extra time thinking over the binding, making the finished product the best it can possibly be.

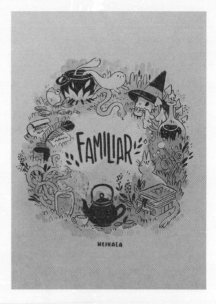

FAMILIAR, 2016
A short comic book about a witch who summons her first familiar (an animal-shaped spirit that acts as a servant to a witch or magician).

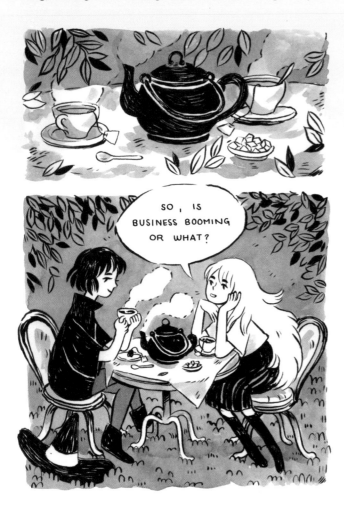

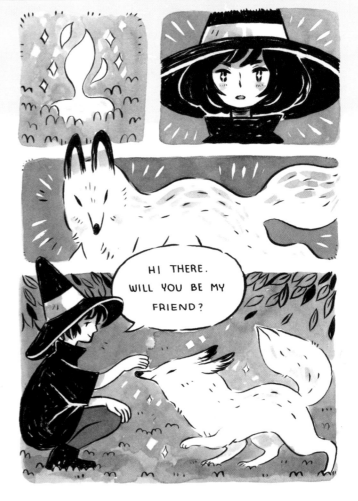

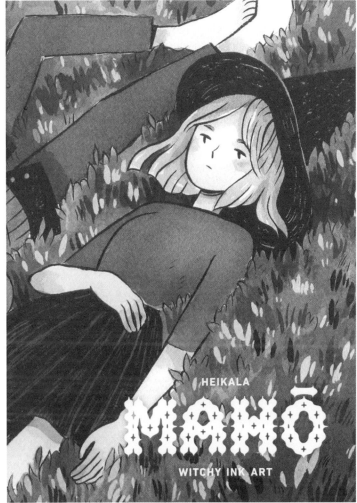

MAHŌ, 2016

My first publication after graduation. The book contains Inktober works from 2016.

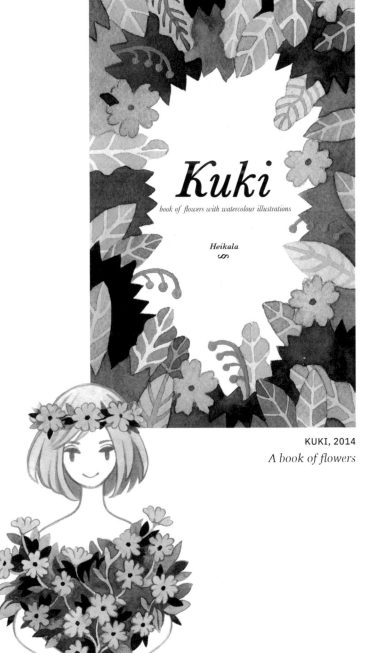

KUKI, 2014

A book of flowers

To date, I have self-published and sold six art books and two comics. My favorites include: *Kuki*, a booklet that introduces five different flowers personified as characters, and comes with small sachets of seeds from each of the illustrated flowers; *Lines*, the sketchbook with various sketches placed into categories by technique with a unique paper used for each section (as featured on page 105); and, *Once*, a compilation of my 2017 Inktober art pieces and sketches.

These personal favorites are the ones where I have had the chance to experiment with paper materials and special printing methods, and for this professionally published book, *The Art of Heikala*, the added design features and finishes are no exception.

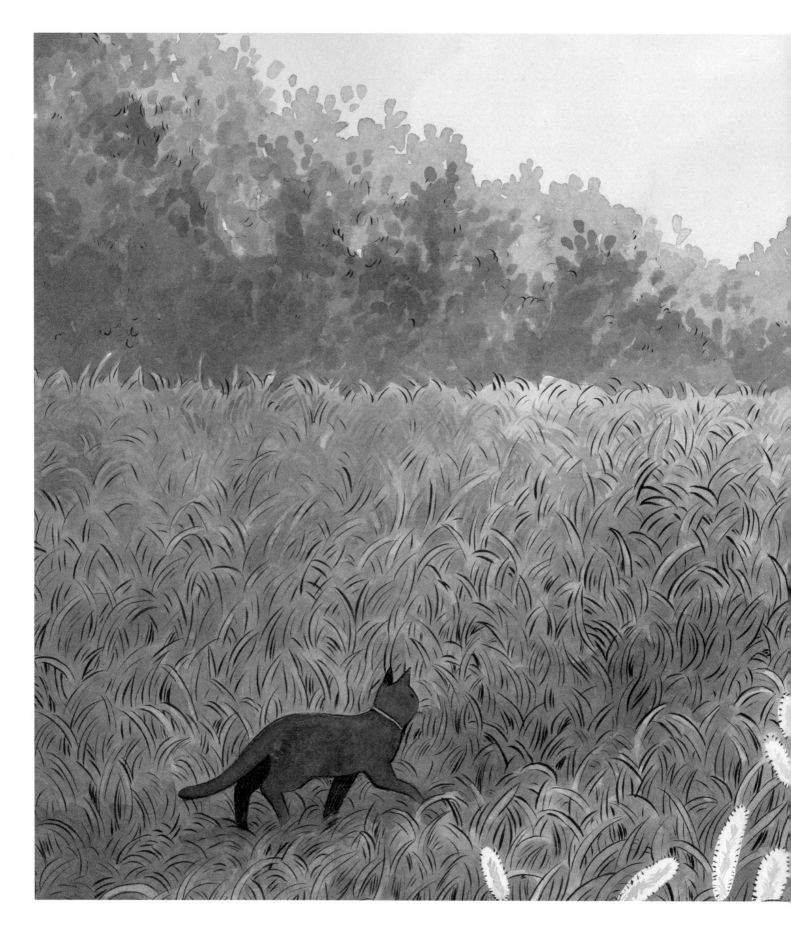

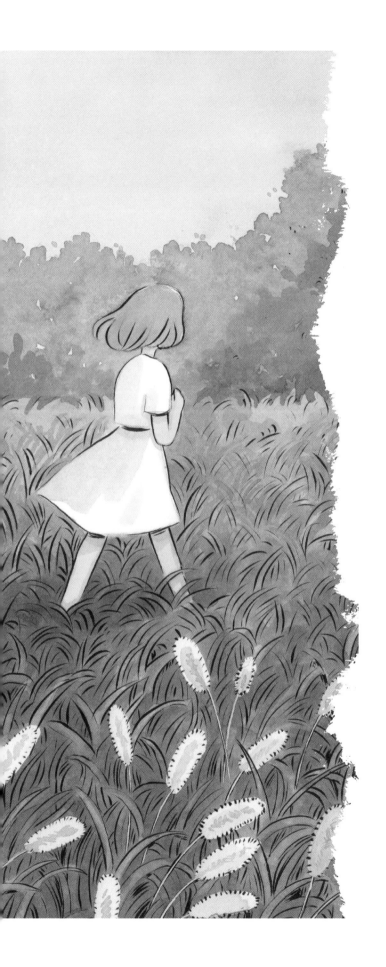

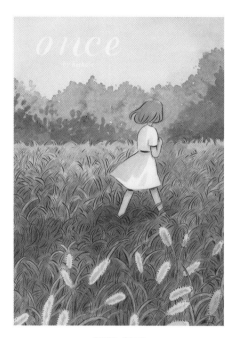

ONCE, 2017
My second Inktober artbook. I was motivated to improve my illustrations, or by getting better at creating backgrounds, character interactions, and composition.

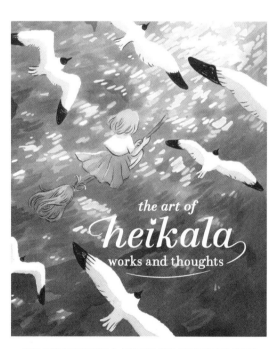

THE ART OF HEIKALA: WORKS AND THOUGHTS, 2019
My first, professionally produced publication. I wanted the book itself to be a work of art so I chose different papers for the inside pages, and a number of special finishes for the front cover.

Designing products

I have enjoyed coming up with business ideas ever since I can remember. For example, when I was a child I was always looking forward to Easter and *virvonta* – a Finnish Palm Sunday tradition when children go from door to door dressed as witches offering decorated sprigs of pussy willow to their neighbors, which were meant to help them ward off bad spirits (for a "prize" of candy or coins) – it is a similar tradition to trick-or-treating. Some children would go out with just a handful of decorated sprigs to do their rounds, but I started preparing and decorating my branches at least a week before, making a production line on our kitchen table with a bunch of colorful decorations and pussy willow twigs. Then on the day, my mom would dress me up as the most amazing-looking traditional witch and I would go out to the neighborhood with a wheelbarrow full of twigs. At the end of the day I would return home with a huge pile of candy, chocolate, and coins.

I have always loved learning how things are made. My curiosity has led me into crafting pieces with all kinds of materials. I first started designing products as a hobby, creating paper goods to be sold as postcards and prints, and whenever I learned a new technique, like screen printing for example, I used that knowledge to create new pieces and tangible objects with my illustrations.

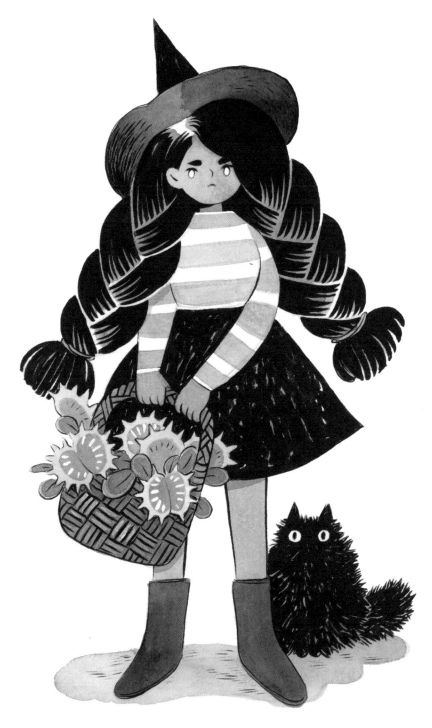

FLOWER DELIVERY, 2017

I am a bit of a perfectionist when it comes to product quality, making hundreds of sketches before settling on a design, and until my last years at university I created all of my products by hand. I printed them at school, assembled them by hand, and also screen printed everything myself.

For my final thesis project at university, I created a line of five different products, which were all objects that I hadn't designed before. It meant I had to leave my comfort zone to ask for help from local manufacturers. Even though there were some initial hiccups in the production, and not all of my designs ended up being produced, I ended up with some lovely items that I wouldn't have been able to make on my own. I still find it a bit hard to delegate things to others, but I am happy to have met amazing professionals with enthusiasm for their craft who have been able to help me make beautiful products and bring them to life.

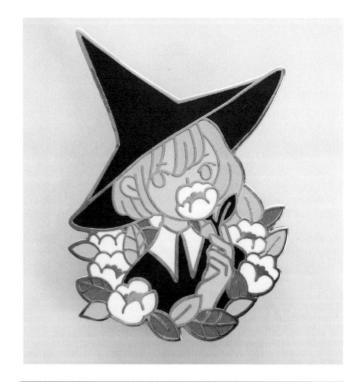

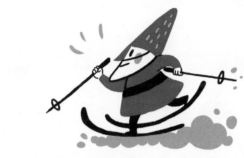

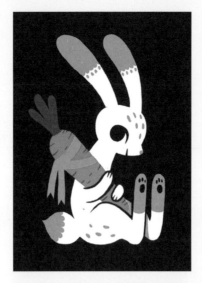

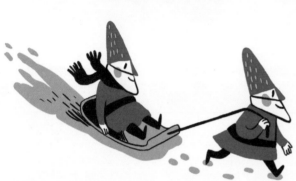

Graphic design

Studying graphic design at university helped my art improve more than any other course had up to this point. Even though I was struggling to find my style and visual voice, I learned so much about illustration and visual communication. Pleasingly, I was able to put into practice what I had learned about "creating a visual identity" when I started to build my own brand straight after university.

I also tried many new techniques during my studies – one of which was illustrating digitally. This turned out to be an invaluable process to learn even though I ended up going back to traditional mediums eventually.

My background in graphic design studies has also proved useful when I have created new products because through my studies I had the chance to interact with manufacturers, which helped me when I set up my business. I also learned a lot about typography, illustration, and other basic skills that I use in my work daily.

For me, detail is really important. I love paying attention to every little thing and want it all to not only be visually beautiful but also well-thought-out. Even if it is just a tiny element, I feel certain that someone will notice and appreciate it.

MANEKI NEKO, 2017

Backgrounds for short animation

Backgrounds shown here from *Susume, Karolina* written and directed by Mateusz Urbanowicz.

The animation is sponsored by Otsuka Pharmaceutical Co., Ltd. (the maker of CalorieMate balanced food) and was produced at animation studio Colorido.

In 2018, a fellow illustrator and watercolor artist, Mateusz Urbanowicz, asked me to help him with painting some backgrounds for a short animation he was directing. The animation was for a campaign to support Karolina Styczyńska from Poland – the first female, foreign shōgi (Japanese chess) player to become a professional.

I painted the backgrounds with the visual guidelines created by Mateusz's storyboard, the animation studio's sketches, and Mateusz's color roughs – emulating Mateusz's lovely, soft watercolor style.

This was my first time using pencils for outlines in a watercolor painting, and creating such true-to-life settings, so at times I struggled during the process. The project was a great lesson for me. I learned more about three-dimensionality, and using watercolors for paintings in a "set" style. I have since been able to use this knowledge in my own works.

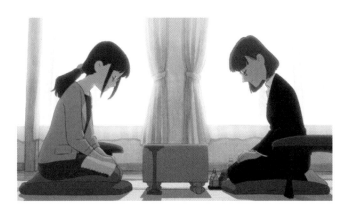

Tutorials

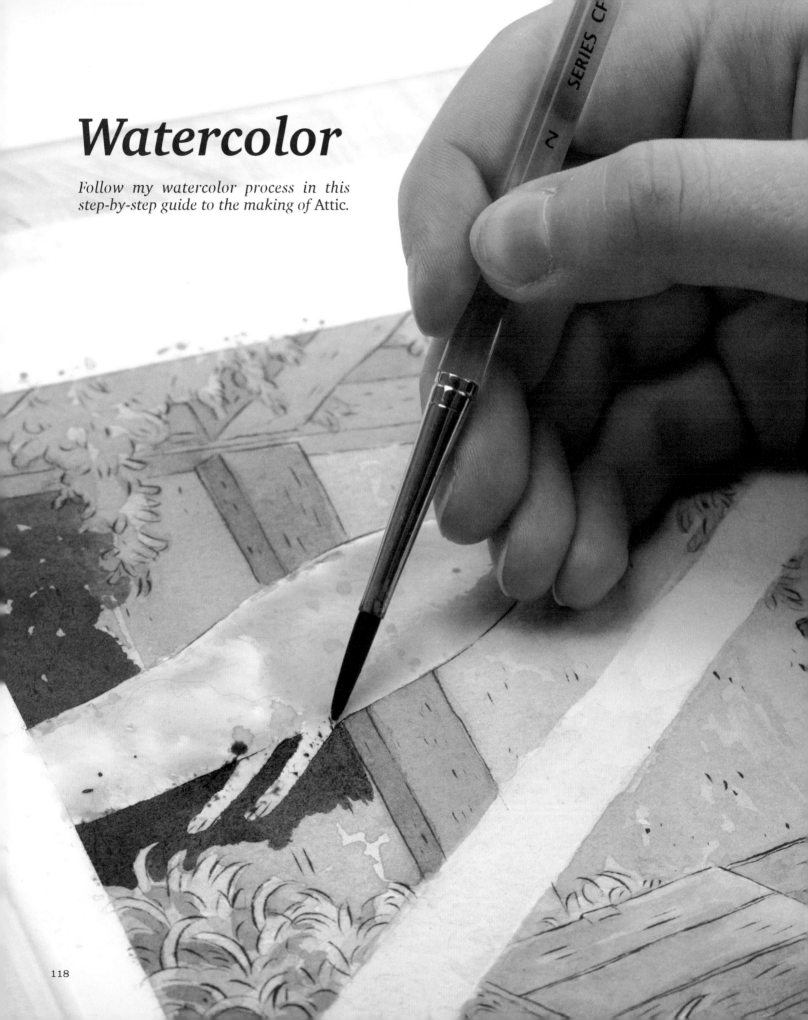

Watercolor

Follow my watercolor process in this step-by-step guide to the making of Attic.

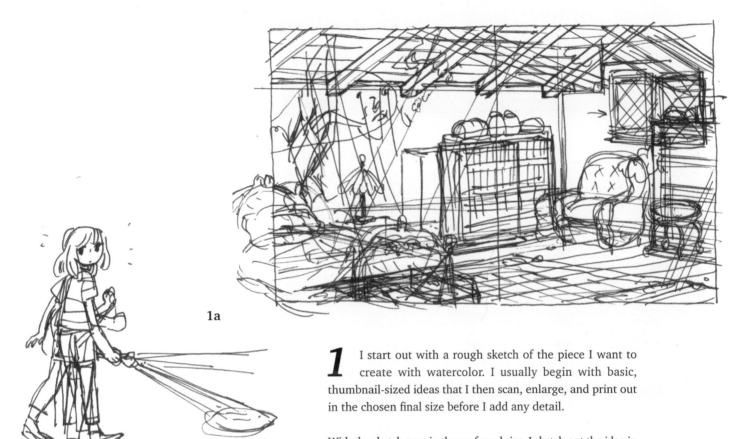

1a

1 I start out with a rough sketch of the piece I want to create with watercolor. I usually begin with basic, thumbnail-sized ideas that I then scan, enlarge, and print out in the chosen final size before I add any detail.

With the sketch now in the preferred size, I sketch out the idea in more detail and move forward with this.

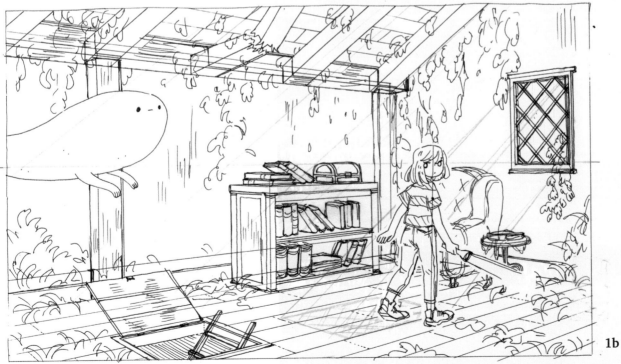

1b

2 I secure the sketch onto the watercolor paper, and using a light table, I trace the sketch onto the watercolor paper with colored pencils. I prefer to use light-toned colored pencils instead of a plain pencil so that the lines blend with the watercolors better.

3 I attach the watercolor paper with masking tape on each side onto a preferred surface, preventing the paper from buckling too much. The surface could be a table, but I tend to use a cutting board as it enables me to rotate the illustration when needed.

4 I work from top-left to bottom-right when inking the lines with a brush pen because I am right-handed and this prevents the ink from smudging. I also ink the background and its objects first, leaving the important characters till last. This way, my hand has become used to the process and I am less likely to make big mistakes on the focal part of the picture.

5 In this illustration I decided not to outline the objects that appear in the rays of sunlight coming from the window and the cracks in the wall because this will produce a clear difference between the light and dark areas in the finished piece.

2a

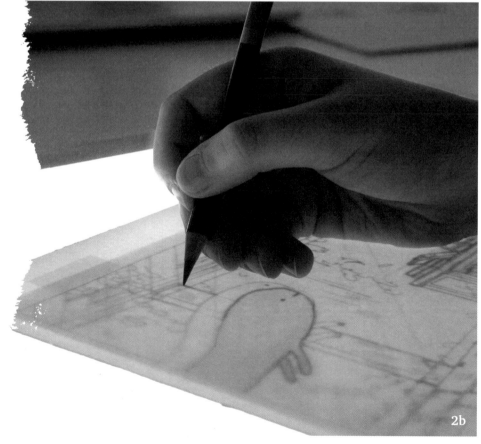

2b

120

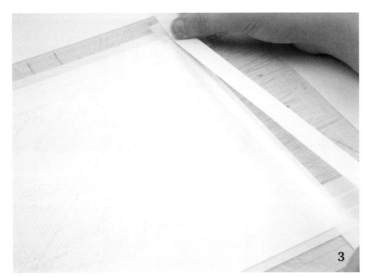

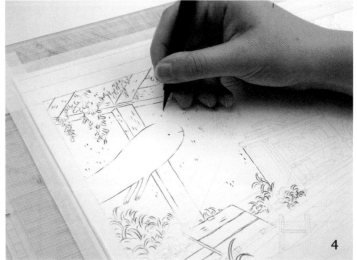

3

4

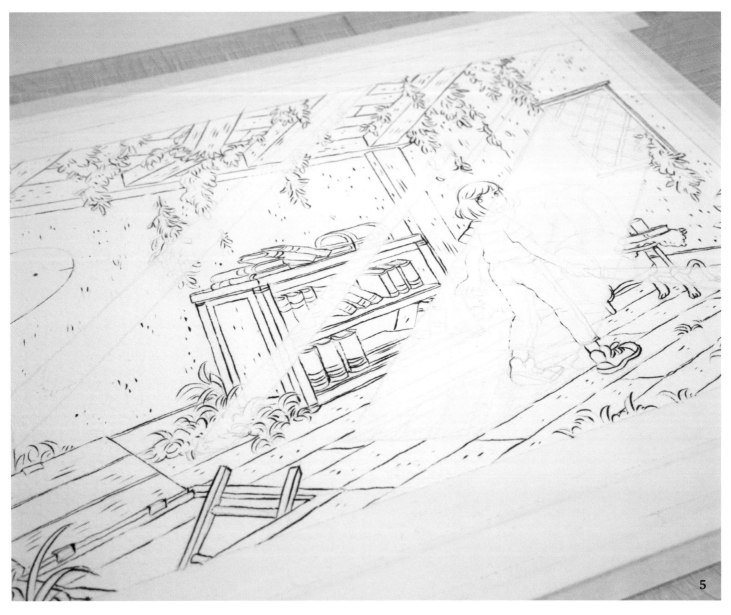

5

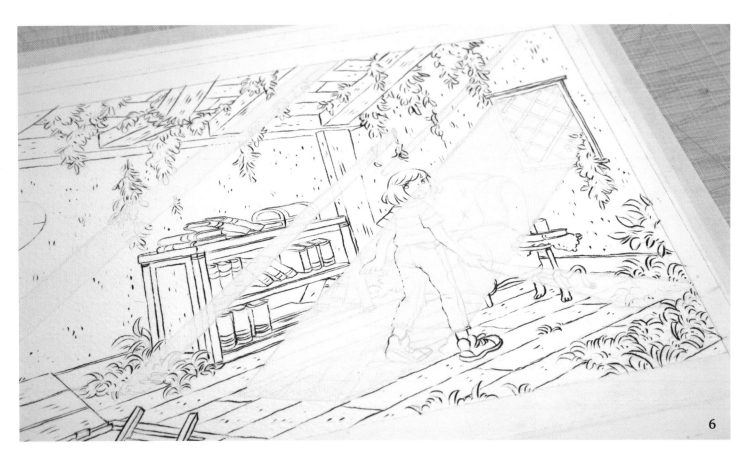

6 I start to mix the first few colors for the illustration. I begin with the lighter tones and will most likely color big areas with similar tones. I therefore use a lot of water to mix a generous amount of the first few colors. I begin with the areas that will be the lightest in the illustration.

7 I want to leave the ghost white until the end, so I cover it with masking fluid meaning I can work on the areas close to it with dark intense tones without having to worry about then affecting the ghost. The masking fluid takes a little while to dry, about 5–10 minutes.

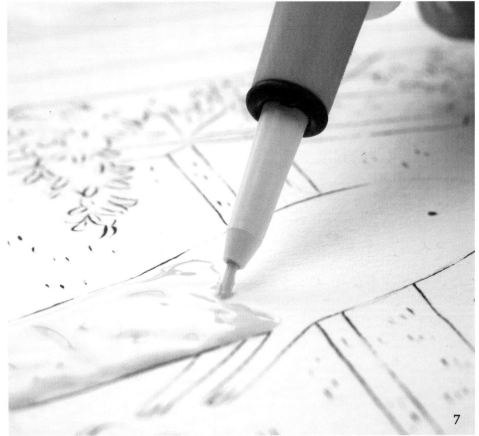

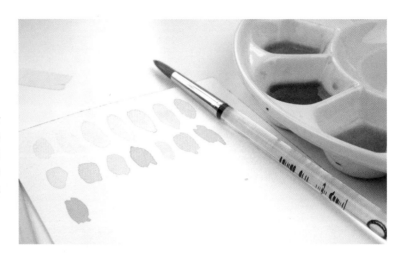

TIP: Use a scrap piece of watercolor paper to try out the colors you are mixing to test how they will look. You will be surprised at how different the colors look on the palette compared to how they appear when dry on the paper.

8 I move on to other large areas and start working with slightly darker tones to those I used for the rays of light. I use a generous amount of water and vary with splotches of green, brown, and blue to give a varying wash of color to the large area.

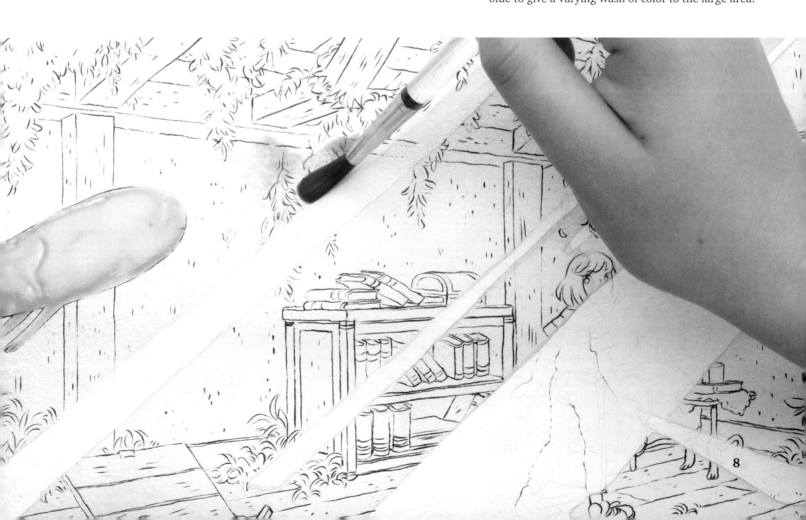

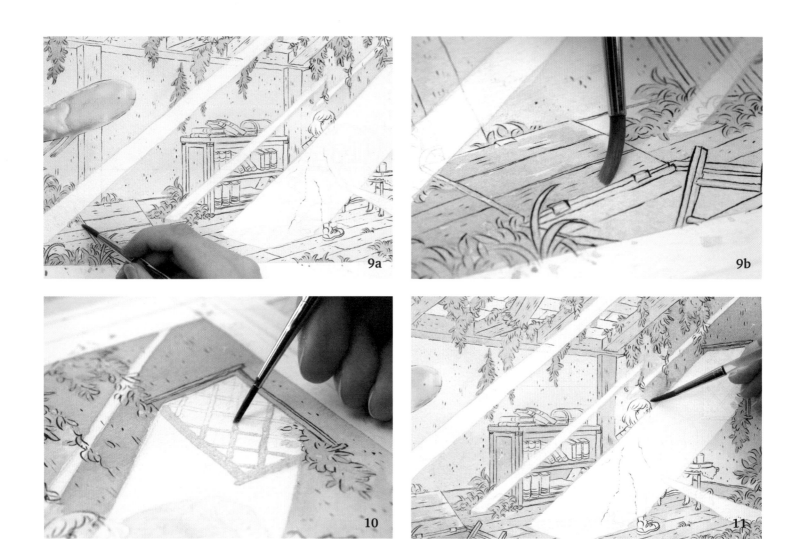

9 I mix new colors – this time using more color from the pan and less water – and start to color the objects in the image with a base tone.

10 As I work on the illustration I try to think where the lightest areas will be according to how the light source interacts with everything. I make sure there is a clear contrast of light and dark in the objects: for example, with the window shown here I make the grid and the corner of the window where the sun shines through really light, and the top-right-hand corner of the window where it will be in shadow much darker.

11 I slowly work from lighter tones to darker tones, creating darker shades with each layer I apply. At this point, I start to experiment with the tone of the shadow I would like this illustration to have. In the end, I settle on a dark-bluish tone for all the shadows to suggest it is the middle of the day.

12 I now move on to the objects that will be filled with more intense colors. I make sure I don't start this until the area near them is completely dry because stronger colors are prone to bleeding onto lighter-toned areas when wet.

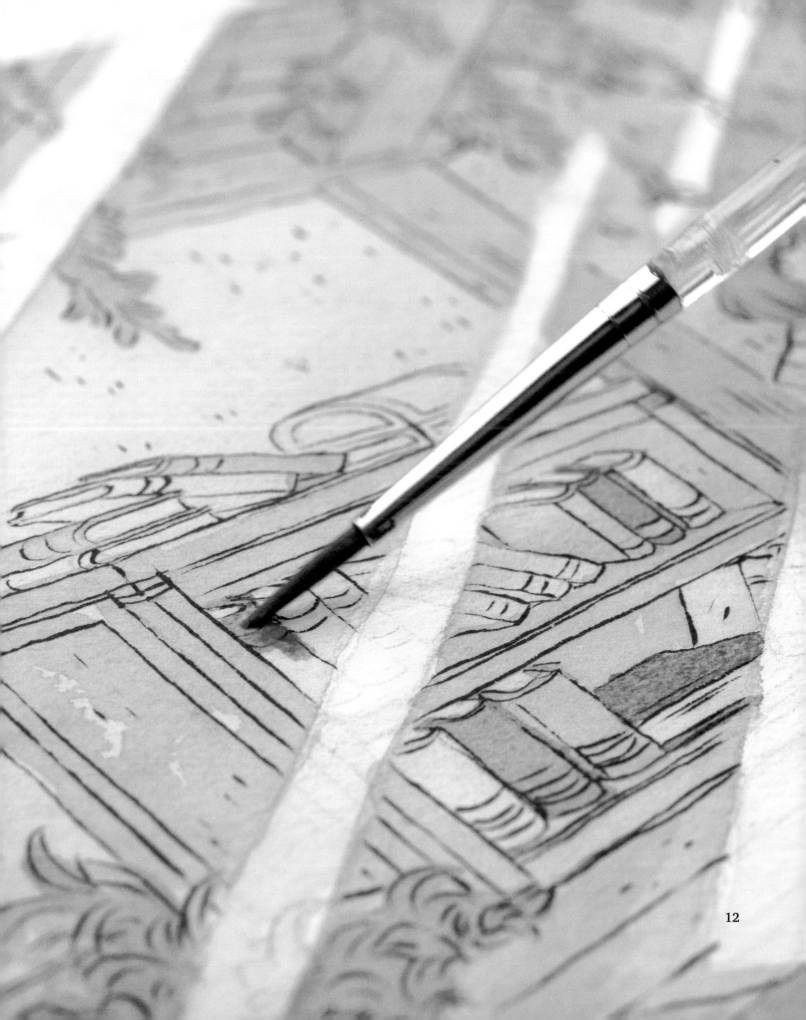

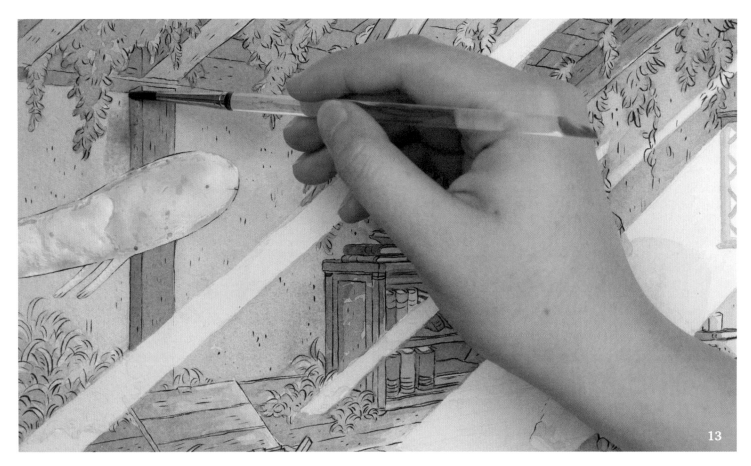

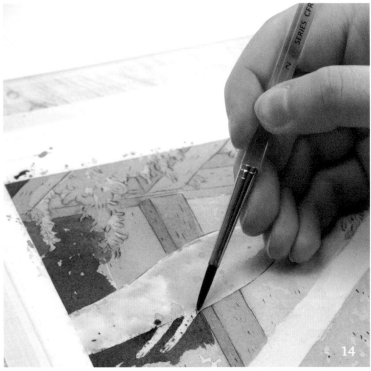

13 At this point, I am almost finished with all of the base colors for each object in the illustration, so I experiment with the shadows, trying to figure out on which sides of the objects the shadow will fall.

14 Once the base colors for the painting are dry, I mix a large amount of the dark blue colors for the shadows, and begin painting the darkest areas of the picture.

15 The rest of the process involves adding the same tone as the shadows, on top of the base colors. If I notice that a base color is too light, I will add in a layer of the same color to make it darker before applying the shadow.

Once I have added more depth to them, I notice that they still seem too white. Ideally I would like to leave the light coming from the window as it is, but decide to carefully add a layer of green to the thinner rays to blend them into the background more.

16 I notice that the rays of lights that are coming from the small cracks in the worn-down walls look a bit too bright next to the dark shadowy areas so, moving from the end of the ray of light to its source, I begin to add more detail to the objects behind the light. This makes it look like you can see through the light. I also use very wet paint to create a gradient effect from the light to the dark in the rays.

17 Once I am almost finished with the illustration, I remove the masking fluid from the ghost with the flat end of a brush. You can also use an eraser but, depending on the masking fluid you use, you might need a hardier tool. Remember to always use a clean tool for removing masking fluid otherwise you could end up with smudges on the area you wanted to protect.

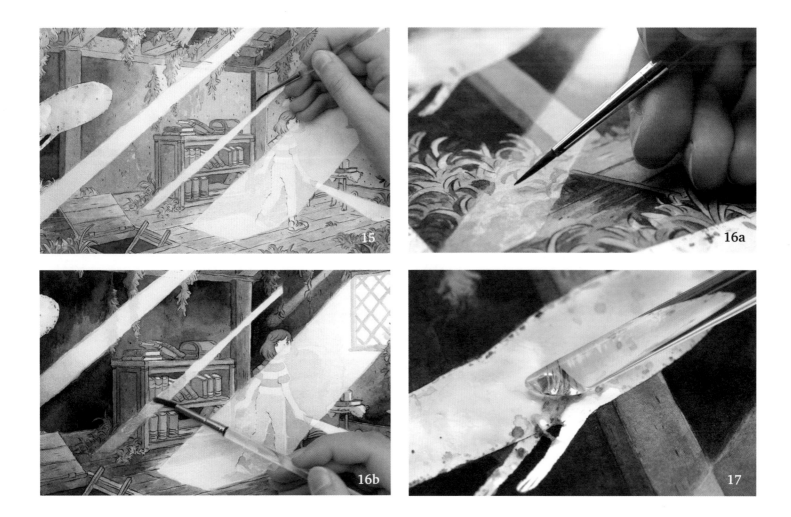

15

16a

16b

17

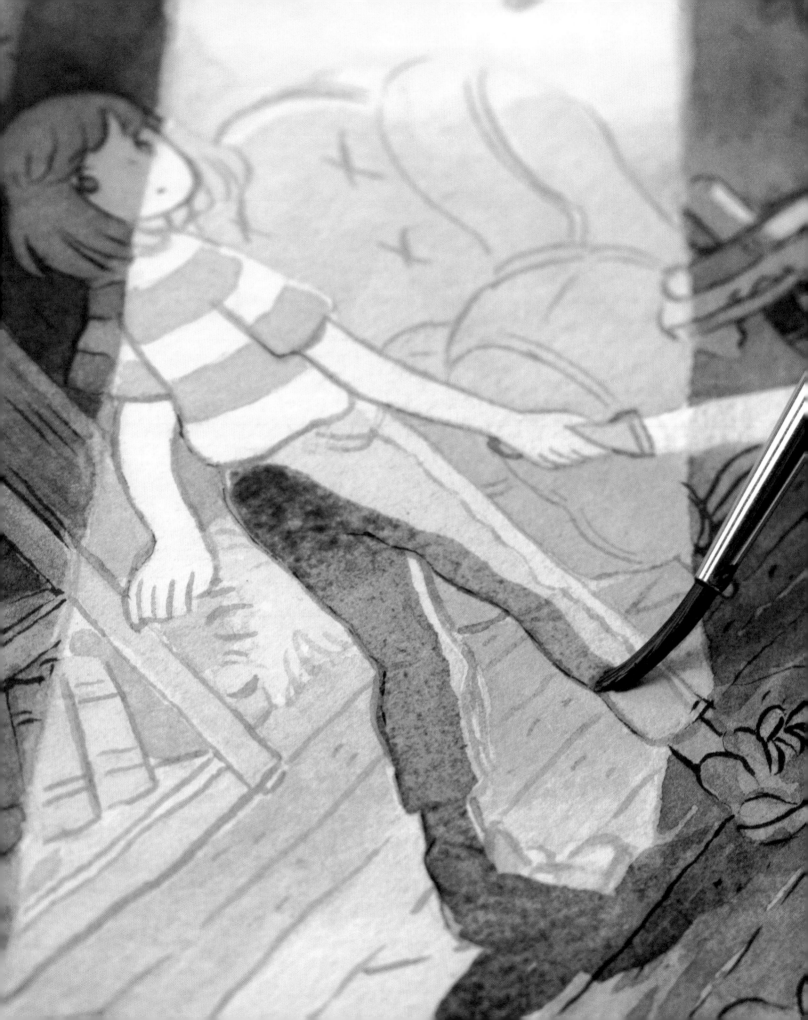

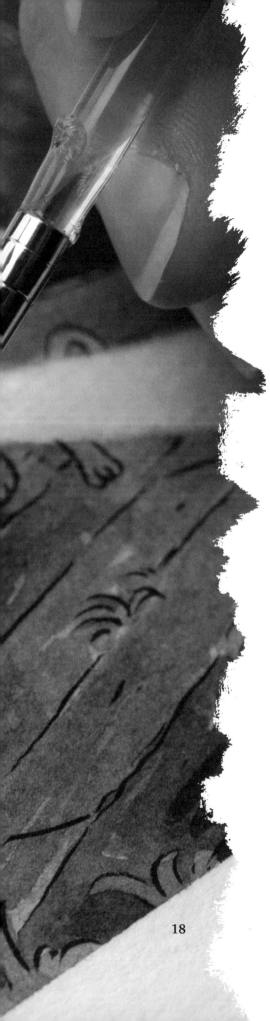

18 For the finishing touch, I decide to make a shadow for the character in the illustration. I was a bit worried that this would ruin it, and it is a bit of a shame to cover the character, but the lighting looks more realistic with a shadow on her back.

19 The painting is now ready for me to carefully remove the masking tape from the edges. Some papers are really sensitive and might rip if you use a tape with strong adhesive – I recommend using masking tape with weak adhesive when dealing with watercolor papers.

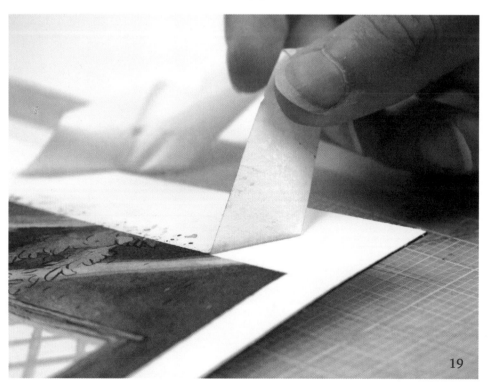

18

19

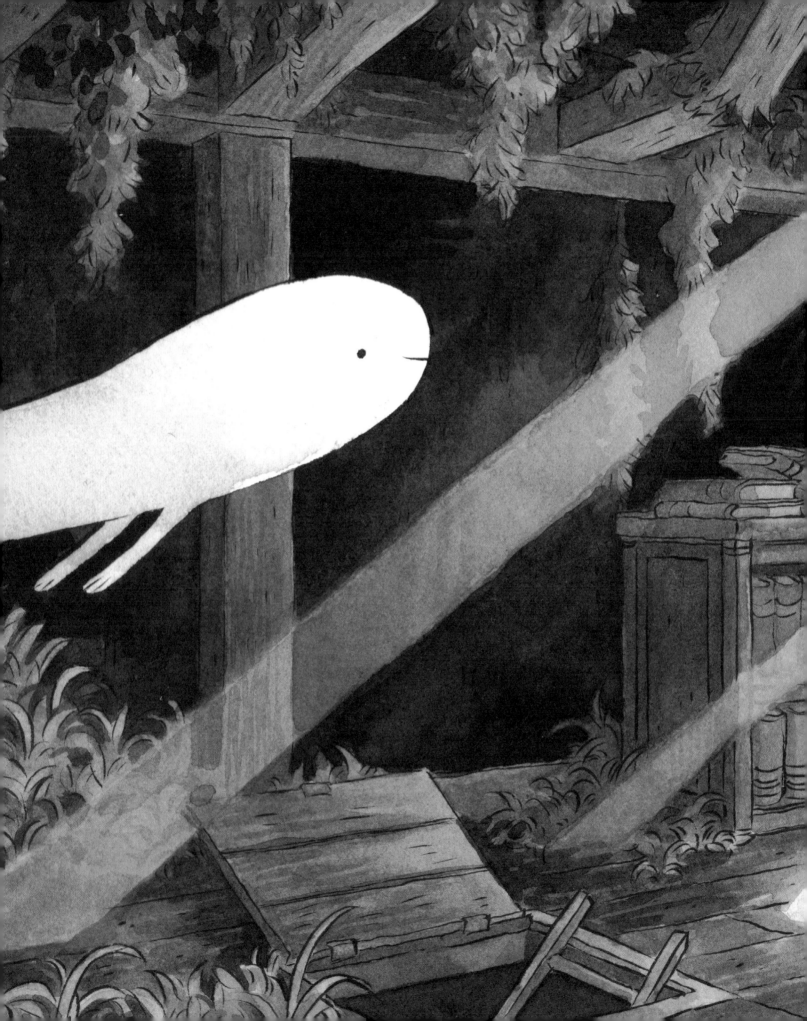

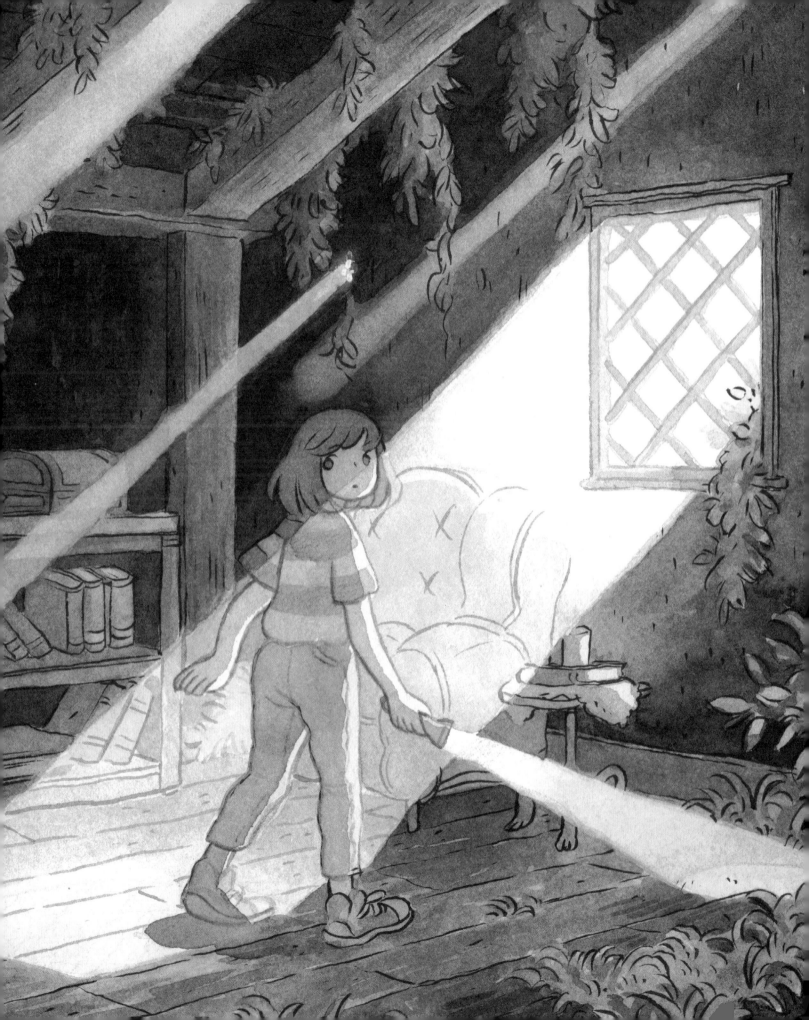

Ink

Learn how to create an ink piece with this tutorial on the making of Waves.

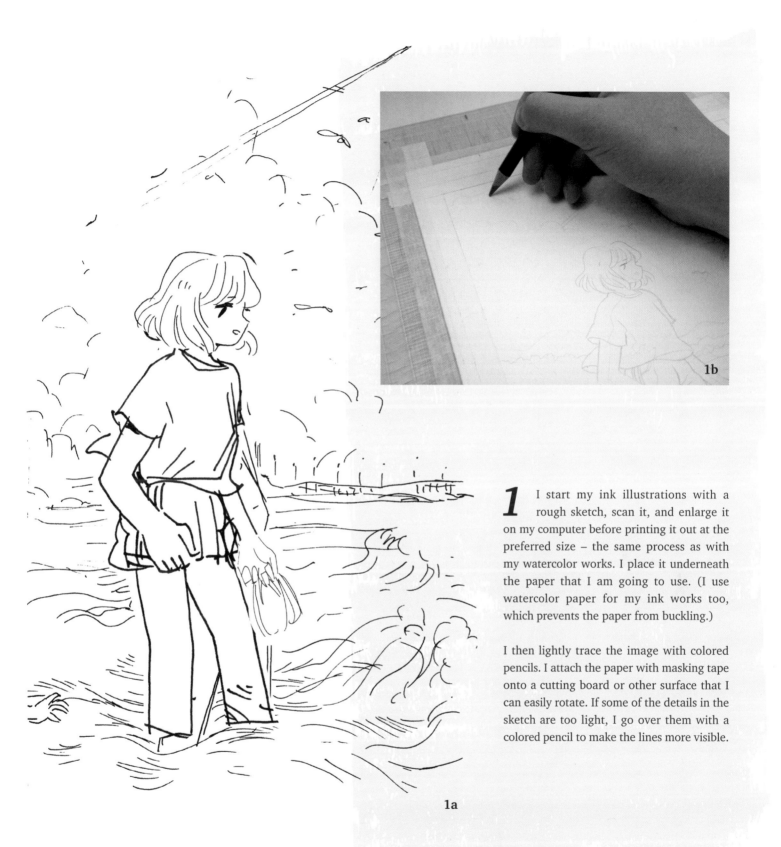

1b

1 I start my ink illustrations with a rough sketch, scan it, and enlarge it on my computer before printing it out at the preferred size – the same process as with my watercolor works. I place it underneath the paper that I am going to use. (I use watercolor paper for my ink works too, which prevents the paper from buckling.)

I then lightly trace the image with colored pencils. I attach the paper with masking tape onto a cutting board or other surface that I can easily rotate. If some of the details in the sketch are too light, I go over them with a colored pencil to make the lines more visible.

1a

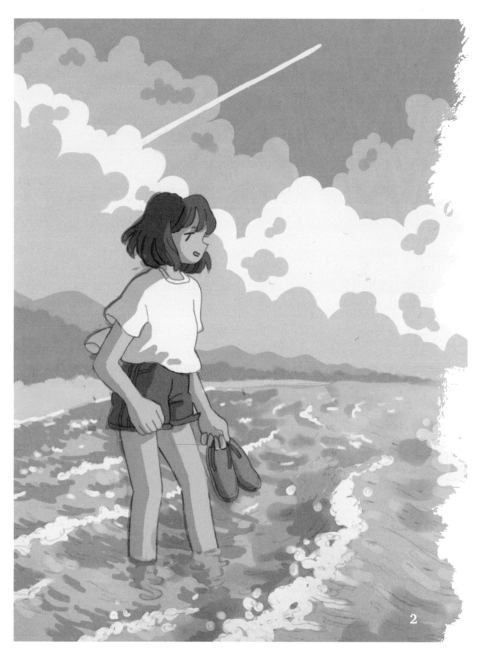

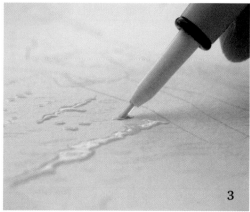

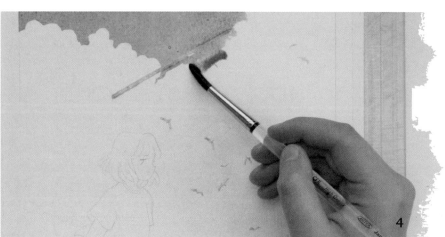

2 If I am not too sure of the colors that I would like to use, I make a quick mock-up with Photoshop or with Procreate on an iPad and refer to this throughout the process. It is really helpful to do this when working with colored inks as it is impossible to remove a color once you have laid it onto the paper.

3 There are going to be a lot of tiny white areas surrounded by vast dark areas of color in this illustration, so I decide to use masking fluid to cover the foam of the waves, the seagulls, and the trail of the jet engine – this makes it easier to work around the tricky details with ink.

4 I start by inking the sky using one of the darkest colors; I blend a lot of this color so I can work quickly to create a smooth, even finish for the sky.

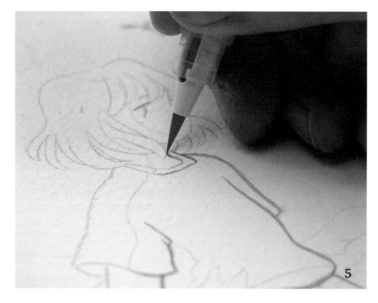

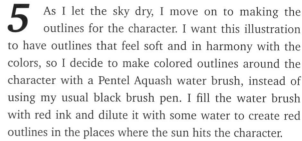

5 As I let the sky dry, I move on to making the outlines for the character. I want this illustration to have outlines that feel soft and in harmony with the colors, so I decide to make colored outlines around the character with a Pentel Aquash water brush, instead of using my usual black brush pen. I fill the water brush with red ink and dilute it with some water to create red outlines in the places where the sun hits the character.

6 Then I fill another water brush barrel with blue ink and use it to outline the character in places that are left in the shadow. I want the background to have more of a painterly look so I leave it without outlines.

7 I begin to paint the details in the farthest cloud, mixing a tone of pale purple ink for the stylized shadows in it. Then I let the ink dry thoroughly and work on some other details in the character before coming back to the cloud.

I then place a layer of ink (that is the lighter color of the farthest cloud) on top of the sky and the cloud to achieve an even area of color and to avoid having to move carefully along the edge where the cloud meets the sky.

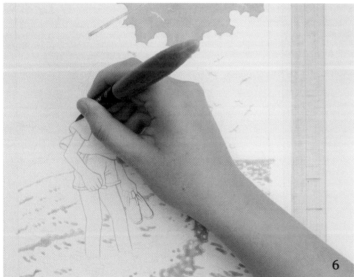

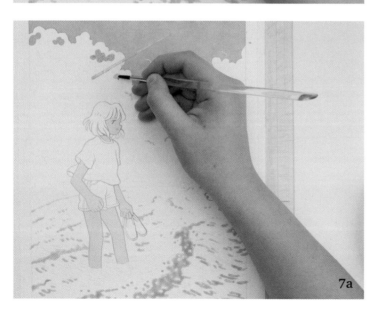

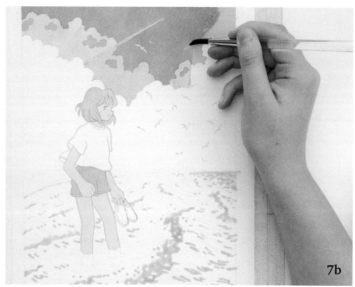

8 I mix a more concentrated color of the character's skin tone and apply it over already-painted parts for the shadows to suggest strong sunlight is hitting the character.

9 I begin to color the large area of ocean in the lower part of the illustration. The masking fluid that I laid out earlier comes in handy here, as I only have to worry about not getting the blue ink on the character.

10 At this point, I remove the masking fluid from the trail of the jet so I can move on to coloring the cloud. I leave all other areas of masking fluid intact for now. Then I color the lightest areas of the front cloud with a pale tone of yellow.

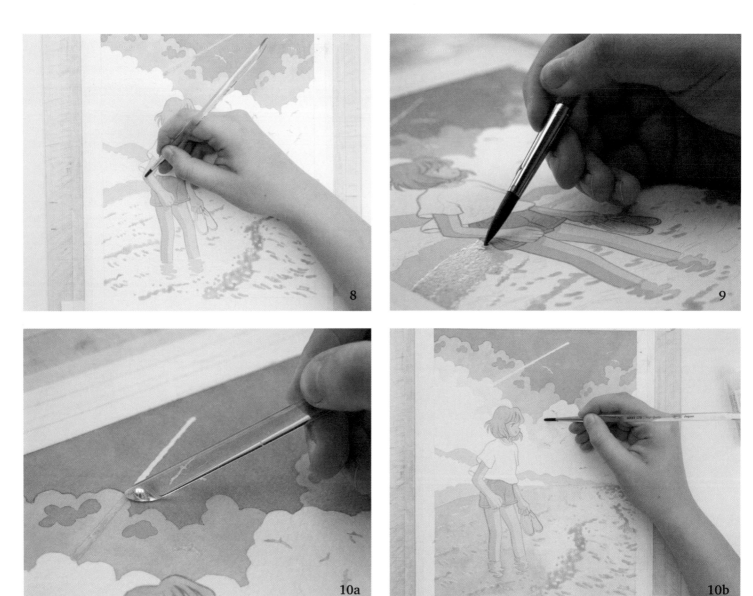

11 Now, I color over the large area of ocean with a darker tone of blue to create waves on the surface and, using the same tone, I add a layer of blue on top of the reflection of the character's feet so it looks like the feet are underwater.

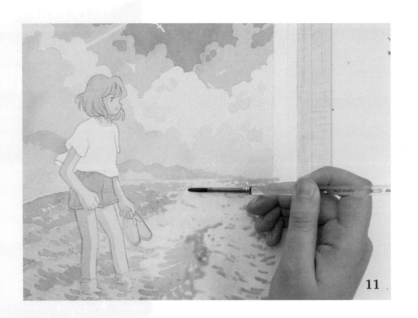

11

12 I use a purplish blue tone for the shadows in the character's shirt. The great difference between the tone of the shirt and the shadows on it makes it look like the sunlight is powerful.

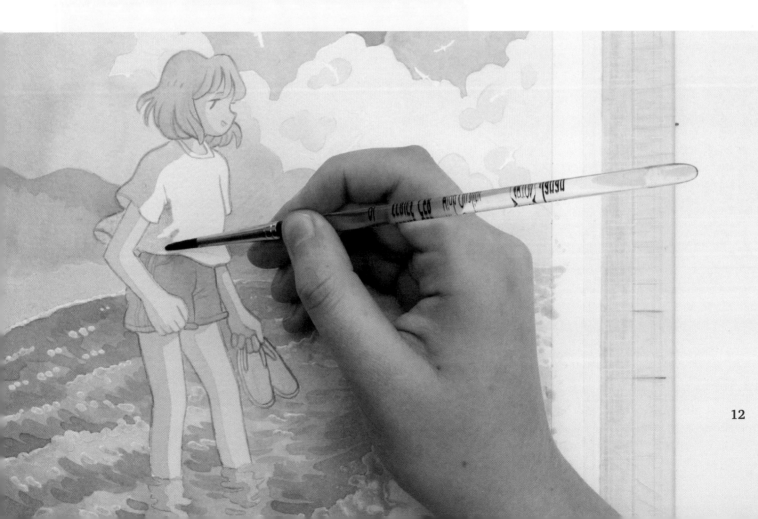

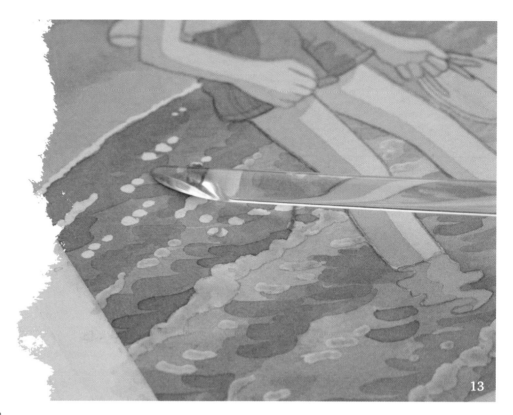

13

13 Once I am satisfied with the overall color of the large areas in the painting I remove the masking fluid from the rest of the artwork. It is very important that the painting is all dry when removing the masking fluid otherwise you might accidentally smudge the wet color.

14 After removing the masking fluid, I add some light orange ink to some of the sparkles in the water to create a feeling that the light source is emitting an orange/yellow glow.

15 I decide to darken the tones of the shadows in the hair and on the shorts. I go over the outlines of the character with some red and blue ink one more time so the character will stand out from the background.

16 I decide the foam on the waves behind the girl should blend in more so I add in one more layer of blue to parts of the bottom-left corner.

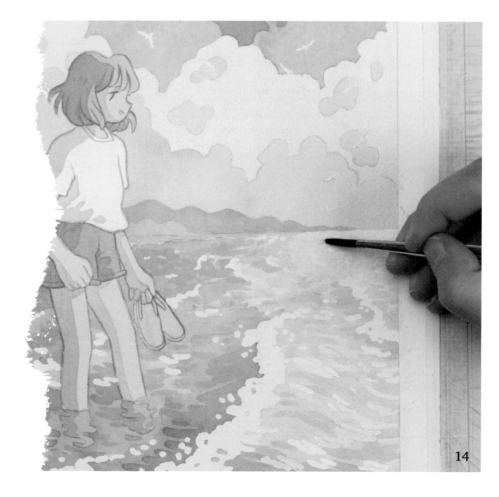

14

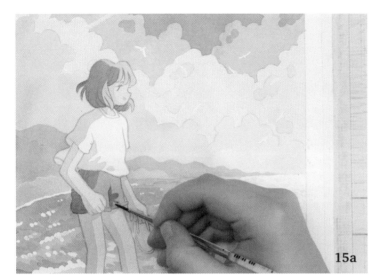

15a

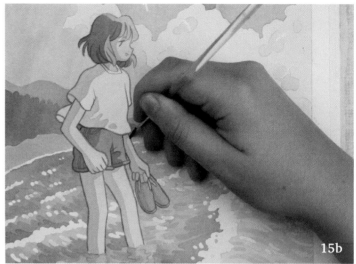

15b

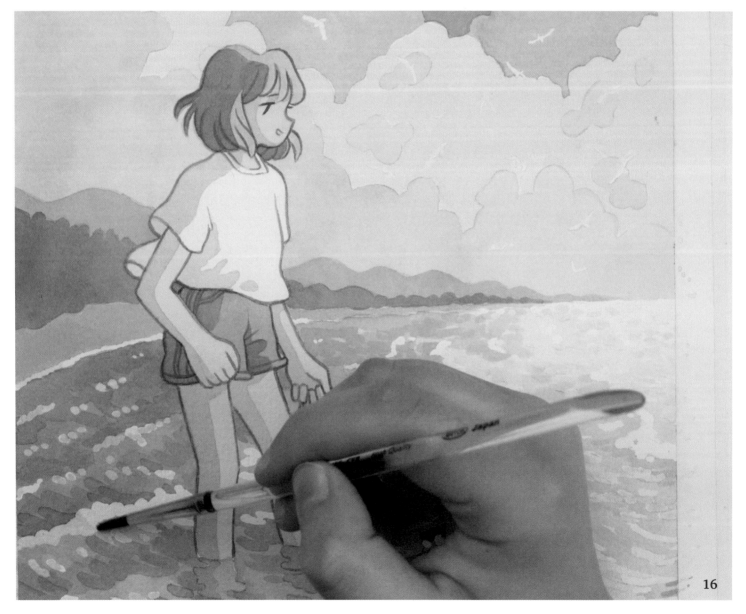

16

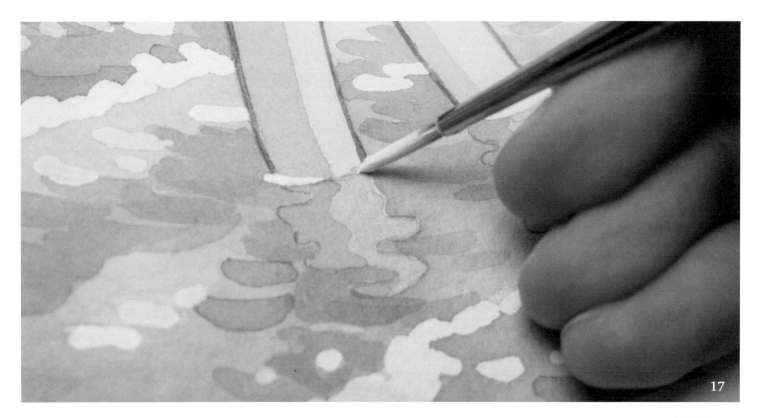

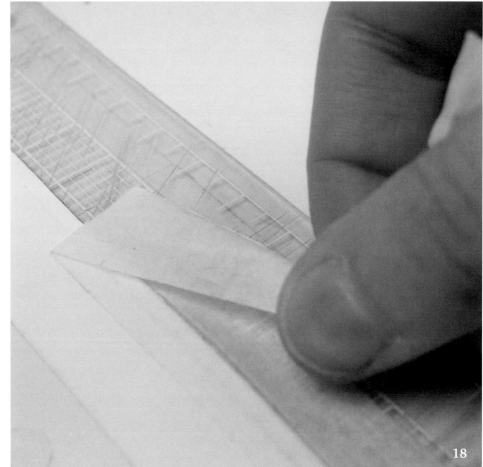

17 For finishing touches, I add a tiny amount of white poster color to the edge where the feet meet the water – this also creates foam.

18 Finally, I carefully remove the masking tapes from all of the edges. Remember to remove it by pulling away from the painted area to prevent the paper from tearing your image.

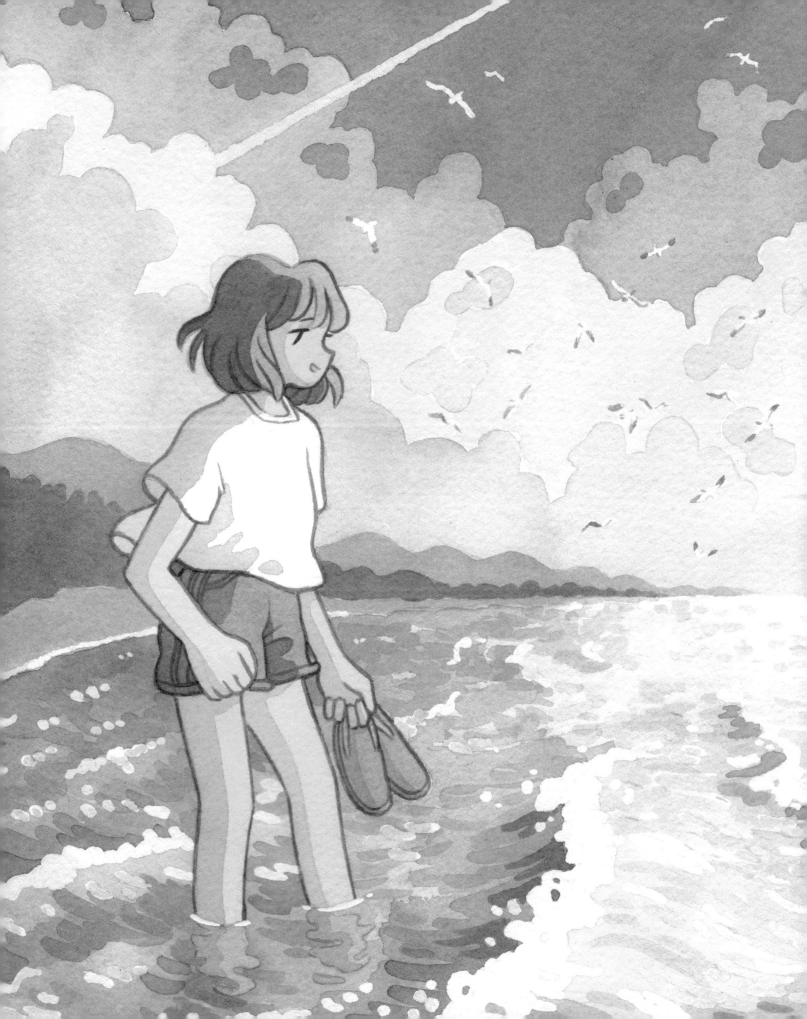

Enamel pin

A step-by-step guide to producing a Japanese kitsune (translated "fox") mask enamel pin.

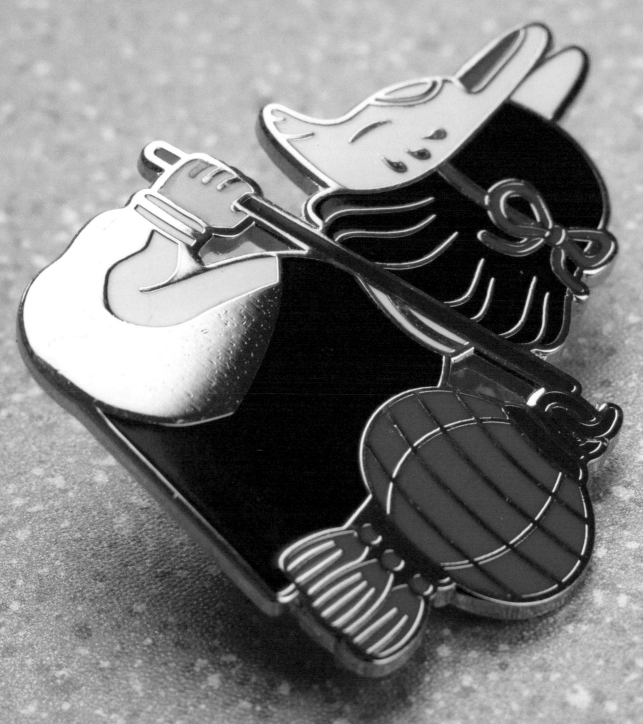

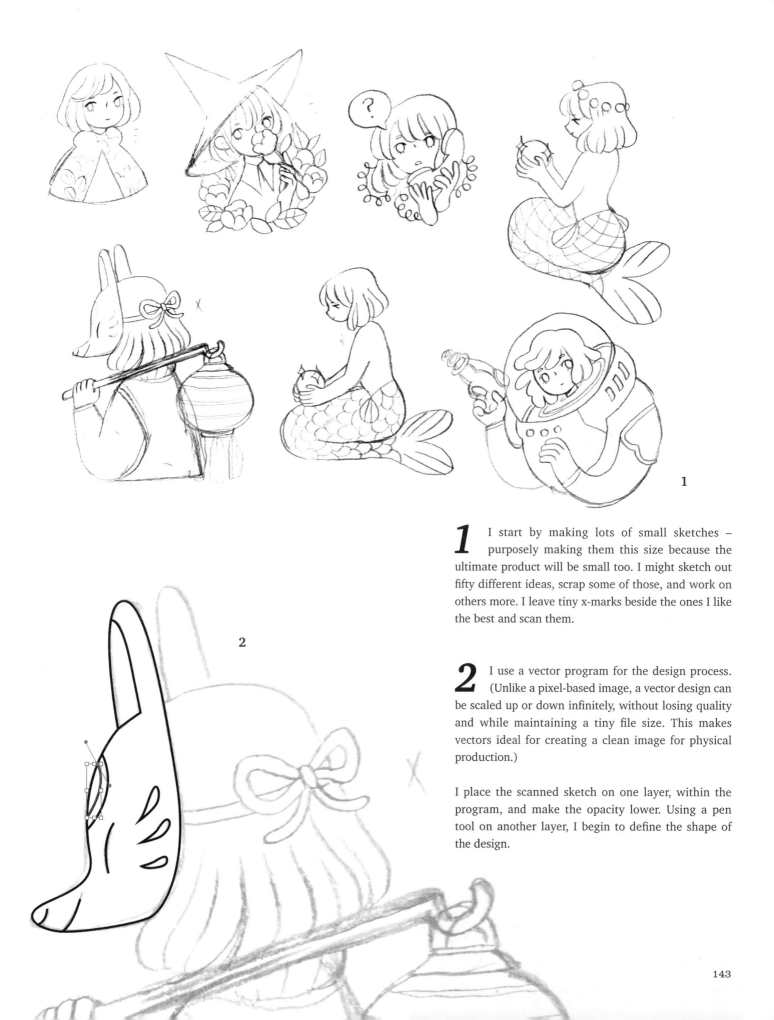

1 I start by making lots of small sketches – purposely making them this size because the ultimate product will be small too. I might sketch out fifty different ideas, scrap some of those, and work on others more. I leave tiny x-marks beside the ones I like the best and scan them.

2 I use a vector program for the design process. (Unlike a pixel-based image, a vector design can be scaled up or down infinitely, without losing quality and while maintaining a tiny file size. This makes vectors ideal for creating a clean image for physical production.)

I place the scanned sketch on one layer, within the program, and make the opacity lower. Using a pen tool on another layer, I begin to define the shape of the design.

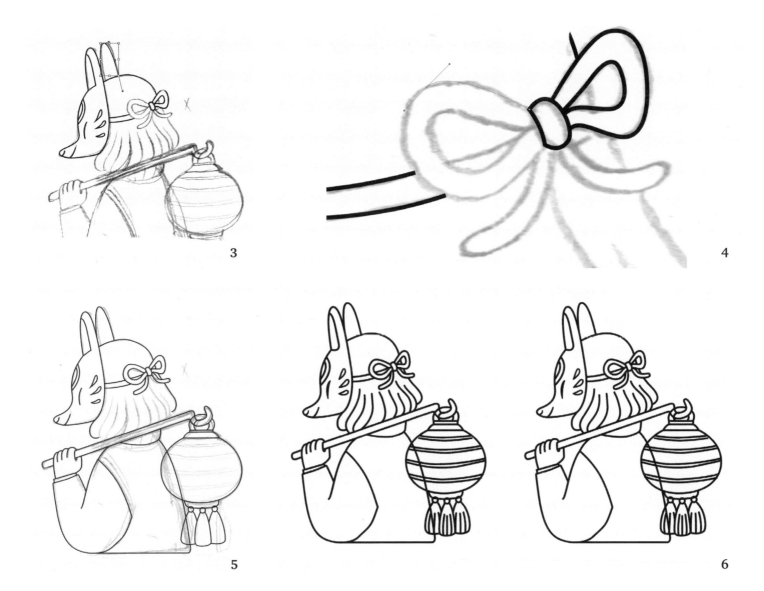

3 4 5 6

3 I start with the easiest parts and develop the sketch underneath to create more polished shapes, keeping the vector line very thin at this point, so I can see the sketch better.

4 After making the most prominent features of the design, I move on to the finer details. I might make slight changes at this point and remove some of the smallest closed areas. I have learned that the more detailed the final design, the likelier it is for the finished pins to come out with mistakes and misprints in them, so I prefer to keep them simple.

5 I also keep the design simple so it is easy to understand – I zoom in and out a lot to decide if the designs are too small.

6 Once I am happy with the details and the overall look of the vector design, I make the lines thicker. I try to avoid making any of the lines too thin; the recommended minimum line thickness for hard enamel pins is about 0.2 mm. At this point, I also make a copy of the design so that I can go back in my steps or try different line thicknesses on the duplicate.

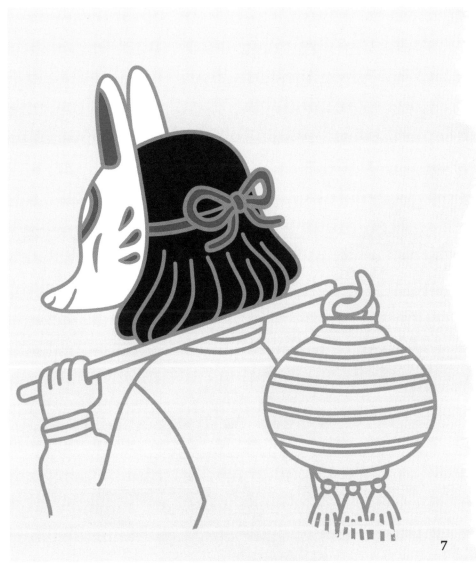

7 Now I begin laying out the colors for the design. For this pin I choose gold plating; gold paint is often used in kitsune masks, so I thought it would be appropriate for this design. I make the colors on a separate layer and lock the line art layer, so it doesn't get in the way.

8 I begin by making separate shapes for each colored part of the design; it is then easier to just click a shape that I want to modify. While I am focused on the shapes, I don't worry about forming the perfect color combination.

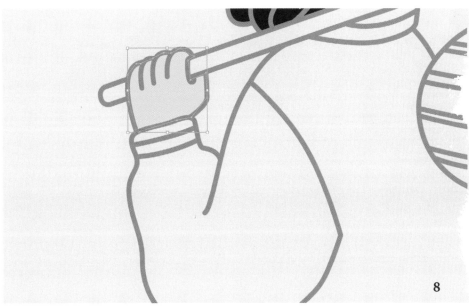

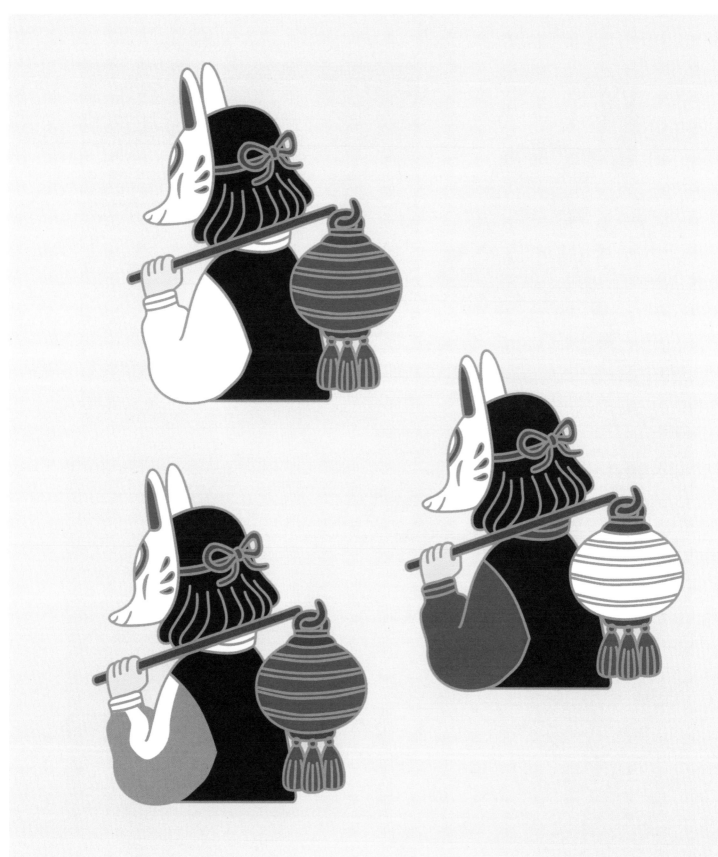

9

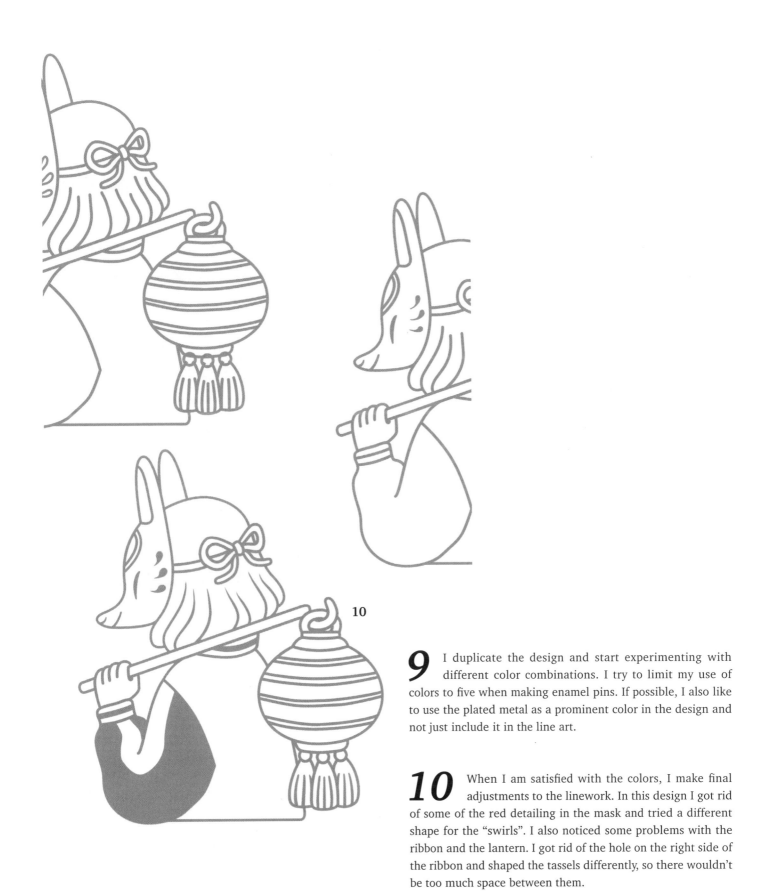

9 I duplicate the design and start experimenting with different color combinations. I try to limit my use of colors to five when making enamel pins. If possible, I also like to use the plated metal as a prominent color in the design and not just include it in the line art.

10 When I am satisfied with the colors, I make final adjustments to the linework. In this design I got rid of some of the red detailing in the mask and tried a different shape for the "swirls". I also noticed some problems with the ribbon and the lantern. I got rid of the hole on the right side of the ribbon and shaped the tassels differently, so there wouldn't be too much space between them.

11 I make one last change to the pattern of the lantern and then I am happy with design. I make a duplicate of the whole thing, fill it with a gold color, and make the outline of the copy a bit thicker. I place the duplicate right below the finished design, so the outline of the design is a bit wider than the lines inside the image.

12 Once the pin design is finished, I make a guide for the manufacturer: the colors, where the holes will be, and the size. I use a Pantone color guide to determine the exact colors I want for the design, but ultimately the colors that can be used in the final pin design are limited to the enamel paints that the manufacturer has. Getting the exact hue you want might not be possible, but manufacturers usually do send over a PDF proof beforehand and might also be willing to take photos of the first batch of the pins for you.

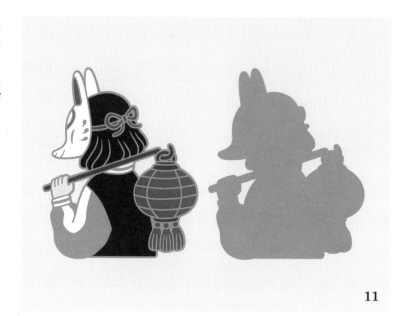

11

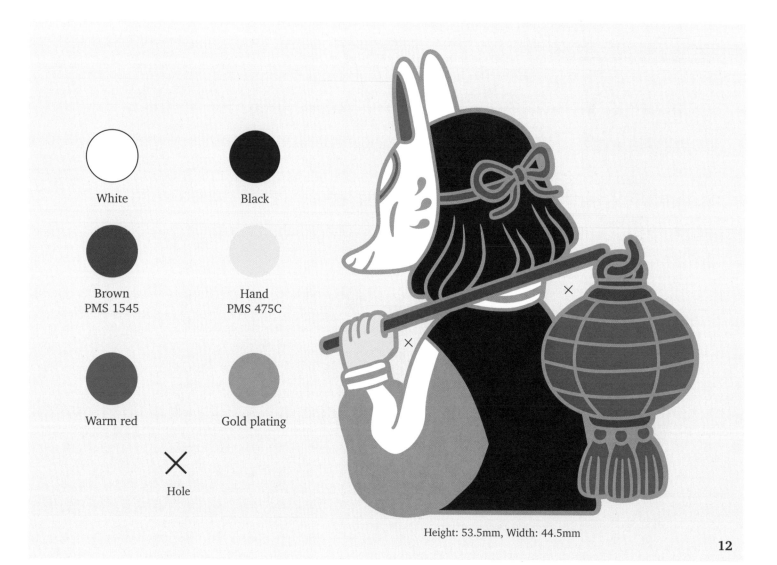

White

Black

Brown
PMS 1545

Hand
PMS 475C

Warm red

Gold plating

✗

Hole

Height: 53.5mm, Width: 44.5mm

12

148

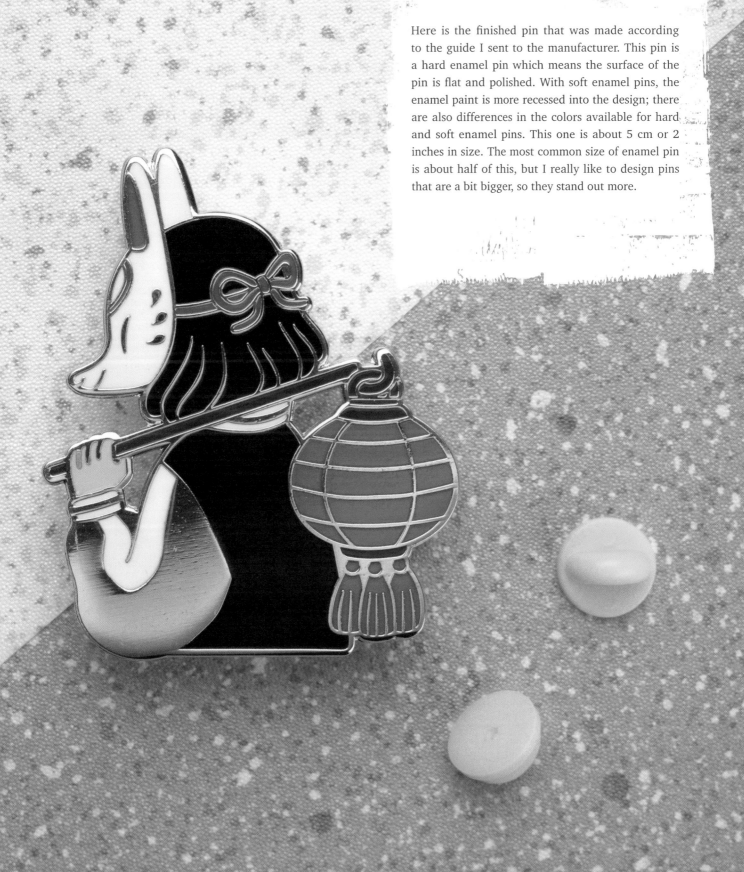

Here is the finished pin that was made according to the guide I sent to the manufacturer. This pin is a hard enamel pin which means the surface of the pin is flat and polished. With soft enamel pins, the enamel paint is more recessed into the design; there are also differences in the colors available for hard and soft enamel pins. This one is about 5 cm or 2 inches in size. The most common size of enamel pin is about half of this, but I really like to design pins that are a bit bigger, so they stand out more.

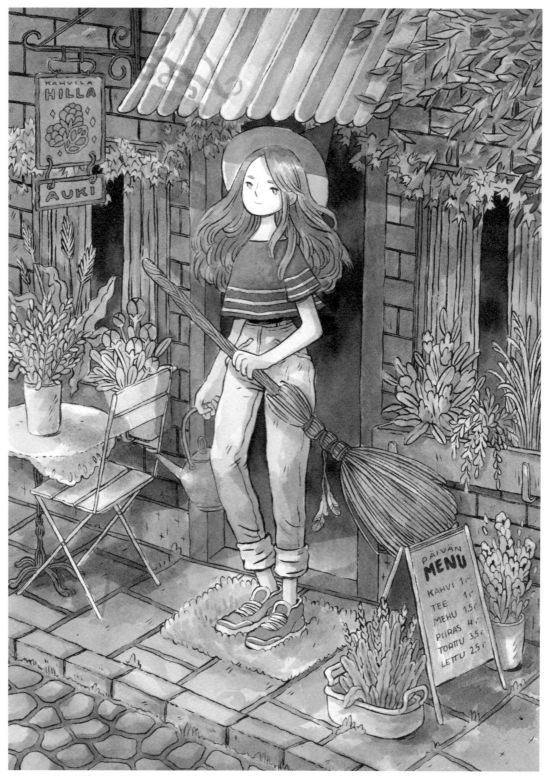

CLOSING TIME, 2018

Thank you

A big thank you to all the people who support me so I can create art every day. By sharing, liking, commenting, or buying something from my shop, you help keep me motivated to create things with my hands. I am constantly surprised by your enthusiasm towards my works and I hope to continue to delight you with my art in the future.

Thank you to all of you who backed this book during the Kickstarter campaign; to people who shared lovely thoughts about the book and the campaign; and to those who, at events and online, told me how much they anticipated this book. I was blown away by your support and the encouraging words, and your enthusiasm towards this project inspired me a ton!

An enormous thank you to the 3dtotal team, and my editor Kinnor specifically – there would be no *The Art of Heikala* without you. Thank you to the team for all your hard work, dedication, and the assistance you gave me as we created this book.

Thank you to my friends, I am lucky to have you in my life, and a special thank you to Markku for the lovely logo for this book. Thank you also, Pepe, for helping me with the campaign video and animation, and with various things for the book. Thank you for the love and support, I am lucky to have you in my life.

All my love to my family for their support during this project. Thank you, Mom, for the encouragement and support – you were always there for me.

3dtotal Publishing

3dtotal Publishing is a leading independent publisher specializing in trailblazing, inspirational, and educational resources for artists.

Our titles feature top industry professionals from around the globe who share their experience in skillfully written step-by-step tutorials and fascinating, detailed guides. Illustrated throughout with stunning artwork, these best-selling publications offer creative insight, expert advice, and essential motivation.

Fans of digital art will find our comprehensive volumes covering Adobe Photoshop, Pixologic ZBrush, Autodesk Maya, and Autodesk 3ds Max must-have references to get the most from the software. This dedicated, high-quality blend of instruction and inspiration also extends to traditional art. Titles covering a range of techniques, genres, and abilities allow your creativity to flourish while building essential skills.

Well-established within the industry, we now offer over 50 titles and counting, many of which have been translated into multiple languages the world over. With something for every artist, we are proud to say that our books offer the 3dtotal package.

Visit us at 3dtotalpublishing.com

3dtotal Publishing is an offspring of 3dtotal.com, a leading website
for CG artists founded by Tom Greenway in 1999.